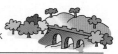
目錄 • 目次 • CONTENTS

U0108706

序 序文 Preface

歡迎光臨姿采萬千的香港，在享受這個大都市的繁華和經濟活力之餘，別忘了走進廣闊青翠的秀麗郊野，體驗那令人心曠神怡的大自然魅力！

香港予人的印象是高廈林立的都市，可是佔地最廣的卻是空曠蒼翠的郊野。在1,100平方公里的土地上，設有23個特色各異的郊野公園，佔全港面積大約四成；當中蘊藏著無數迷人的風景，包括海岸島嶼、群山疊翠、叢林草坡、偏遠古村，處處風光如畫，教人沉醉。

機場所在的大嶼山，為香港最大的海島，擁有全港第二及第三高的山峰和原始的山野景致；西貢海岸綫曲折綿長，島嶼星羅棋布，可在其中找到許多香港最出色的山海勝景；新界廣袤遼闊，峻峭山嶺連綿不絕，幽遠鄉郊動人心扉；在香港島則有讓人遠離煩囂的蒼翠山林。

大部分郊野公園都有公共交通工具直達，而且需時不多，往來便捷。公園內闢有路標清晰的郊遊及遠足山徑，康樂地點則設有桌椅、燒烤爐、涼亭、營地等不同設施。在這些美麗的野外環境中，可以遠足、漫步、燒烤、露營，又或只是單純地欣賞秀美不凡的大自然景色。

你會發現，在舉世聞名的城市風貌之外，香港的自然美景多不勝數。那些純淨無暇的天然環境，不僅讓你更了解香港的不同面貌，亦將讓你帶著大自然所賦予的驚喜和感動滿載而歸。

美しい眺めとにぎわいの街、香港へようこそ！ 活気あふれる大都会の魅力とダイナミックな経済発展の姿を楽しむと同時に、風光明媚なカントリーサイドを是非とも訪問して下さい。魅力的な野生あふれる香港との出会いはきっと忘れられない思い出となるでしょう。

香港へやって来る方々の第一印象は高層ビルの建ち並ぶ超近代都市です。おかげで香港の土地の太宗部分はカントリーサイドであるという事実はかすんでしまいそうです。香港には２３ものカントリーパークがあり、個性豊かなパークを総計すると面積は香港の陸地部分1100平方米の実に40％にもなるのです。その中には海岸、離島、急峻な山岳地域、森に覆われた斜面、辺境の旧村等の雄大で息を飲むほど美しい景観が広がっています。どこを見ても異なる風景が私たちを迎え、自然の探索は大きな楽しみをもたらしてくれます。

チエック・ラップ・コック国際空港のあるランタオ島は香港の離島で最大です。手つかずのカントリーサイドに香港で第2、第3の高峰が聳えています。

西貢は凹凸の激しい長い海岸綫で有名です。無数の島々に取り囲まれ、その島のいくつかは香港で最も雄大な海景に恵まれています。

新界は野生あふれる緑で覆われています。ゆるやかに起伏する山なみと牧歌的な田舎の村落がこの一帯の特徴です。香港島には、都心に近いにもかかわらず、そこを訪れると街の喧騒を忘れられるような手つかずの山々があります。

どのカントリーパークへも公共交通機関で行けます。時間もそんなにかかりません。パークの中には指導標が完備したカントリートレイルやハイキングトレイルがあります。ピクニックエリアにはテーブル、ベンチ、バーベキュー施設、雨よけの東屋、キャンプ場があります。眺めの良いカントリーサイドはハイキング、ウォーキング、バーベキュー、キャンピングに最適です。

香港には有名な街並み以上にもっと素晴らしいものがあることを知れば嬉しくなるでしょう。時間を作ってカントリーサイドのあちこちに出かけ、これまでとは違った面を見てください。汚れの無さと圧倒的な自然美は私たちに元気をくれます。自然と一体になるつもりでその楽しい驚きを味わって下さい。そうすれば香港を去る時にはすっかり満足して、しかも大いに元気付けられていることでしょう。

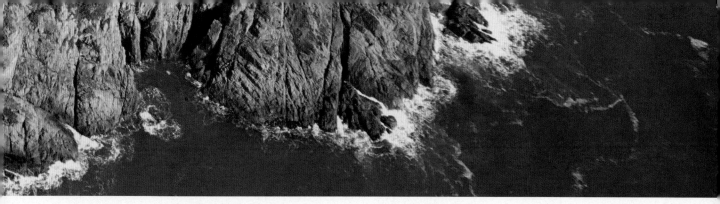

Welcome to Hong Kong, the city of sights and sounds. While you enjoy the bustling urban charm and dynamic economy of the territory, don't forget to visit our picturesque countryside. An encounter with enchanting wild Hong Kong promises to be a memorable experience.

Visitors' first impression of Hong Kong is a modern metropolis full of high-rises. This belies the fact that the largest chunk of our land is open countryside. In this city of 1,100 square kilometres, there are 23 country parks. Each with its individual appeal, these parks account for some 40% of Hong Kong's total land area. Within their boundaries you will find natural grandeur and breathtaking beauty : ocean shores, islands, verdant mountain ranges, wooded slopes and remote ancient villages. Everywhere you look, a different landscape beckons. Exploring nature's secrets brings the greatest pleasure.

Lantau, home of Chek Lap Kok Hong Kong International Airport, is the largest outlying island of Hong Kong. Here you find the territory's second and third highest mountains rising up in the virgin countryside. Sai Kung is famous for its long indented coastline. It is a region embraced by numerous islets. Some of them boast the most spectacular vistas and seascapes in Hong Kong. The New Territories are made up of wild green expanses. The region is characterized by undulating peaks and ridges, as well as bucolic rural hamlets. The urban areas of Hong Kong Island, is close to pristine hills where visitors can escape from the city humdrum.

Most country parks are accessible by public transport and the journey is seldom long. Getting around is fast and convenient. Inside these oases there are well sign-posted country trails and hiking trails, while picnic areas offer tables and benches, barbecue pits, rain shelters and campsites. Indeed, the scenic countryside is ideal for hiking, leisure walking, country barbecue and wild camping, or simply taking it slow to luxuriate in the captivating natural vistas.

You will be pleased to discover that Hong Kong has a lot more to offer than her famous city skyline. Take some time to discover our many countryside destinations, for they will show you a different facet of Hong Kong. Be invigorated by their pureness and stunning natural beauty. Be ready to connect with nature and relish her pleasant surprises. You will leave Hong Kong inspired.

張少卿女士 *JP*
Miss CHEUNG Siu Hing *JP*
漁農自然護理署署長 *Director of Agriculture, Fisheries and Conservation*

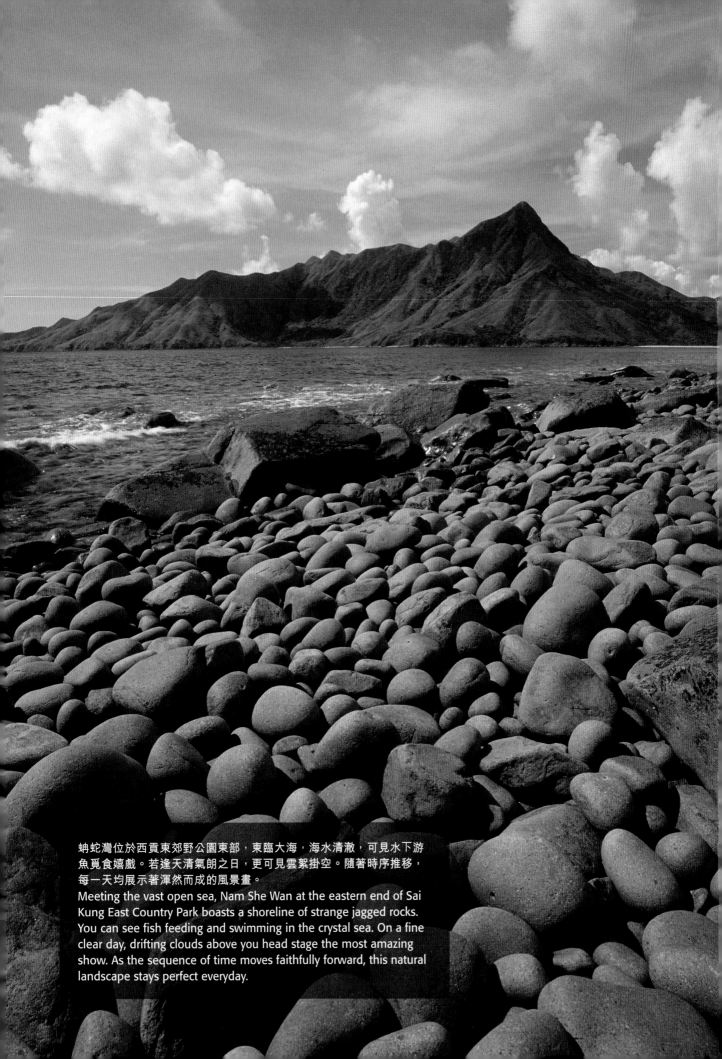

蚺蛇灣位於西貢東郊野公園東部，東臨大海，海水清澈，可見水下游魚覓食嬉戲。若逢天清氣朗之日，更可見雲絮掛空。隨著時序推移，每一天均展示著渾然而成的風景畫。

Meeting the vast open sea, Nam She Wan at the eastern end of Sai Kung East Country Park boasts a shoreline of strange jagged rocks. You can see fish feeding and swimming in the crystal sea. On a fine clear day, drifting clouds above you head stage the most amazing show. As the sequence of time moves faithfully forward, this natural landscape stays perfect everyday.

西貢東郊野公園及橋咀郊野公園

西貢（サイクン）東部 &
橋咀（シャープ島）
Sai Kung East and
Kiu Tsui Country Parks

地圖
MAP —— *p.7*

西貢東郊野公園由西貢半島東部與糧船灣組成，範圍包括萬宜水庫、糧船灣洲、大浪灣、北潭凹、上窰及黃石碼頭一帶。公園面積達4,477公頃。

西貢東部カントリーパークは西貢半島東部の相当部分を占めています。そこには萬宜水庫（ハイアイランド貯水池 High Island Reservoir）、大浪湾（タイロン湾 Tai Long Wan）、北潭凹（パクタムアウ Pak Tam Au）、黃石（ウォンシエック、Wong Shek）埠頭等々が含まれます。4,477ヘクタールの山々と海岸地帯をカバーし名勝地は数知れません。

Sai Kung East Country Park occupies a vast area of east Sai Kung Peninsula. Within its borders are High Island Reservoir, High Island, Tai Long Wan, Pak Tam Au, Sheung Yiu, Wong Shek Pier and the surrounding countryside. The park covers 4,477 hectares of uplands and coasts, with numerous scenic spots.

郊野景點

萬宜水庫是本港最大的水塘，為公園內最具規模的人工建築。東壩別具特色的巨大錨形石防波堤，配合毗鄰的破邊洲和附近一帶呈六角柱狀節理的火山凝灰岩地貌，構成一幅幅獨特的風景畫，別具吸引力。這是擁有最多海灣的郊野公園，其中西灣最負盛名，與緊接的鹹田灣、大灣、東灣，合稱「大浪四灣」，不少人都慕名而至。高468米的蚺蛇尖雖然只位列全港主要高峰第16名，卻因山形尖峭突出，成為西貢東郊野公園最顯而易見的地標。若想向蚺蛇尖進發，須具備豐富的遠足經驗，且有較佳的體能和耐力，但經歷必定難忘。橋咀郊野公園位於西貢牛尾海，佔地100公頃，是本港面積最小的離島郊野公園。公園由鄰近八個海島組成，最大的為橋咀洲，其他七個小島為橋頭、白沙洲、大鏟洲、小鏟洲、枕頭洲、游龍角及斷頭洲。遊人可在西貢墟碼頭乘坐街渡前往各島遊覽。

郊遊路綫

著名的麥理浩徑以北潭涌為起點，繞過萬宜水庫南面，橫跨八個郊野公園，西至屯門為終點。麥理浩徑第一及第二段均位於西貢東郊野公園，首段大致平緩，沿岸的奇岩怪石和浪茄沙灘的優美風光俱引人入勝。第二段由浪茄開始，跨越西灣山後，便可以欣賞到雄奇壯闊的「大浪四灣」景致，尖峭挺拔的蚺蛇尖則聳立於海灣之後。

公園內另設四條郊遊徑，鹿湖郊遊徑可遠眺清水灣半島、萬宜水庫及馬鞍山；北潭郊遊徑原為一條鄉村古道，可欣賞美麗的滘西洲、鹽田仔、橋咀及釣魚翁的景色；上窰郊遊徑全段為平緩小徑，沿途可眺望斬竹灣、鹽田仔、滘西洲等西貢內海的風光。

此外，由北潭涌至上窰民俗文物館的北潭涌自然教育徑可作為優秀的戶外教育場所。上窰家樂徑及黃石家樂徑設有休憩地點，一般只需1至2小時便可走畢；分別位於大灘及黃石的樹木研習徑則設有解說牌，為遊人介紹有趣的樹木。

見所

ハイアイランド貯水池はこの一帯で最大の貯水池であり、人工物です。貯水池の東側の堰堤の下には巨大なテト

ラポッドが並んでいて、破邊洲(Po Pin Chau)の流紋凝灰岩の六角柱状節理と好対照をなしています。貯水池は美しく観光客と地質学者を共に魅了しています。

西貢カントリーパークには多くの湾や入江があります。西湾は香港で最も有名な浜で、鹹田(ハムティン湾 Ham Tin)、大湾(Tai Wan)、東湾(Tung Wan)と共に西貢の珠玉のような海岸線、大浪湾(タイロン湾 Tai Long Wan)を形作っています。

468メートルの高さにwそそり立つ虫再蛇尖(シャープ・ピーク Sharp Peak)は西貢東部カントリーパークで最も目立つ存在です。香港の山の中では高さは16位ですがその急峻なピラミッドの山容で有名です。健康な経験者しか登頂を試みてはなりません。登りは大変に厳しいのですが登頂の達成感と素晴らしい眺めで苦労は充分報われます。

広さは約100ヘクタールで香港で最も小さなカントリーパークです。最大の島が橋咀。そのほかに北から枕頭洲(Cham Tau Chau)、小鏟洲(Siu Tsan Chau)、大鏟洲(Tai Tsan Chau)、白沙洲(Pak Sha Chau)、游龍角(Yau Lung Kok)、断頭洲(Tuen Tau Chau)と並んでいます。この島々を見るには西貢の埠頭で街渡(kaido)と呼ばれるボートを雇ってゆく必要があります。

主要ルート
マクリホーストレイルの出発点は北澤涌(パクタムチュン Pak Tam Chung)です。そこからハイアイランド貯水池の南側を通り、8個のカントリーパークをぬけて西方の屯門(チュンムン Tuen Mun)まで100キロにわたって続いています。このマクリホーストレイルのステイジ1と2が西貢東部カントリーパークの中を通ります。

第1ステイジはほとんど平坦な道で、海岸沿いでは不思議な岩の造形が見られます。美しいロンケー湾の景色はいつも魅惑的です。

第2ステイジはロンケー湾から始まります。西湾山を越えると背後に印象的なシャープピークが聳えるタイロン湾の広大な眺めが飛び込んできます。

カントリーパークにはあと4つのトレイルがあります。鹿湖カントリートレイルでは清水湾(クリアウォーター半島Clear Water)、ハイアイランド貯水池、そして馬鞍山(Ma On Shan)の眺めが楽しめます。

かつては古い村の道だったパクタムカントリートレイルからはカウ西洲(カウサイチャウKau Sai Chau)、塩田仔

(Yim Tin Tsai)、橋咀洲(Sharp)島そして釣魚翁(Hi Junk Peak)の海岸綫が眺められます。

上窰(Sheung Yiu)カントリートレイルは斬竹湾(Tsam Chuk Wan)、塩田仔(Yim Tin Tsai)、カウ西洲などの内海の島や湾を見はるかす平坦で容易な道です。

パクタムチュン自然径は野外学習に最適なトレイルです。パクタムチュンから出発して西貢カントリーパークの中の上窰(Sheung Yiu)民族文物館にいたります。家族連れの訪問者のためには上窰家族径と黄石家族径があります。どちらも途中に休憩所がありたいていの人が1〜2時間で歩けます。またカントリーパーク内には2つの樹木径があ

ります。大灘湾(Long Harbour)樹木径と黄石樹木径です。興味深い植物が生え、解説板があります。

Attractions
High Island Reservoir is the largest reservoir in the territory, and the grandest man-made construction within the park. The east embankment of the reservoir is lined with a spectacular cofferdam with giant dolosse units, offset by striking volcanic tuff in hexagonal stacks. The lake commands a brand of beauty of its own, enchanting both leisure travelers and geologists. Sai Kung East Country Park has the largest number of bays and coves. Sai Wan is one

前往方法 • 行き方 • HOW TO GET THERE

西貢東郊野公園 Sai Kung East Country Park

A 北潭涌 Pak Tam Chung

在鑽石山港鐵站乘搭92號巴士或於彩虹港鐵站C出口乘坐1A小巴往西貢總站，轉乘開往黃石碼頭的94號巴士，在北潭涌巴士站下車。每逢星期日及公眾假期，亦可在鑽石山乘搭96R巴士直抵北潭涌。

MTRの彩虹(Choi Hung)のC出口からミニバス1A、あるいはMTR鑽石山(Diamond Hill)C2出口からバス92で西貢(Sai Kung)バスターミナルへ。バス94に乗り換え黃石碼頭(Wong Shek Pier)方面へ。途中北潭涌(Pak Tam Chung)のゲイト前で下車日祝日にはMTR鑽石山(Diamond Hill)C2出口からバス96Rで直接北潭涌(Pak Tam Chung)まで行ける

From the bus station beside Diamond Hill MTR (鑽石山港鐵站), take bus 92 or take the minibus 1A from Exit C of Choi Hung (彩虹) MTR station to get off at the Sai Kung (西貢) Town terminus, then taking bus 94 for Wong Shek Pier (黃石碼頭). Alight right before the Pak Tam Chung bus stop (北潭涌巴士站). On Sundays and public holidays, you can reach Pak Tam Chung directly from Diamond Hill (鑽石山) by catching the 96R bus.

B 西灣路尾 End of Sai Wan Road

在鑽石山港鐵站乘搭92號巴士到西貢總站，轉乘開往黃石碼頭的94號巴士，於北潭涌下車，乘坐的士直達西灣路尾。或於彩虹港鐵站C出口乘坐1A小巴往西貢總站，在西貢墟親民街乘坐29R村巴直達西灣路尾。

MTRの彩虹(Choi Hung)のExit C出口からミニバス1A、あるいはMTR鑽石山(Diamond Hill)からバス92で西貢(Sai Kung)方面へ。西貢墟親民街(Chan Man Street)(ウェルカム+マックの前)でミニバス29Rあるいは緑色のタクシーに乗り換え西貢西貢道路の終点まで

From the bus station beside Diamond Hill MTR (鑽石山港鐵站), take bus 92 to get off at the Sai Kung (西貢) Town terminus, then taking bus 94 for Wong Shek Pier (黃石碼頭). Alight at the Pak Tam Chung bus stop (北潭涌巴士站) and change to taxi to Sai Wan Road. Or, take the minibus 1A from Exit C of Choi Hung (彩虹) MTR station to the Sai Kung (西貢) Town terminus, and change to minibus 29R at Chan Man Street from Sai Kung Town to the end of Sai Wan Road.

C 北潭凹 Pak Tam Au

在鑽石山港鐵站乘搭92號巴士，或於彩虹港鐵站C出口乘坐1A小巴前往西貢總站，轉乘開往黃石碼頭的94號，或乘假日行駛的96R巴士，在北潭路最高點的北潭凹巴士站下車。該巴士站對面設有一座公廁，亦是經赤徑前往大浪西灣的路徑入口。

MTRの彩虹(Choi Hung)のExit C出口からミニバス1A、あるいはMTR鑽石山(Diamond Hill)からバス92で西貢(Sai Kung)バスターミナルへバス94あるいは96Rに乗り換え黃石碼頭(Wong Shek Pier)方面へ北潭涌(Pak Tam Chung)のゲイトを越え、2〜3の停留所を過ぎ、北潭路(Pak Tam Road)を登りきった最高点の北潭凹(Pak Tam Au)下車道を挟んで反対側にトイレ、赤徑(Chek Keng)経由の大浪西灣(Tai Long Sai Wan)への入り口あり

Take bus 92 from Diamond Hill (鑽石山) MTR station or minibus 1A from Choi Hung (彩虹) to Sai Kung (西貢) Town terminus, then taking the 94 or 96R (only holidays) in the direction of Wong Shek Pier (黃石碼頭). Alight at Pak Tam Au bus stop (北潭凹巴士站), the highest point on the Pak Tam Road (北潭路). This bus stop is opposite to a public toilet and is the entrance to Tai Long Sai Wan (大浪西灣) via Chek Keng (赤徑).

橋咀郊野公園 Kiu Tsui Country Park

於西貢巴士總站旁，可乘搭街渡前往橋咀或廈門灣。

西貢バス停留所のそばの埠頭から水上タクシー（街渡 kaido)で橋咀(Kiu Tsui)あるいは廈門灣(Hap Mun Bay)へ。

Take boat (kaido) to Kiu Tsui or Hap Mun Bay by the Sai Kung bus terminus.

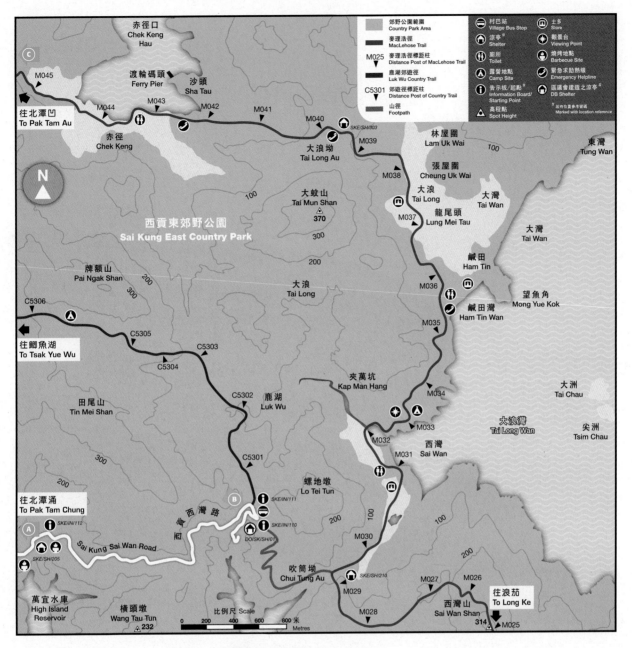

Major Routes map — Sai Kung East Country Park (西貢東郊野公園)

Legend:
- 郊野公園範圍 Country Park Area
- 麥理浩徑 MacLehose Trail
- M025 麥理浩徑標距柱 Distance Post of MacLehose Trail
- 鹿湖郊遊徑 Luk Wu Country Trail
- C5301 郊遊徑標距柱 Distance Post of Country Trail
- 山徑 Footpath
- 村巴站 Village Bus Stop
- 涼亭 Shelter
- 廁所 Toilet
- 露營地點 Camp Site
- 告示板/起點 Information Board/Starting Point
- 高程點 Spot Height
- 士多 Store
- 觀景台 Viewing Point
- 燒烤地點 Barbecue Site
- 緊急求助熱線 Emergency Helpline
- 區議會建造之涼亭 DB Shelter
- 城市位置參考號碼 Marked with location reference

of the most famous beaches in Hong Kong. Together with Ham Tin Wan, Tai Wan and Tung Wan, it makes up Tai Long Wan, the jewel of Sai Kung's idyllic coastline.Towering 468m above the lowlands, Sharp Peak is the most prominent landmark of Sai Kung East Country Park. Although ranking only 16th in height among Hong Kong's peaks, it is famous by its sheer conical profile. Only experienced hikers in good physical shape should attempt to scale its heights. The climb is undoubtedly strenuous, but the great sense of achievement and spectacular vistas make it all worthwhile. Kiu Tsui Country Park in Port Shelter of Sai Kung occupies an area of 100 hectares. It is the smallest island country park in Hong Kong. To see these islands, take boat (kaido) at the Sai Kung Town ferry pier.

Major Routes

Pak Tam Chung is the starting point of the famous MacLehose Trail. The first stage is mostly level walk. Along the shores, you will find unusual rock formations, and the picturesque Long Ke beach never fails to charm. Stage 2 starts at Long Ke. Beyond Sai Wan Shan, the great sweep of Tai Long Wan comes into view, accentuated by the ever striking presence of Sharp Peak in the background.

The country park has four other country trails. Luk Wu Country Trail offers lovely scenery of the Clear Water Bay Peninsula, High Island Reservoir and Ma On Shan. Pak Tam Country Trail, formerly an ancient village path, gives coastal views of Kau Sai Chau, Yim Tin Tsai, Sharp Island (Kiu Tsui) and High Junk Peak

(Tiu Yue Yung). Sheung Yiu Country Trail is an easy level walk that overlooks inshore islands and bays like Tsam Chuk Wan, Yim Tin Tsai and Kau Sai Chau.

Pak Tam Chung Nature Trail is an ideal destination for field study and nature education. To cater to family visitors, Sai Kung East Country Park offers Sheung Yiu Family Walk and Wong Shek Family Walk. Both walks have midway stops where you can take a rest, and most people can complete these courses in one or two hours. Also in the country park are two tree walks: Tai Tan Tree Walk and Wong Shek Tree Walk lined by interesting flora species with information plates.

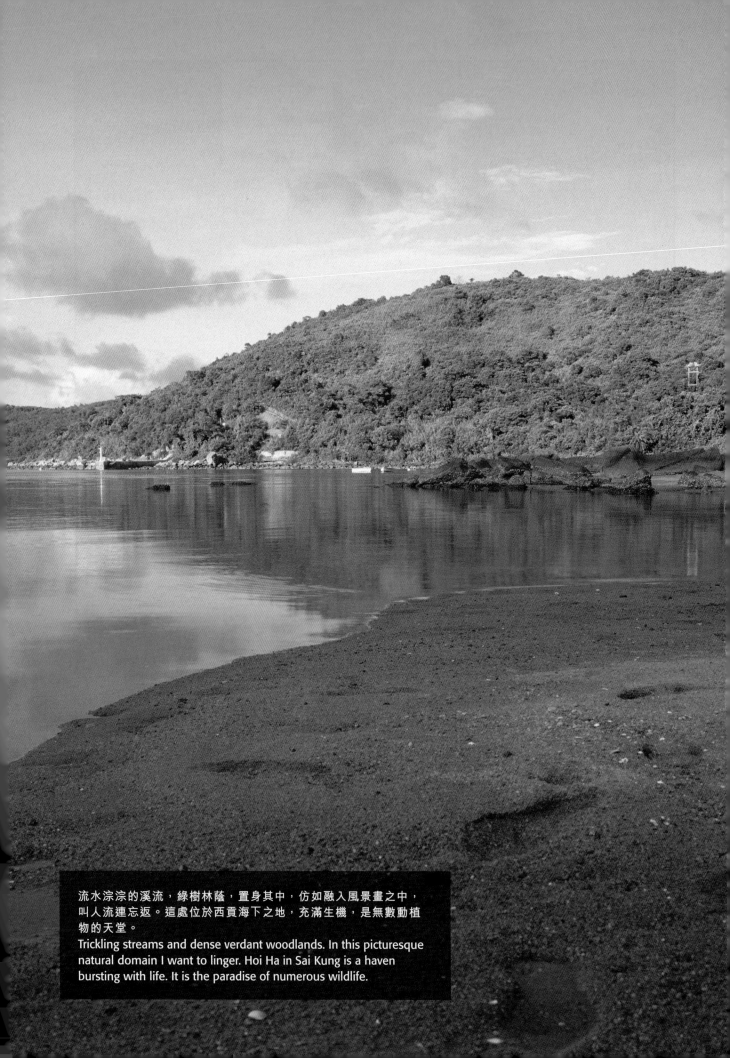

流水淙淙的溪流，綠樹林蔭，置身其中，仿如融入風景畫之中，叫人流連忘返。這處位於西貢海下之地，充滿生機，是無數動植物的天堂。

Trickling streams and dense verdant woodlands. In this picturesque natural domain I want to linger. Hoi Ha in Sai Kung is a haven bursting with life. It is the paradise of numerous wildlife.

西貢西郊野公園及灣仔擴建部分

西貢（サイクン）西部＆
灣仔擴建部分
Sai Kung West Country Park
and Wan Tsai Extension

地圖 —— p.11
MAP

西貢西郊野公園位於西貢半島西部，面積達3,000公頃，除了數條偏僻小村外，北潭凹至榕樹澳一帶都在其範圍之內。灣仔擴建部分於1996年劃定，佔地123公頃，位於西貢西郊野公園的東北部。灣仔半島原為採泥區，工程完成後，當局便把它闢為郊野公園；這裏的露營設施極受市民歡迎，為舉辦大型露營活動的理想場地。

西貢西部カントリーパークは西貢半島の西部にある野生的な一帯3,000ヘクタールを占めています。遠隔の地にある村を除いてパクタムアウから榕樹澳（Yung Shue O）にいたるほとんどの地域がカントリーパークの中にあります。北東端の123ヘクタールの灣仔半島ではかつて泥を掘削していましたがそれが終わったあと1996年にカントリーパークに追加編入されました。巨大なキャンプ場がありキャンパーに評判です。

Sai Kung West Country Park occupies 3 000 hectares of wild country in the western part of Sai Kung Peninsula. Except for a few remote villages, the entire region that extends from Pak Tam Au to Yung Shue O is encompassed within the country park. Sai Kung West Country Park (Wan Tsai Extension) was designated in 1996. This additional section is a 123-hectare peninsula at the northern tip of the park. Originally a burrow area, it was incorporated into the country park after burrowing ceased. The large camping facilities are very popular with outdoor enthusiasts.

 ### 郊野景點

西貢西郊野公園最受歡迎的郊遊勝地包括黃竹灣、大網仔、北潭涌、榕樹澳及荔枝莊等；海岸公園的所在地海下，每逢假日都吸引很多遊人到訪。公園內有多座山峰，嶂上高原即坐落其中，山腳下是企嶺下海，遊走於山徑上，群山與海灣的優美風光一覽無遺。位於北潭涌的西貢郊野公園遊客中心設有圖片展覽，介紹西貢的自然環境、鄉村發展、萬宜水庫和郊野公園的特色，並提供該郊野公園的設施及活動等資料。

灣仔擴建部分自成一角，漫遊其中，可飽覽優美的海灣風光及形態獨特的岩石。由陸路前往，先途經海下村，其間可參觀灰窰遺址及海下灣海洋生物中心。劃定為海岸公園的海下灣，石珊瑚多達60種，佔全港石珊瑚物種近七成，更有約120種珊瑚魚，吸引不少遊人以浮潛等方式觀賞。

郊遊路綫

公園內設有多條難度不一的徑道，供遠足人士享受郊遊樂趣。其中麥理浩徑第三段由北潭凹至水浪窩，風景優美，但難度較高；大灘郊遊徑亦同樣只適宜有遠足經驗者使用，由這裏可遠眺塔門、高流灣、東心淇及土瓜坪等內海山光水色，以及蚺蛇尖的雄偉山景。

連接嶂上和榕樹澳的一段石級路漫長且陡斜，稱為「天梯」，極具挑戰性。在海下路近猴塘溪入口，沿嶂上郊遊徑的石階緩緩上山，途經廢棄的黃竹塱村，四周環山疊翠，右方的石屋山高481米，為西貢最高峰；左方則有岩頭山、牛耳石山和東南方較矮的畫眉山；畫眉山的南面及西南面有雷打石山及雞公

山，一山接一山，可謂山巒起伏。由坳門展望，榕樹澳及企嶺下海的海灣景致盡入眼簾，對岸的馬鞍山及八仙嶺則各具氣勢，並可見吐露港和赤門海峽的壯麗風光。

若是一家大小同遊，則可選擇北潭涌家樂徑、北潭涌樹木研習徑、北潭涌遠足研習徑或灣仔自然教育徑等平緩易走的短程路綫。

見所

この公園内の有名な目的地としては黄竹湾（Wong Chuk Wan）、大網仔（Tai Mong Tsai）、パクタムチュン、榕樹澳（Yung She O）、荔枝荘（Lai Chi Chong）等があります。

海下（Hoi Ha）には起伏に富んだ山々に囲まれた海下マリーンパークがあります。険しい山稜の間から美しい嶂上（Cheung Sheung）高原が見えます。

企嶺下海（Three Fathoms Cove）のはるか上からは何さえぎるものも無い西貢の山々と海岸の眺めが見られ印象的です。

パクタムチュンのビジターセンターには西貢の自然環境、田園地帯の開発、ハイアイランド貯水池、カントリーパークそしてパーク内の施設や活動情報についての写真が展示されています。

香港の辺境にある西貢西部カントリーパークにはるばると出かければ郊野探索の楽しみを味わえます。息を呑むような沿岸の景色と奇妙な岩の造形が楽しめます。

湾仔（Wan Tsai）にゆくには海下村までバスに乗り、そこから歩きます。昔の石灰窯があり、途中には海洋生物センターがあります。海下湾マリーンパークは周りを岬で囲まれた湾で、香港の全珊瑚のほぼ70％にあたる60種類以上の珊瑚と約120種類の珊瑚海の魚が

います。この色彩豊かな海中庭園には多くのスキューバダイバーやシュノーケラーが訪れます。

主要ルート

公園内には様々な難易度のハイキングルートがあります。その一つがマクリホーストレイルの第3ステイジでパクタムアウと水浪窩（Shui Long Wo）を結んでいます。このルートは景色は良いのですが肉体的には大変厳しいものです。

大灘（Tai Tan）カントリートレイルも経験者用のルートです。そこからは内海の景色と塔門（Tap Mun）、高流湾（Ko Lau Wan）、東心淇（Long Hill）、土瓜坪（To Kwan Peng）等が眺められます。わたしたちを虜にしてしまいそうなシャープピークがやや遠くに見えます。

嶂上（Cheung Sheung）から榕樹澳（Yung She O）へと向かう部分は目まいがするほど長い階段で始まります。ヤコブの梯子として知られたこの部分は香港の最も厳しいハイキングルートの一つでしょう。この難路に立ち向かうにはバスで海下道路を行き、猴塘渓（Hau Tong Kai）のそばで降ります。道は山の斜面沿いに何段にも続く石の階段で始まりま

す。廃村の黄竹塑村（Wong Cuk Long）そして山あいの草原を通ってゆきます。右手には高度481メートルの西貢最高峰石屋山（Shek Uk Shan）、左手には岩頭山（Ngam Tau Shan）、牛耳石山（Ngau Yee Shek Shan）そして南方から南西にかけては畫眉山（Wa Mei Shan）、雷打石山（Lui Ta Shek Shan）、そして鶏公山（Kai Kung Shan）が聳えています。見渡す限り山々が連なり息を呑むほどの素晴らしい眺めです。村を過ぎると g 坳門（Au Mun）です。すぐ下にユンシューオーと企嶺下海が見渡せます。吐露港（トロハーバー Tolo Harbour）と海峡の向こうには巨大な馬鞍山（Ma On Shan）と八仙嶺がたちはだかっています。

一帯には家族向けの簡単な散歩道が沢山あります。パクタムチュン家族径、パクタムチュン樹木径、パクタムチュンハイキング練習トレイル、湾仔自然径などです。

Attractions

Popular leisure destinations of Sai Kung West Country Park include Wong Chuk Wan, Tai Mong Tsai, Pak Tam Chung, Yung Shue O and Lai Chi Chong. Hoi Ha Wan by the coast is where you find Hoi Ha Wan Marine Park. The Park is a mountainous terrain with a series of undulating hills. In between arduous spurs you find the scenic Cheung Sheung Plateau. Sitting high above Three Fathoms Cove (Kei Ling Ha Hoi), it gives unobstructed views of the Sai Kung peaks and coasts. Indeed, the Cheung Sheung hill trail offers a most memorable hiking experience. The Sai Kung Country Park Visitor Centre in Pak Tam Chung has a photo gallery featuring Sai Kung's natural environment, rural development, High Island Reservoir and country parks, as well as facilities and activities information.

前往方法・行き方・HOW TO GET THERE

A 西貢西郊野公園灣仔擴建部分 Sai Kung West Country Park— Wan Tsai Extension

在鑽石山港鐵站乘搭92號巴士，或於彩虹港鐵站C出口乘坐1A小巴往西貢總站，轉乘7號專線小巴至海下。在總站下車後靠右走，穿過海下村，沿小徑步行約半小時即達灣仔半島。

MTRの彩虹（Choi Hung）のC出口からミニバス1A、あるいはMTR鑽石山（Diamond Hill）C2出口からバス92で西貢（Sai Kung）方面へ。西貢墟（ウェルカム＋マックの前 Sai Kung Town）でミニバス7に乗り換えて海下村（Hoi Ha Village）で下車。右手に向かい、海下村を抜け、踏み跡を30分ほど行くと灣仔（Wan Tsai）半島に着く。

Take bus 92 from Diamond Hill（鑽石山）MTR station or minibus 1A from Choi Hung（彩虹）to Sai Kung（西貢）. Take minibus 7 from Sai Kung Town（西貢墟）and alight at Hoi Ha Village（海下村）terminus. Keep to the right and pass through the Hoi Ha Village. Follow the footpath and the Wan Tsai（灣仔）Peninsula is about half an hour ahead.

有關前往西貢其他郊野公園的交通資料，請參考第6頁。Please see P.6 for access information to Sai Kung Country Parks.

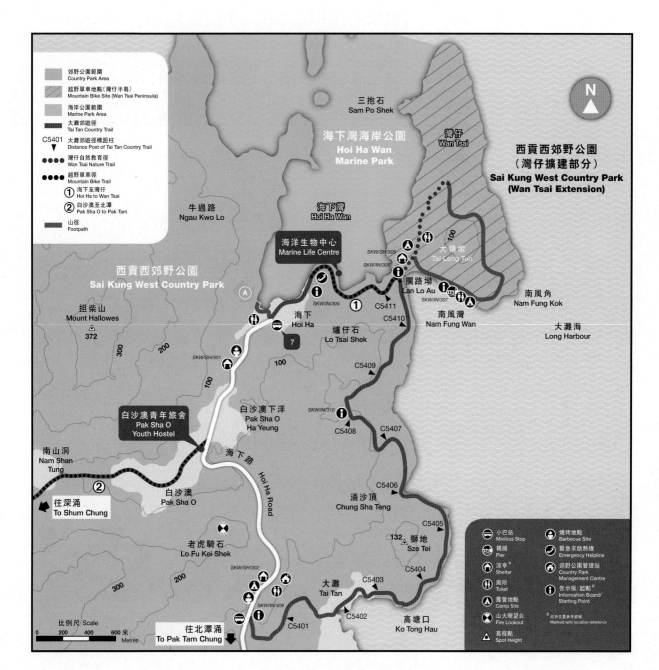

Map Legend

- 郊野公園範圍 Country Park Area
- 越野單車地點（灣仔半島）Mountain Bike Site (Wan Tsai Peninsula)
- 海岸公園範圍 Marine Park Area
- 大灘郊遊徑 Tai Tan Country Trail
- C5401 大灘郊遊徑標距柱 Distance Post of Tai Tan Country Trail
- ●●●● 灣仔自然教育徑 Wan Tsai Nature Trail
- ●●●● 越野單車徑 Mountain Bike Trail
- ① 海下至灣仔 Hoi Ha to Wan Tsai
- ② 白沙澳至北潭 Pak Sha O to Pak Tam
- 山徑 Footpath

Map place names:

三抱石 Sam Po Shek
海下灣海岸公園 Hoi Ha Wan Marine Park
灣仔 Wan Tsai
西貢西郊野公園（灣仔擴建部分）Sai Kung West Country Park (Wan Tsai Extension)
牛過路 Ngau Kwo Lo
海下灣 Hoi Ha Wan
海洋生物中心 Marine Life Centre
大嶺墩 Tai Leng Tun
南風角 Nam Fung Kok
西貢西郊野公園 Sai Kung West Country Park
擔柴山 Mount Hallowes 372
海下 Hoi Ha
爐仔石 Lo Tsai Shek
攔路坳 Lan Lo Au
南風灣 Nam Fung Wan
大灘海 Long Harbour
白沙澳青年旅舍 Pak Sha O Youth Hostel
白沙澳下洋 Pak Sha O Ha Yeung
南山洞 Nam Shan Tung
海下路 Hoi Ha Road
往深涌 To Shum Chung
白沙澳 Pak Sha O
涌沙頂 Chung Sha Teng
老虎騎石 Lo Fu Kei Shek
132 獅地 Sze Tei
大灘 Tai Tan
高塘口 Ko Tong Hau
往北潭涌 To Pak Tam Chung

Symbols legend:

- 小巴站 Minibus Stop
- 碼頭 Pier
- 涼亭 Shelter
- 廁所 Toilet
- 露營地點 Camp Site
- 山火瞭望台 Fire Lookout
- 高程點 Spot Height
- 燒烤地點 Barbecue Site
- 緊急求助熱線 Emergency Helpline
- 郊野公園管理站 Country Park Management Centre
- 告示板/起點 Information Board/Starting Point

西貢 | Sai Kung

Tucked away in a remote corner of Hong Kong, Sai Kung West Country Park (Wan Tsai Extension) is a pleasure to explore. Here, you can enjoy breathtaking coastal scenery and see extraordinary rock formations. To get to Wan Tsai by road, take public transport to Hoi Ha Village where you can visit relics of ancient lime kilns and Hoi Ha Marine Life Centre enroute. Hoi Ha Wan Marine Park is a sheltered bay harbouring more than 60 coral species, or nearly 70% of Hong Kong's total, and about 120 coral fishes. This colourful underwater garden is visited by many scuba divers and snorkellers.

Major Routes

Inside the park, you find hiking routes of varying difficulty levels. One of them is Stage 3 of the MacLehose Trail which leads from Pak Tam Au to Shui Long Wo. This scenic route is challenging and physically demanding. The Tai Tan Country Trail is also a route for experienced hikers. It offers vistas of inshore seascape and landscape attractions.

The section extending from Cheung Sheung to Yung Shue O is a long flight of dizzying steps. Known as Jacob's Ladder, it is one of Hong Kong's most challenging hikes. Get on Cheung Sheung Country Trail which begins with a series of stone steps that wind up the slopes, and continues on to an abandoned Wong Chuk Long village and a grass flat nestled between rolling hills. On your right is the 481m Shek Uk Shan, the highest spur in Sai Kung. On your left are Ngam Tau Shan, Ngau Yee

Shek Shan and the more gentle Wa Mei Shan in the southeast. Further out, on the south and southwest sides of Wa Mei Shan, Lui Ta Shek and Kai Kung Shan rear up. This striking landscape is breathtaking. For as far as your gaze can reach, magnificent crests loom over the coastal lowlands. Beyond the old village you come to Au Mun where sweeping vistas await: immediately below lie Yung Shue O and Three Fathoms Cove; across the water majestic massifs of Ma On Shan and Pat Sin Leng tower over Tolo Harbour and Tolo Channel.

For a family day out, there are many easy hiking routes around the area: Pak Tam Chung Family Walk, Pak Tam Chung Tree Walk, Pak Tam Chung Hiking Practice Trail and Wan Tsai Nature Trail.

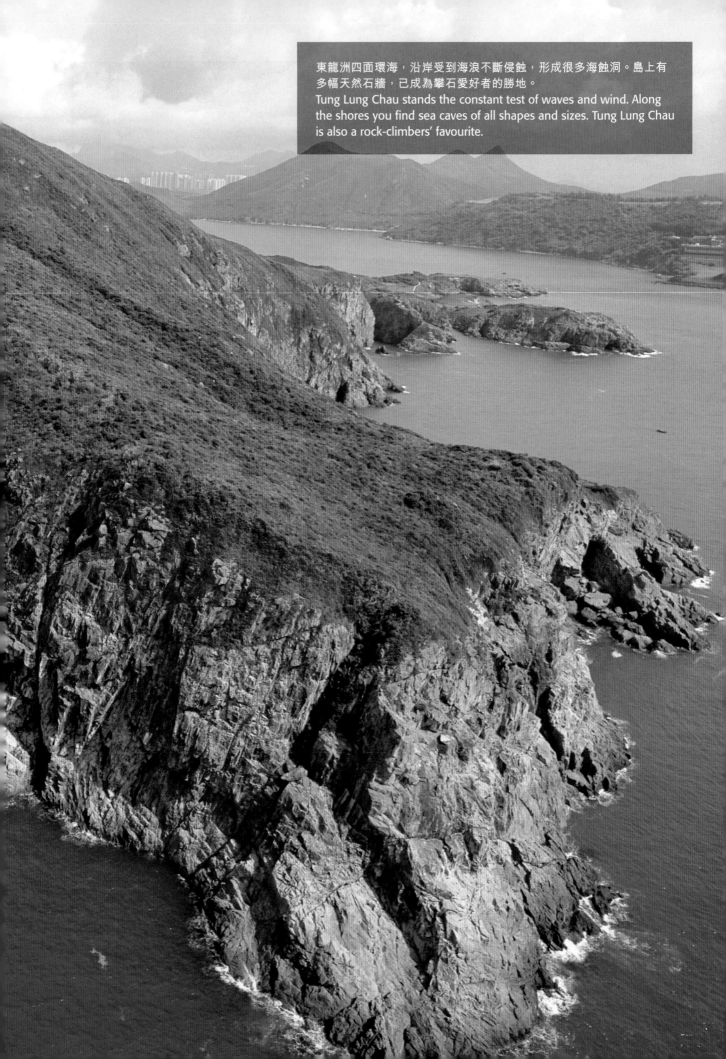

東龍洲四面環海，沿岸受到海浪不斷侵蝕，形成很多海蝕洞。島上有多幅天然石牆，已成為攀石愛好者的勝地。
Tung Lung Chau stands the constant test of waves and wind. Along the shores you find sea caves of all shapes and sizes. Tung Lung Chau is also a rock-climbers' favourite.

清水灣郊野公園及
東龍洲炮台特別地區

清水湾（クリアウォーターベイ）&
東龍洲炮台特別区
Clear Water Bay Country Park
and Tung Lung Fort Special Area

地圖
MAP *p.15*

郊野景點

遊人前往該區，可於清水灣道末端的大坑墩起步，這兒路徑平緩，且是全家郊遊燒烤野餐的理想地點。大坑墩的高處空曠臨風，是理想的放風箏地點。清水灣半島的海岸是一個沉沒海岸，因此有不少特別地質或地形供研究和欣賞。

東龍洲炮台於康熙年間（1662年至1722年）建造，現已被列為法定古跡。遺址旁更建有一所展覽館，以供遊人參觀。島上還有一個古代石刻，位於東北岸，面臨大海。此石刻高180厘米，長240厘米，是現時香港境內所知最大的石刻。

郊遊路綫

清水灣郊野公園之最，莫過於被稱為香港四大險峰之一的釣魚翁。該山高344米，山勢雄奇，以最後一段路至為險峻。頂峰的東面是懸崖，崖下山坡一直延伸至清水灣及避風塘。沿釣魚翁郊遊徑向北步行數公里，便可到達上洋山的瞭望處。郊遊徑起伏多姿，沿路兩旁盡是令人賞心悅目的景觀，其中又以釣魚翁最為壯麗。

清水灣郊野公園的主要範圍包括由坑口向南伸展至大廟灣的山脈，以及清水灣道以東延伸至龍蝦灣一帶的小山，佔地615公頃。東龍洲位於清水灣半島南端的海面，島上北岸的清代炮台遺跡及附近營地約三公頃的面積，已於1979年6月劃定為東龍洲炮台特別地區。

615ヘクタールのカントリーパークには新界南東部の山々が含まれます。坑口（Hang Hau）から起伏のある山なみを南へ向かい大廟湾（Joss House Bay）にいたります。東は龍蝦灘（Lung Ha Wan）にいたります。東龍洲はクリアウォーターベイ半島の南端の先の小島です。1979年にそこにある清代の砲台の遺跡と周辺3ヘクタールの兵営跡地が東龍洲（Tung Lung Chau）炮台特別区指定されました。

The 615-hectare Clear Water Bay Country Park takes in a wide rugged terrain in the southeastern New Territories. Its boundaries extend southwards from Hang Hau to the undulating mountain range that screens Joss House Bay, and continue eastwards to the hillocks around Lung Ha Wan. Tung Lung Chau is a small island off the southern coast of Clear Water Bay Peninsula. The Qing Dynasty fort ruins and the surrounding 3 hectares camp site were declared a special area in June 1979.

奇石嶙峋可説是清水灣郊野公園的另一特色，因此，在觀賞過釣魚翁後想一睹奇特地貌，大嶺峒便非去不可。高291米高的大嶺峒，包圍清水灣東面的海角，故此可登山俯瞰整個受海浪衝擊的海岸。若經龍蝦灣的小徑踏步而上，更可在高處的山坡看到經侵蝕後露出的岩石，在低處山丘之下則為狹長的金黃色火山岩。呈鋸齒形的果洲群島於遠方海上冒出，每個小島均有以火山岩組成的頂峰及獨特之外貌，極為有趣。

清水灣郊野公園有多條郊遊徑，供不同郊遊的愛好者選擇，像位於大坑墩的樹木研習徑，全程只有1.55公里，穿越於山腰密林之間，共設15個景點，以介紹不同植物，絕對適合一家大小同遊。

東龍洲平日是人跡罕至的孤島，但假日則成為市民的露營熱點。營地風景優美，並設有燒烤爐和涼亭等設施。東龍洲四面環海，沿岸受到海浪不斷侵蝕，形成很多海蝕洞。島上有一條環山小徑，走畢全程需2小時。島上有多幅天然石牆，已成為攀石愛好者的勝地。

見所

クリアウォーター道の終点の大坑墩(Tai Hang Tun)から歩き始めます。家族連れのハイカーにとっては大変気持ちの良いスタート地点です。ここではよちよち歩きの子供でも安全に歩けます。釣魚翁と大嶺峒(Tai Leng Tung)の間の峠にあたるこの場所はバーベキュー場としても有名でとても眺めの良いところです。

クリアウォーター半島は典型的な冠水海岸地形で、その地質史からするとユニークな地形の標本と言えます。真剣に地質調査をするにせよあるいは自然の景観を愛好するにせよクリアウォーターでは多くのものが得られます。

記録によれば東龍洲(Tung Lung Chau)砲台は康熙帝の時代(1662-1722)に建設され、その後何百年にもわたって改修、改築を繰り返し現在見られるような姿になりました。古い砲台の隣に展示室があり公開されています。

島の北東の海岸沿いには複雑な龍の模様のような古い石の彫刻があります。高さ180センチ、幅240センチで香港で発見された石の彫刻で最大のものです。

主要ルート

クリアウォーターベイカントリーパークの最大の呼び物は、香港の4大峻峰の一つの釣魚翁です。高さ344

メートル、最後の登りの厳しさは登山者を試すかのようです。急な頂上の東面では絶壁が緑深い麓に向かってなぎ落ちています。

釣魚翁カントリートレイルを登ると上洋山(Sheung Yeung Shan)の見晴台に出ます。両側に息を呑むほどの眺めが広がります。釣魚翁の崖が見える東側の眺めは圧巻です。

クリアウォーターベイカントリーパークは岩山とエメラルド色の海で有名です。釣魚翁で広大な眺めを楽しんだ後には大嶺峒(Tai Leng Tung)山で特異な地形を眺めることをお勧めします。291メートルのこの山はクリアウォーター湾の東側を包み込むようにしています。山の下には波に洗われる長い海岸綫が続いています。

北側の龍蝦湾(Lung Ha Wan)から高みに登ると海岸沿いに風波にさらされた岩が見られます。見下ろすと小山には黄金色の火山岩の帯が走っています。沖合いでは鋸歯状のナインピン群島が圧倒的な存在を誇っています。

カントリーパークの中にはいくつかのカントリートレイルがあり興味と体力に応じたルートが選べます。大坑墩(Tai Hang Tun)の1.5キロの樹木径には15種類の樹木についての解説板があります。

周囲を海に囲まれているため東龍洲は常に波と風に打たれています。海岸沿いには様々な形と大きさの海蝕洞窟があります。島の周回路からは大浪湾、石澳、鯉魚門、将軍澳等まで眺め

られます。2時間ほどの行程です。東龍洲はまたロッククライマーのメッカです。自然の岩がロッククライミングの練習にふさわしいのです。

Attractions

Begin your journey in Tai Hang Tun at the end of Clear Water Bay Road. It is a comfortable starting point for family hikers. Here, even toddlers can wobble along safely. This is a popular barbecue and picnic destination. Tai Hang Tun – the pass between High Junk Peak and Tai Leng Tung – is another sightseeing vantage point with scenery as beautiful as this, who can bear to leave? Exposed and windy, Tai Hang Tun is a good place to fly a kite. Clear Water Bay Peninsula is a typical submergent coast. Given this geological history, the country park is a showcase of unique landforms and topographic features.

Tung Lung Fort was built during the reign of Emperor Kangxi (1662-1722). Next to the old fort is an exhibition hall open to the public. On the northeastern coast, there is an ancient rock carving by the sea with intricate dragon-like art work. Measuring 180 cm tall and 240 cm long, it is the largest rock carving recorded in Hong Kong.

Major Routes

High Junk Peak – one of the four major treacherous peaks in Hong Kong – is the number 1 attraction of Clear Water Bay

前往方法・行き方・HOW TO GET THERE

Ⓐ 清水灣郊野公園 Clear Water Bay Country Park

在鑽石山港鐵站C2出口乘搭91號巴士或於將軍澳港鐵站A1出口乘坐103M專線小巴。若前往釣魚翁郊遊徑，可在清水灣道五塊田巴士站下車；到龍蝦灣郊遊徑及大坑墩的話，可在大坳門巴士站下車，再沿路標前行。

鑽石山(Diamond Hill) C2出口からバス91、あるいはMTR将軍澳(Tseng Kwan O)からミニバス103M でクリアウォーター方面へ釣魚翁(High Junk Peak)カントリートレイルへは五塊田(Ng Fai Tin)近くのクリアウォーターベイ道路の駐車場で下車龍蝦灣郊遊徑(Lung Ha Wan Country Trail)と大坑墩(Tai Hang Tun)へは清水灣道(Clear Water Bay Road)と大坳門道(Tai Au Mun Road)の交叉点で下車。

Take KMB 91 from the Diamond Hill (鑽石山) MTR station or green minibus 103M from Tseung Kwan O (將軍澳) MTR station. For High Junk Peak (釣魚翁) Country Trail, get off at Clear Water Bay Road Ng Fai Tin bus stop (五塊田巴士站). For Lung Ha Wan Country Trail (龍蝦灣郊遊徑) and Tai Hang Tun (大坑墩), alight at the Tai Au Mun bus stop (大坳門巴士站) and follow the trail-signs.

東龍洲 Tung Lung Chau

於星期六及假日在鯉魚門三家村或西灣河碼頭乘搭街渡前往，船程大約20分鐘。查詢電話：鯉魚門三家村(珊瑚海航運：2513 1103)、西灣河碼頭(林記街渡：2560 9929)。

鯉魚門(Lei Yue Mun)の三家村(Sam Ka Tsuen)あるいは西灣河埠頭からフェリー。東龍洲まで約20分。電話：三家村(珊瑚海フェリー 2513 1103).西灣河(林記フェリー 2560 9929)

Take boat (kaido) from Sam Ka Tsuen at Lei Yue Mun or Sai Wan Ho Ferry Pier. It takes about 20 minutes. Ferry services telephone enquiries: Sam Ka Tsuen (Coral Sea Ferry: 2513 1103), Sai Wan Ho (Lam Kee kaido: 2560 9929)

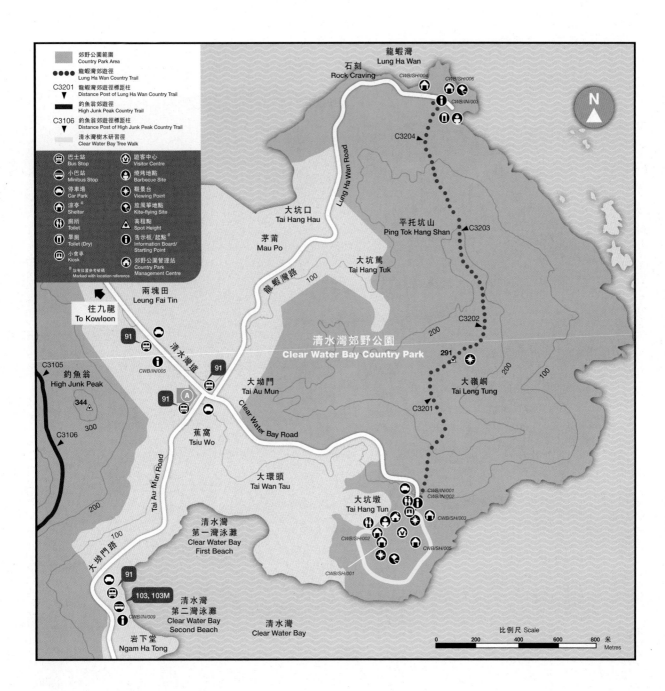

Country Park. Towering 344m above the lowlands, High Junk Peak tests hikers with a tough final ascent. On the east face of its abrupt summit, precipices plunge down to densely wooded foothills, where buttress slopes stretch all the way to Clear Water Bay and the typhoon shelter beyond. The High Junk Peak Country Trail, a hillside green walk, takes you to a lookout atop Sheung Yeung Shan. This sinuous route offers breathtaking views on both sides. The eastern view, revealing jagged cliffs of High Junk Peak, is particularly arresting.

Clear Water Bay Country Park is renowned for rocky uplands and emerald waters. After enjoying the grand vistas at High Junk Peak, why not go on to Tai Leng

Tung for a show of extraordinary landforms? Rising up 291m, the peak envelops the eastern corner of Clear Water Bay. Under this magnificent crest, the long wave swept seashore unfolds. A path leads from Lung Ha Wan to a high point, where you can see weathered rocks exposed along the coast. Down below, the foothills flaunt narrow strips of golden volcanic rock. Farther out is the serrated profile of the Ninepin Group.

There are several country trails within the borders of Clear Water Bay Country Park. Hikers can select one that suits their interest and ability, such as the 1.55km tree walk in Tai Hang Tun, which cuts across dense woodlands in the mid slope, it features 15 stops with information on different plants.

There are few visitors to the Tung Lung Chau on weekdays, but on weekends it is a popular camping destination. The camp site is set in a scenic spot and offers barbecue, pavilion and other facilities. Surrounded by sea on four sides, Tung Lung Chau stands the constant test of waves and wind. Along the shores you find sea caves of all shapes and sizes. A circular route on the island gives enchanting coastal vistas. The route takes 2 hours to complete. Tung Lung Chau is also a rock-climbers' favourite.

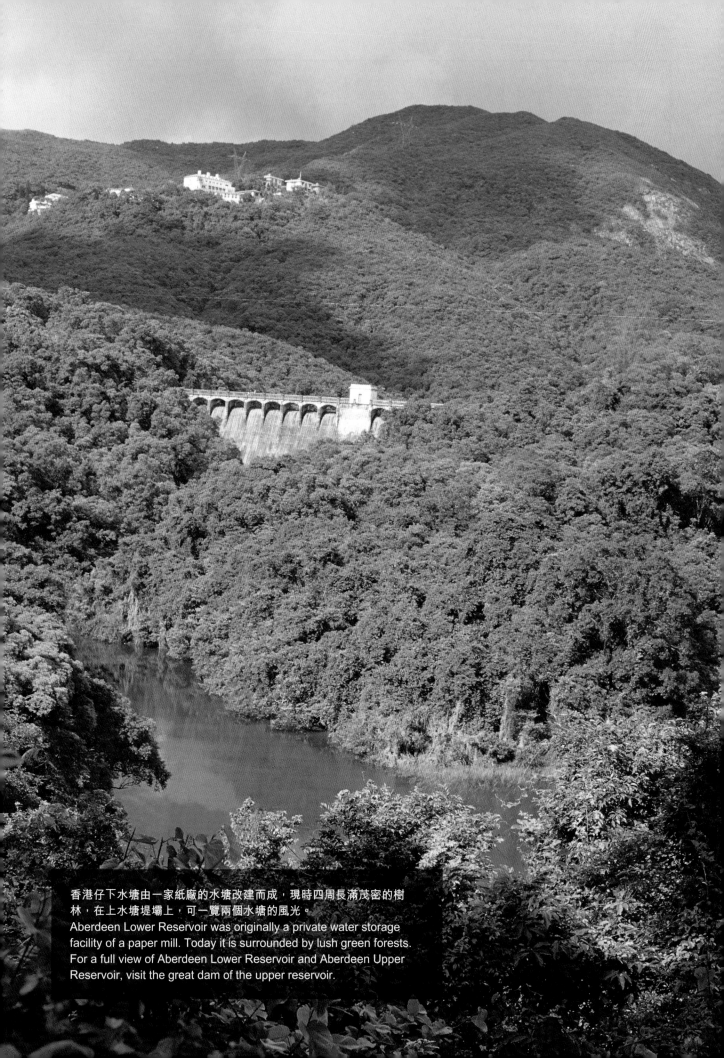

香港仔下水塘由一家紙廠的水塘改建而成，現時四周長滿茂密的樹林，在上水塘堤壩上，可一覽兩個水塘的風光。

Aberdeen Lower Reservoir was originally a private water storage facility of a paper mill. Today it is surrounded by lush green forests. For a full view of Aberdeen Lower Reservoir and Aberdeen Upper Reservoir, visit the great dam of the upper reservoir.

香港仔郊野公園、薄扶林郊野公園及龍虎山郊野公園

香港仔（アバディーン Aberdeen），薄扶林（ポクフーラム Pok Fu Lam），龍虎山（Lung Fu Shan）Aberdeen, Pok Fu Lam and Lung Fu Shan Country Parks

地圖 MAP — *p.19 & p.21*

香港仔、薄扶林及龍虎山三個郊野公園位於港島西部。香港仔郊野公園早在1977年成立，是本港最早開拓的郊野公園之一，佔地423公頃，覆蓋港島南面山坡，包括金馬倫山、田灣山、香港仔上水塘及香港仔下水塘一帶；北面則為灣仔峽，南面為香港仔及黃竹坑。

　　薄扶林郊野公園在1979年成立，面積270公頃，由環繞薄扶林水塘的土地組成。公園環抱太平山，維港景色盡收眼底。

　　龍虎山郊野公園於1998年成立，面積只有47公頃，是全港最小及最新的郊野公園。

1977年に指定されたアバディーンカントリーパークは香港島のカントリーパークで最も古いものの一つです。423ヘクタールのパークは金運倫理山（Cameron）、田湾山（Tin Wan Shan）、アバディーン上下貯水池等の南側の山や谷の広い地域をカバーしています。北端は腕仔峽（Wan Chai Gap）、南端はアバディーンと黃竹坑（Wong Chuk Hang）です。

　　ポクフーラムカントリーパークはポクフーラム貯水池を取り囲む270ヘクタールの森の殿堂です。ビクトリアピークのまわりに設置され、ビクトリアハーバーの素晴らしい景観に恵まれています。

　　わずか47ヘクタールの龍虎山（Lung Fu Shan）カントリーパークは1998年に指定されたばかりの最も小さい最新のパークです。

Aberdeen, Pok Fu Lam and Lung Fu Shan Country Parks are located at the western part of Hong Kong Island. Designated in 1977, Aberdeen Country Park is one of the oldest country parks in Hong Kong. The 423-hectare park covers a wide domain of southern uplands and valleys on Hong Kong Island: Mount Cameron, Tin Wan Shan, Aberdeen Upper Reservoir and Aberdeen Lower Reservoir. It extends to Wan Chai Gap in the north, Aberdeen and Wong Chuk Hang in the south.

　　Designated in 1979, Pok Fu Lam Country Park is a 270-hectare sylvan sanctuary encompassing the Pok Fu Lam Reservoir. This picturesque country park is set in the foothills of Victoria Peak. There is a spectacular view of Victoria Harbour.

　　Occupying a limited site of 47 hectares, the Lung Fu Shan Country Park is the smallest and newest country park in Hong Kong, designated in 1998.

郊野景點

香港仔郊野公園環繞香港仔上下水塘，這兩個水塘在1931年建成，是港島區最後建成的水塘，存水量達1,250萬立方米。遊人可在堤壩之上，觀賞青翠山谷的四季自然變化，壯麗景色一覽無遺。金夫人馳馬徑以二十世紀初香港總督金文泰的夫人命名，圍繞香港仔山谷高處，沿路有多個青翠多樹的山坡、溪澗和石橋，更可遠眺深水灣及壽臣山一帶的景色。

薄扶林水塘於1863年建成，為港島首個水塘，植物及雀鳥種類繁多，具特別科學價值。水塘西北面設有薄扶林家樂徑，最宜一家大小同遊。

龍虎山郊野公園的最大特色為松林炮台及堡壘等遺跡。松林炮台建於1903年，位處海拔307米的高地上，以地勢來說，實為全港炮台之冠。原來的炮床、指揮台及多座掩蔽體，仍保存得相當完整。

郊遊路綫

香港仔、薄扶林及龍虎山郊野公園設有多條郊遊徑，包括自然教育徑、樹木研習徑、健身徑及長途遠足徑。

香港仔自然教育徑環繞香港仔下水塘的東面，連接香港仔上下水塘的水壩，長約1.2公里，全程均十分平坦，只需約1小時便可走畢。樹木研習徑則始於香港仔水塘道的郊野公園入口，全長350米，一直延伸到香港仔上水塘，沿途共介紹23種樹木。由香港仔水塘道進入，沿引水道而上就可到達健身徑。薄扶林本地樹木研習徑全長2.2公里，行畢全程需時約45分鐘。

爐峰自然步道循研習徑延伸至夏力道，返回爐峰峽，並沿薄扶林水塘道抵達山明水秀的薄扶林水塘。路上設有

30個傳意牌，介紹「太平山」與「爐峰」之名的由來、太平山的雨和霧、植物、昆蟲、地形及地質、雀鳥、薄扶林水塘、歷史悠久的薄扶林村等。

港島徑的第一及第二段位於薄扶林郊野公園範圍內。第一段由山頂纜車總站開始，經盧吉道及夏力道至薄扶林水塘道，全長7公里，需時約2小時。在盧吉道的中段，大廈林立的港島心臟地帶就在腳下，亦可眺望維港兩岸的海港風光。夏力道末端的草坡可遠眺南丫島等港島西南部的風光，亦是觀賞夕陽西沉的好地方。

港島徑第二段由薄扶林水塘道南行至貝璐道，全長4.5公里，需時約1.5小時。此段位於薄扶林郊野公園植林區內，路上綠樹成蔭，可看見香港仔及鴨脷洲等港島南區景色。

港島徑的第三及第四段位於香港仔郊野公園，兩段共長14公里，走畢全程只需約4小時，最適合初學遠足人士或親子遠足團。

見所

アバディーン上下貯水池香港島最後の貯水池で1931年に作られました。1,250万㎡あります。今日では貯水池は深い森に囲まれ、ダムの上には香港南部の雄大な自然が広がり、季節ごとに様々に異なる眺めが楽しめます。

公園の中には気楽で愉快なレディークレメントライドと言う道があります。この道を散策したり乗馬するのが好きだった総督クレメント卿の妻の名前をとったものです。アバディーン谷の斜面をゆく道沿いには心和ませるような森の景色が続きます。小川や石の橋も

あります。深水湾（Deep Water Bay）、寿臣山（Shouson Hill）その他近くの湾や入り江そして海峡も見えます。

1863年に完成したポクフーラム貯水池は香港で最も古い貯水池です。北西部にはポクフーラム家族径があり様々な種類の植物や鳥が見られます。

龍虎山カントリーパークの小山の上にあるパインウッド砲台は1903年に建設された古い軍事施設の遺跡です。海抜307メートルの位置にあるパインウッドは最も高い位置にある防衛施設でした。

主要ルート

アバディーン下貯水池の東側を辿るアバディーン自然径は上下のダムを結んでいます。1.2キロのこの道はほぼ水平で誰でも1時間くらいで歩けます。アバディーン樹木径はカントリーパークの南側の入り口から始まり350メートルほどでアバディーン上貯水池に着きます。

2.2キロの原生樹木径沿いには香港原生の植物が植えられています。ピークギャレリアのそばから始まる周回路の盧吉道（ルガーロード Lugard Road）は45分くらいで歩けます。

爐峰自然径（ピークトレイル Peak Trail）は夏力道（ハーロックロード Harlech Road）に合流し曲がりくねってビクトリアギャップに戻ります。そこからのどかなポクフーラム貯水池への下りが始まります。

香港トレイルは全体が8ステイジに分けられた長いトレイルでその内ステイジ1と2がポクフーラムカントリーパーク内に有ります。ステイジ1はピ

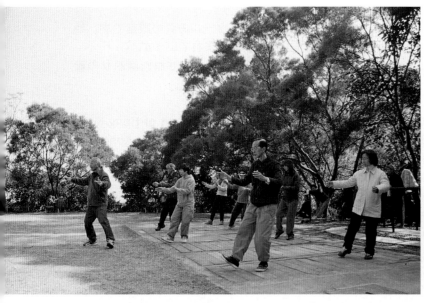

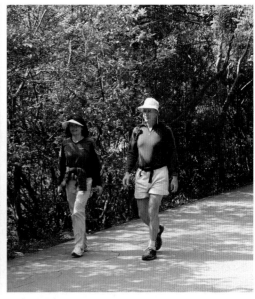

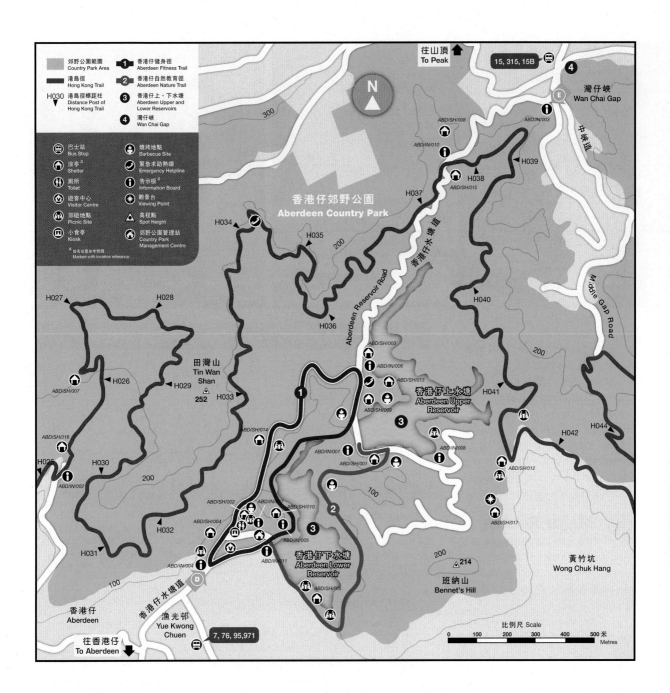

ークトラムの駅からルガーロードと重なって始まり、そのあとポクフーラム貯水池道へと下ってゆきます。前長7キロ、2時間ほどの道です。

ルガーロードは広くて平らな道なのでピークを訪れる人々に大変人気です。半分ほど行くと香港市街地が正に足元に広がります。ビクトリアハーバーと巨大都市が魔法のようなスカイラインを作っています。ハーレック道の西端の草地からはラマ島と香港島南西部分の展望が広がります。日没を眺めるにも最適の場所です。

ステイジ2はポクフーラム貯水池道から貝璐道（Peel Rise）へ向かいます。カントリーパークの境界上にあり奇力山（Mt. Kellett）下の導水路沿いの道

で、南東へ4.5キロ、1時半ほどの距離です。すぐそばに香港仔（アバディーン Aberdeen）と鴨利洲（Ap Lei Chau）が見えてきます。香港トレイル　ステイジ 3、4と様々なトレイルがあります。この2つの香港トレイルはあわせて14キロ、4時間ほどで歩けアマチュアのハイカーや子供連れに適しています。

Attractions

Aberdeen Upper Reservoir and Aberdeen Lower Reservoir, the two lakes encircled by the country park, were completed in 1931. Totaling 12.5 million m³ of water storage capacity, they were the last two reservoirs built by the Government on Hong

Kong Island. Today, the lakes are surrounded by dense forests. Atop the dam, the natural grandeur of southern Hong Kong is unveiled without reserve, and the magnificent view changes with the season.

Lady Clementi's Ride is named after the wife of Governor Sir Clementi. Skirting along the slopes above Aberdeen Valley, the ride offers soothing woodland scenery. Along the way are a series of wooded slopes, hill streams and stone bridges. You can also gaze across Deep Water Bay, Shouson Hill and nearby bays, coves and channels.

The Pok Fu Lam Reservoir, completed in 1863, is the oldest water storage facility on Hong Kong Island. To its northwest you find the Pok Fu Lam Family Walk which

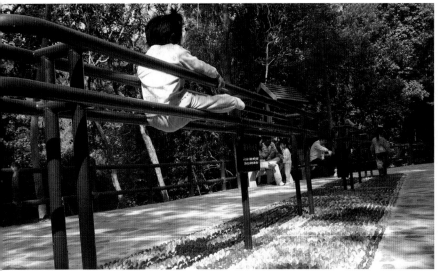

lies within the Pok Fu Lam Reservoir Site of Special Scientific Interest (SSSI), with its diverse plants and birds.

Sitting on a knoll in Lung Fu Shan Country Park, Pinewood Battery is the remains of an old military fort built in 1903. Pinewood is the highest defense facility of its kind, commanding a high vantage point 307m above sea level. The original gun emplacement, commanding platform and shelters are preserved intact.

Major Routes

There are different types of trail within Aberdeen, Pok Fu Lam and Lung Fu Shan Country Parks, including nature trail, tree walk, fitness trail and long distance hiking trail.

Orbiting around the eastern rim of the Aberdeen Lower Reservoir, the Aberdeen Nature Trail links up the upper and lower dams. This 1.2km trail is mostly level walk and most visitors can complete it in about an hour. The Aberdeen Tree Walk, another pleasant route, starts at the country park entrance on Aberdeen Reservoir Road. This 350m trail ends at the Aberdeen Upper Reservoir. Walking up Aberdeen Reservoir Road along the catchwater, you soon arrive at a fitness trail with many unusual fitness facilities. Here in the woods, there is fun for all ages.

The 2.2km Pok Fu Lam Native Tree Walk features Hong Kong's 23 native plant species. Winding along Lugard Road by the Peak Galleria, this short route takes about 45 minutes to complete.

The Peak Trail follows the whole length of the Pok Fu Lam Native Tree Walk, and continues on to Harlech Road where it winds

前往方法・行き方・HOW TO GET THERE

薄扶林郊野公園 Pok Fu Lam Country Park

A 山頂 The Peak

在花園道乘搭纜車，又或乘坐交易廣場的15號巴士或國際金融中心的1號專綫小巴，均可直達山頂。

花園道（Garden Road）からピーク・トラム、交易廣場（Exchange Square）からバス１５、あるいは國際金融中心（IFC）からミニバス１で頂上へ。

Take the Peak Tram from Garden Road（花園道）, bus 15 from Exchange Square（交易廣場）or green minibus 1 from IFC（國際金融中心）to get to the Peak.

B 薄扶林水塘 Pok Fu Lam Reservoir

在中環港外綫碼頭乘搭任何前往香港仔或華富邨的巴士，在薄扶林水塘道巴士站下車，沿水塘道上山方向步行5分鐘即到達水塘入口。

セントラルの港外綫碼頭（Central Ferry Piers）からアバディーンあるいは華富邨（Wah Fu Estate）向けのバスで、薄扶林騎術學校（Pok Fu Lam Riding School）, へ。5分登れば貯水池。

Get on any bus from the Central Ferry Piers（港外綫碼頭）headed for Aberdeen or Wah Fu Estate（華富邨）, and hop off at the Pok Fu Lam Reservoir Road bus stop（薄扶林水塘道巴士站）, walking uphill for 5 minutes to access the reservoir.

C 龍虎山郊野公園 Lung Fu Shan Country Park

在中環乘坐13號巴士，或在龍匯道乘搭3或3A小巴至旭龢道巴士總站，下車後沿克頓道步行15分鐘，再往上山方向續走至龍虎山郊野公園。

セントラルからバス13、あるいは龍匯道（Lung Wui Road）からミニバス3、3Aで旭龢道（Kotewall Road）へ。 克頓道（Hatton Road）を歩いて15分で龍虎山郊野公園（Lung Fu Shan Country Park）へ。

Take bus 13 from Central（中環）or minibus 3 or 3A from Lung Wui Road（龍匯道）to Kotewall Road（旭龢道）. Follow the Hatton Road（克頓道）for 15 minutes and walk up to Lung Fu Shan Country Park（龍虎山郊野公園）.

D 香港仔郊野公園 Aberdeen Country Park (p.19)

在中環、銅鑼灣、鴨脷洲或西鐵南昌站分別乘搭7、76、95或971號巴士，於漁光道海鷗樓巴士站下車，沿香港仔水塘道上行10分鐘即到達公園入口。

セントラル、コーズウェイベイからバス7, 76, 95あるいは971で漁光道（海鷗樓カモメのビル）（Yue Kwong Road）へ。香港仔水塘道路（Aberdeen Reservoir Road）を10分ほど歩けば公園入り口

Take buses 7, 76, 95 or 971 from Central, Causeway Bay, Ap Lei Chau or Nam Cheong MTR station respectively. Get off at Sea Gull House（海鷗樓）of Yue Kwong Road（漁光道）. Walk up along Aberdeen Reservoir Road（香港仔水塘道）for 10 minutes to the Park entrance.

E 灣仔峽 Wan Chai Gap (p.19)

在交易廣場乘坐15號巴士，於灣仔峽道巴士站下車；又或自皇后大道東的環境保護署灣仔環境資源中心起步，沿灣仔自然徑上行至灣仔峽。

交易広場（Exchange Square）からピーク行の15番バスに乗り灣仔峽道（Wan Chai Gap Road）で下車。あるいはクイーンズロード東の環境保護署灣仔環境資源中心（Environmental Centre）から灣仔自然徑（Wan Chai Green Trail）伝いに灣仔峽道（Wan Chai Gap Road）まで登る。

Take bus 15 for Peak from Exchange Square（交易廣場）. Alight at Wan Chai Gap Road（灣仔峽道）bus stop. Alternatively, start at the EPD Environmental Centre（環境保護署灣仔環境資源中心）on Queen's Road East（皇后大道東）and climb up to the gap following the Wan Chai Green Trail（灣仔自然徑）.

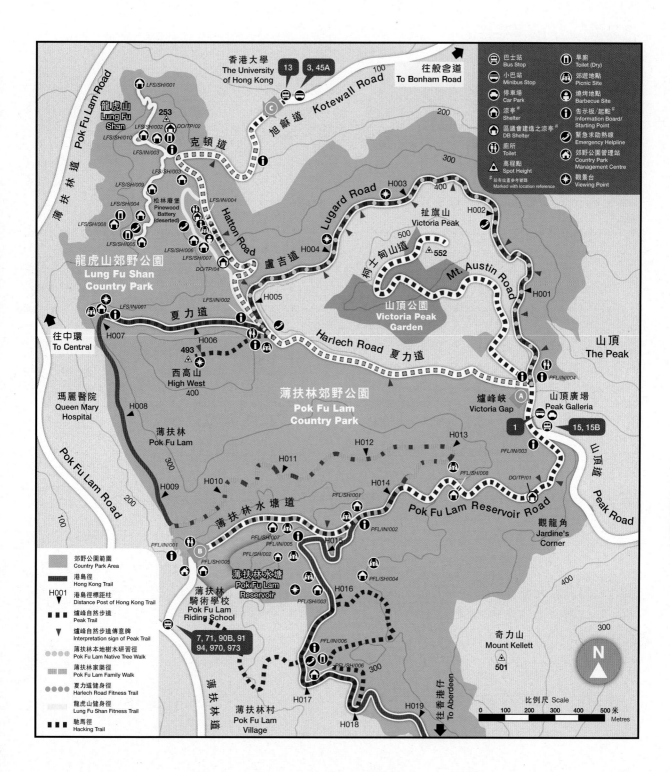

back to Victoria Gap for a descent to the idyllic Pok Fu Lam Reservoir.

Both the Hong Kong Trail Stage 1 and Stage 2 lie within the bounds of Pok Fu Lam Country Park. Starting at the Peak Tram Station, Stage 1 follows Lugard Road and the west end of Harlech Road before winding down to Pok Fu Lam Reservoir Road. 7 km in total length, it takes about 2 hours to complete. About halfway down Lugard Road, the heart of Hong Kong Island is spread right under your feet. Off the shore, Victoria Harbour and the mega towers that line the coasts make up a magical city skyline. The grass flat at the end of Harlech Road offers panoramic views of Lamma Island and the southwestern region of Hong Kong Island. It is also a choice location for watching sunset.

Stage 2 leads from Pok Fu Lam Reservoir Road to Peel Rise. Extending south for 4.5km, the trail takes about 1.5 hours to complete. This shaded tree-lined trail lies within the borders of Pok Fu Lam Country Park. You can also gaze across Aberdeen and Ap Lei Chau along the way.

Stage 3 and Stage 4 of the Hong Kong Trail lie within the Aberdeen Country Park. These two stages of the Hong Kong Trail total 14km in length. They take about 4 hours to complete. These stages are suitable for amateur hikers and parties with children.

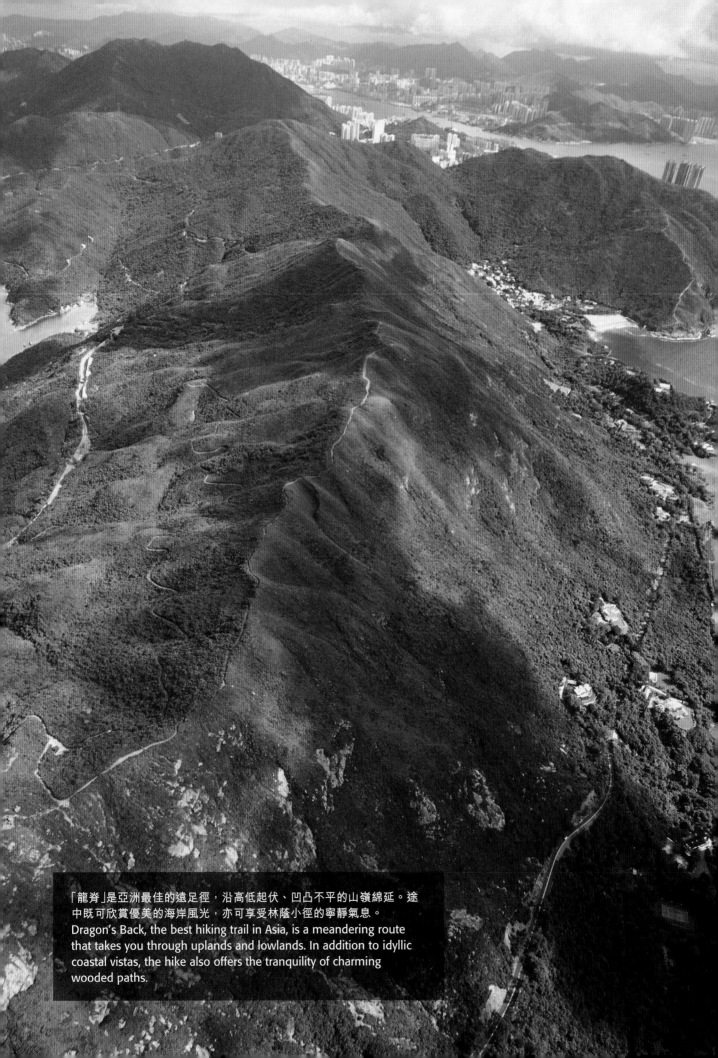

「龍脊」是亞洲最佳的遠足徑，沿高低起伏、凹凸不平的山嶺綿延。途中既可欣賞優美的海岸風光，亦可享受林蔭小徑的寧靜氣息。
Dragon's Back, the best hiking trail in Asia, is a meandering route that takes you through uplands and lowlands. In addition to idyllic coastal vistas, the hike also offers the tranquility of charming wooded paths.

大潭郊野公園、鰂魚涌擴建部分及石澳郊野公園

大潭（タイタム），鰂魚涌拡建設部分＆石澳（シェッコー）
Tai Tam Country Park, Quarry Bay Extension and Shek O Country Park

 地圖
MAP *p.25 & p.27*

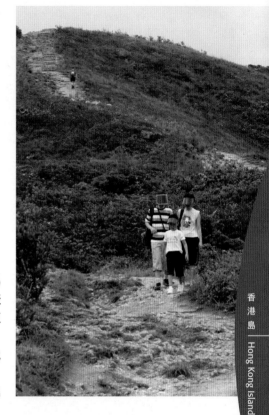

香港島｜Hong Kong Island

大潭郊野公園及其鰂魚涌擴建部分，以及石澳郊野公園均位於香港島的東部。大潭郊野公園成立於1977年，佔地1,315公頃，由北面的渣甸山延伸至南面的孖崗山一帶，以赤柱峽道為界；西達黃泥涌峽，東臨大潭道。

鰂魚涌擴建部分緊接其北面，範圍包括柏架山及畢拿山北坡，佔地270公頃，於1979年劃定。

石澳郊野公園佔地701公頃，北起砵甸乍山及歌連臣山一帶的連綿山嶺，經雲枕山及打爛埕頂山（龍脊），南至鶴咀山。

タイタムカントリーパークは香港島の東にひっそりとたたずんでいます。北の渣甸山（Jardine's Lookout）から孖崗山（The Twins）にかけて広がる波打つ山並みを越えて南の境界、赤柱道（Stanley Gap Road）まで続いています。黃泥涌峽（Wong Nai Chung Gap）が西、タイタム道が東の境界になります。1977年に指定され、1,315ヘクタール、香港島の5分の1を占めます。

北側に隣接する鰂魚涌拡建設部分（Quarry Bay Extension）は1979年に指定された小さな保護区です。

香港南東に位置する701ヘクタールのシェッコーカントリーパークは1979年に指定されました。起砵甸乍山（Pottinger Peak）と歌連臣（Mount Collinson）山を結ぶ稜綫から始まり、雲枕山（Wan Cham Shan）、打爛埕頂山（Shek O Peak）を経由して南方の鶴咀山（D'Aguilar Peak）まで続いています。

Tai Tam Country Park, Quarry Bay Extension and Shek O Country Park are located in the eastern part of Hong Kong Island. Designated in 1977, Tai Tam Country Park occupies a total area of 1 315 hectares. From Jardine's Lookout in the north, it sprawls across rolling slopes of The Twins to end at the southern border on Stanley Gap Road. The western border lies in Wong Nai Chung Gap, while Tai Tam Road marks its eastern boundary.

The adjacent Tai Tam Country Park (Quarry Bay Extension), 270 hectares in area, is designated in 1979. The boundary covers Mount Parker and the northern slope of Mount Butler.

The 701-hectare Shek O Country Park was designated in 1979. From the north, it extends along the ridgeline that links Pottinger Peak with Mount Collinson, and crosses Wan Cham Shan and Shek O Peak (Dragon's Back) to reach D'Aguilar Peak in the south.

郊野景點

大潭郊野公園範圍的四個水塘，是港島早期食水供應的主要來源。大潭水塘系統包括大潭上水塘、大潭副水塘、大潭中水塘及大潭篤水塘，建於1889年至1917年之間，總容量為900萬立方米。在寧靜的郊野公園內，仍可發現一些碉堡、彈藥庫及戰時爐灶等戰爭遺跡。

石澳郊野公園最負盛名的是雲枕山與打爛埕頂山之間一段高低起伏的山路——龍脊。於2005年，這裏被《時代》雜誌選為亞洲最佳的遠足徑。

郊遊路綫

港島徑第五段及第六段位於大潭郊野公園，第五段由黃泥涌峽起步，經過黃泥涌水塘北岸及陽明山莊，朝向高433米的渣甸山進發，隨後落坡百多米，途經石礦場，繼而又再攀上高436米的畢拿山，這對體力甚具挑戰性，但在兩峰觀賞到四周壯麗的景色時，即會感到不枉此行。第六段由柏架山道大風坳出發，繼而南行下坡，便可走進大潭谷這片綠色天地，湖光山色盡收眼底。

衛奕信徑第一及第二段縱貫整個大潭郊野公園及其鰂魚涌擴建部分。首段由赤柱峽道出發，經孖崗山、紫羅蘭山至黃泥涌水塘；第二段起點與港島徑第五段相同，於黃泥涌峽出發，途經渣甸山及畢拿山，連接金督馳馬徑及鰂魚涌樹木研習徑，途中既可飽覽秀麗風光，亦可一睹戰時留下的歷史遺跡。

港島徑第七段及第八段位於石澳郊野公園範圍內，第七段是港島徑較易行走的一段，由大潭道起步，沿石澳東引水道而行，貼近郊野公園的邊界。踏過綠樹成蔭的林徑，拐過石碑山，便可以看見大潭港的優美景色。沿途經過爛泥灣村、東丫村、東丫背村、銀坑村等多條漁村，便到達最後一站土地灣村，拾級而上，可達石澳道。回首腳下，土地灣至大潭灣的海灣風光，以及赤柱一帶的宜人景致盡入眼簾。

第八段由石澳道出發，沿溪邊山徑蜿蜒而行，循山脊登上打爛埕頂山，其間山勢險峻，可遠眺附近一望無際的海灣風光，而高低起伏宛如龍脊的山徑，就是龍脊之名的由來。在這裏可由極佳的角度觀賞石澳、大浪灣，甚至東龍洲的優美景色。接著深入樹林之間，山溪處處，寧靜的環境與先前的壯麗景色截然不同。由馬塘坳往大浪灣，整段港島徑在大浪灣終結。

在馬塘坳可選行砵甸乍山郊遊徑至歌連臣角道，郊遊徑平緩易走，兩旁綠樹成蔭，景色宜人，砵甸乍山及歌連臣山就在左右，而在歌連臣山南方的起伏山巒，就是雲枕山及打爛埕頂山，亦是龍脊之所在地。

見所

タイタムカントリーパークには4つの貯水池があり、初期には香港島の枢要な水の供給源でした。タイタム上貯水池、タイタム副貯水池、タイタム中貯水池、タイタム篤貯水池からなるタイタムグループとして知られています。1889年から1917年にかけて作られ、合わせて900万㎡の貯水量を持っています。砦や弾薬庫などの戦争中の遺跡もあります。

ついでトレイルは深い森の中に入ってゆきます。途中丘を流れる小川を横切り、雄大な景観は静かな谷筋の景色に変わります。馬塘坳(Pottinger Gap)から大浪湾へ向かうと香港島の南海岸のダイナミックな景色が広がります。大浪湾が香港トレイルの終点です。これが2005年にタイムスが選んだアジアのベスト散歩道です。

主要ルート

ステイジ5は黄泥涌峡(Wong Nai Chung Gap)から始まり、433メートルの渣甸山(Jardine's Lookout)を越え100メートルほど下って石切り場に至ります。そこから今度は436メートルの畢拿山(Mount Butler)への登りです。強い体力が必要な厳しいトレイルですが山

上からの香港島の素晴らしい眺めは十分苦労に値します。

タイタム谷を見るには柏架山(Mount Parker)道の大風坳(Quarry Gap)から香港トレイルステイジ6を南へ辿りタイタム貯水池の南端から谷へと入って行くのが良いでしょう。

ウィルソントレイルのステイジ1と2はタイタムカントリートレイルと鰂魚涌拡建設部分(Quarry Bay Extension)を縦断しています。ステイジ1は赤柱(スタンレー Stanely)から出発し孖崗山(The Twins)と紫羅蘭山(Violet Hill)を通って黄泥涌峡(Wong Nai Chung Gap)に向かいます。

ステイジ2の出発点は香港トレイルステイジ5の出発点と同じ黄泥涌峡(Wong Nai Chung Gap)です。渣甸山(Jardine's Lookout)と畢拿山(Mount Butler)を越えたあと坂の下で金督馳馬徑(Sir Cecil's Ride)と鰂魚涌(Quarry Bay)樹木径と合流します。

様ステイジ7もパーク内にあります。比較的簡単な道でタイタム道から始まりシェッコー西導水路沿いに続きます。石碑山(Obelisk Hill)の麓をくねくねと続く木陰の多い道からはタイタム湾の素晴らしい眺めが楽しめます。さらに行くと爛泥湾村(Lan Nai Wan)、東Y村(Tung Ah)、東Y背(Tung Ah Pui)、銀坑(Ngan Hang)村等の漁村を通り最後に土地湾(To Tei Wan)にいたります。ここからシェッコー道に向かって階段が登っています。振り返れば浸食谷がエメラルド色の土地湾へ下っているのが見えます。

この素晴らしいルートを辿るには香港トレイルの最後の最も急な部分、ステイジ8を行くことになります。シェッコーに向かうバスが峠を越え下り始めたところでバスを降り打爛埕頂山(Shek O Peak)に向かいます。稜線上の急峻な地形を辿る大変厳しい登りです。高度が上がるにつれターコイズブルーの海の景色が広がります。この部分は起伏が激しく伝説の怪獣龍の背中に似ているところからドラゴンズバックと呼ばれています。見晴台からはシェッコー、大浪湾、東龍洲(Tung Lung Chau)などの素晴らしい眺めが広がります。

ついでトレイルは深い森の中に入ってゆきます。途中丘を流れる小川を横切り、雄大な景観は静かな谷筋の景色に変わります。馬塘坳(Pottinger Gap)から大浪湾へ向かうと香港島の南海岸のダイナミックな景色が広がります。大浪湾が香港トレイルの終点です。

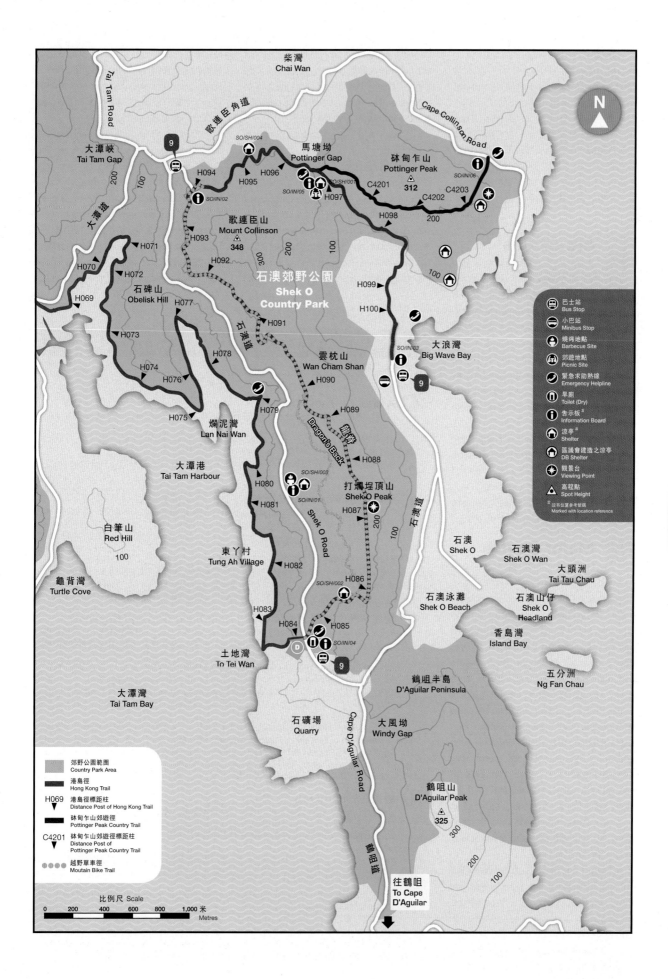

N

柴灣
Chai Wan

大潭峽
Tai Tam Gap

馬塘坳
Pottinger Gap

硃甸乍山
Pottinger Peak
312

Cape Collinson Road

歌連臣山
Mount Collinson
348

石澳郊野公園
Shek O Country Park

Tai Tam Road

石碑山
Obelisk Hill

雲枕山
Wan Cham Shan

大浪灣
Big Wave Bay

爛泥灣
Lan Nai Wan

Dragon's Back

大潭港
Tai Tam Harbour

打爛埕頂山
Shek O Peak

石澳
Shek O

石澳灣
Shek O Wan

白筆山
Red Hill

東丫村
Tung Ah Village

石澳泳灘
Shek O Beach

大頭洲
Tai Tau Chau

龜背灣
Turtle Cove

土地灣
To Tei Wan

石澳山仔
Shek O Headland

香島灣
Island Bay

大潭灣
Tai Tam Bay

石礦場
Quarry

鶴咀半島
D'Aguilar Peninsula

五分洲
Ng Fan Chau

大風坳
Windy Gap

鶴咀山
D'Aguilar Peak
325

往鶴咀
To Cape D'Aguilar

香港島 | Hong Kong Island

巴士站 Bus Stop
小巴站 Minibus Stop
燒烤地點 Barbecue Site
郊遊地點 Picnic Site
緊急求助熱線 Emergency Helpline
旱廁 Toilet (Dry)
告示板# Information Board
涼亭# Shelter
區議會建造之涼亭 DB Shelter
觀景台 Viewing Point
高程點 Spot Height
以下位置參考編號
Marked with location reference

郊野公園範圍
Country Park Area
港島徑
Hong Kong Trail
H069 港島徑標距柱
Distance Post of Hong Kong Trail
C4201 硃甸乍山郊遊徑標距柱
Distance Post of Pottinger Peak Country Trail
越野單車徑
Mountain Bike Trail

比例尺 Scale
0 200 400 600 800 1,000 米
Metres

起砵甸乍(Pottinger)カントリートレイルは導水路沿いの水平な木陰の道です。左は起砵甸乍山(Pottinger Peak)、右は歌連臣(Collinson)山です。

その南では雲枕山(Wan Chan Shan)とシェックコーピークの間の起伏のある稜綫＝ドラゴンズバックが見事な姿を見せています。芝湾(Chai Wan)と小西湾(Siu Sai Wan)の街の景色とは対照的でまるで天上界の眺めのようです。

Attractions

There are 4 reservoirs in Tai Tam Country Park, all of which key water storage facilities of the Island in early years. Known as the Tai Tam Group, they comprise Tai Tam Upper Reservoir, Tai Tam Byewash Reservoir, Tai Tam Intermediate Reservoir and Tai Tam Tuk Reservoir. Built between 1889 and 1917, these reservoirs have an aggregate capacity of 9 million m³. Also in the park are remnants of war, such as forts, magazines and wartime communal stoves.

Shek O Country Park is Hong Kong Island's celebrated natural haven. The Dragon's Back, an undulating ridge top trail between Wan Cham Shan and Shek O Peak, is the crown jewel. This is the Best Asian Hike selected by the *Times* Magazine in 2005.

Major Routes

Hong Kong Trail Stage 5 and Stage 6 lie within the Tai Tam Country Park. Stage 5 begins at Wong Nai Chung Gap and conquers the 433m Jardine's Lookout via the north embankment of Wong Nai Chung Reservoir and Parkview. Beyond the summit, the trail travels downhill for about 100m before continuing along the ridge. After a stone quarry, it trends up again for the 436m Mount Butler. This is a challenging hike requiring considerable physical strength, but the open vistas at the top make it all worthwhile. Atop both spurs, the majestic landscape of Hong Kong Island unfolds before your eyes. To see Tai Tam Valley, follow Stage 6 of the Hong Kong Trail which starts at Quarry Gap of Mount Parker Road, and then descend along the southern slopes to an arcadia of woods, streams and lakes.

Stage 1 and Stage 2 of the Wilson Trail cut right through Tai Tam Country Park and the Quarry Bay Extension. The first stage sets off in Stanley and advances to Wong Nai Chung Reservoir via The Twins and Violet Hill. Stage 2 shares the same starting point with Stage 5 of the Hong Kong Trail – Wong Nai

Chung Gap. After passing Jardine's Lookout and Mount Butler, it joins Sir Cecil's Ride and the Quarry Bay Tree Walk at the end of the slope. This route passes some beautiful scenes and some wartime relics.

Stage 7 and Stage 8 of Hong Kong Trail extend within Shek O. Stage 7 is a relatively easy walk. Starting at Tai Tam Road, the trail skirts along the park border next to the Shek O East catchwater. As it bends around Obelisk Hill, the wooded path gives a spectacular view of the Tai Tam anchorage. Further on, it passes through homely fishing villages – Lan Nai Wan Village, Tung Ah Village, Tung Ah Pui Village and Ngan Hang Village – until

reaching its last stop at To Tei Wan Village. Here, a flight of steps lead up to Shek O Road. Looking back, you can see ravines sloping down to beryl waters of To Tei Wan, Tai Tam Bay and Stanley.

Starting off at Shek O Road, Stage 8 follows the meandering streamside path. The ascent to Shek O Peak is quite strenuous, as the ridge top path cuts through some treacherous terrain. As you ascend, a great sweep of turquoise water comes into view. This section of the trail is known as Dragon's Back, so named because it rolls up and down like the back ridge of the legendary beast. The vantage point offers splendid vistas

 前往方法・行き方・**HOW TO GET THERE**

大潭郊野公園 Tai Tam Country Park

(A) 大潭道 Tai Tam Road

在西灣河港鐵站乘搭14號巴士，於大潭郊野公園巴士站下車。公園入口旁邊設有一座兩層高的公廁。

MTR西灣河(Sai Wan Ho)からバス14で大潭篤ダムを越えたところで下車。公園入り口の横に2階建てのトイレあり。

Take bus 14 at Sai Wan Ho（西灣河）MTR. Alight at the Tai Tam Country Park bus stop. There is a 2 storey public toilet right next to the park entrance.

赤柱峽道 Stanley Gap Road

在中環交易廣場或皇后大道東(東行綫)分別乘搭前往赤柱的6、6A或260號巴士。於春磡角道路口後的衛奕信徑巴士站下車，在公園入口可找到郊野公園地圖板。

セントラルの交易廣場(Exchange Square)で赤柱(Stanley)行きのバス6、6A、260、あるいは皇后大道東(Queen's Road East)沿いの停留所から東向きのバスで春磡角道(Chung Hom Kok Road)の右回りのカーブを越えたら下車(衛奕信徑)。

Take buses 6, 6A or 260 for Stanley（赤柱）at Exchange Square（交易廣場）in Central or from any bus stop along Queen's Road East（皇后大道東）(East Bound). After the bus has passed the right-hand turning for Chung Hom Kok Road（春磡角道）, alight at the Wilson Trail bus stop.

(B) 黃泥涌峽及黃泥涌水塘 Wong Nai Chung Gap and Reservoir

在中環交易廣場或皇后大道東(東行綫)乘搭前往淺水灣或赤柱的6、61或66號巴士。於黃泥涌水塘巴士站下車後，朝油站方向前行轉左，再拾級而上，即抵大潭水塘道，續走15分鐘便到達陽明山莊。

セントラルの交易廣場(Exchange Square)から淺水灣(Repulse Bay)あるいは赤柱(Stanley)向けバス6、61、66、あるいは皇后大道東(Queen's Road East)沿いの停留所から東向きのバスで、黃泥涌峽(Wong Nai Chung Gap)近くの香港木球會(Hong Kong Cricket Club)へ(黃泥涌水塘巴士站)前方のガソリンスタンドで左に曲がり階段を上がって大潭水塘道(Tai Tam Reservoir Road)へ。15分ほどで陽明山莊(Parkview)。

Take buses 6, 61 or 66 for Repulse Bay（淺水灣）or Stanley（赤柱）from Exchange Square（交易廣場）in Central（中環）or from any bus stop along Queen's Road East（皇后大道東）(East Bound). Get off at the Wong Nai Chung Reservoir Bus Stop near Hong Kong Cricket Club（香港木球會）at Wong Nai Chung Gap. Walk up to the petrol station, turn left and walk up the steps to Tai Tam Reservoir Road（大潭水塘道）. Walk for another 15 minutes to Parkview（陽明山莊）.

(C) 鰂魚涌 Quarry Bay

沿鰂魚涌街市旁的柏架山道往上行10分鐘，便可到達郊野公園入口。

鰂魚涌街市(Quarry Bay Market)の横のパーカー山道を10分ほど歩くとパーク入り口。

Walk up along Mount Parker Road next to Quarry Bay Market for 10 minutes to reach the park entrance.

(D) 石澳郊野公園 Shek O Country Park (p.25)

乘搭港鐵至筲箕灣站，在A3出口附近轉乘9號巴士。巴士進入石澳道後，於土地灣巴士站下車。路徑在地圖板旁邊開始。

MTRの筲箕灣(Shau Kei Wan) A3出口からバス9で石澳道(Shek O Road)方面へ。右手に駐車場と展望台を見たら次の停留所で下車(土地灣)。地図表示板のところから道が始まる。

Take the MTR to Shau Kei Wan（筲箕灣）and leave the station by Exit A3. Get on bus 9. Get off at the To Tei Wan（土地灣）bus stop on Shek O Road（石澳道）. The trail starts beside the mapboard.

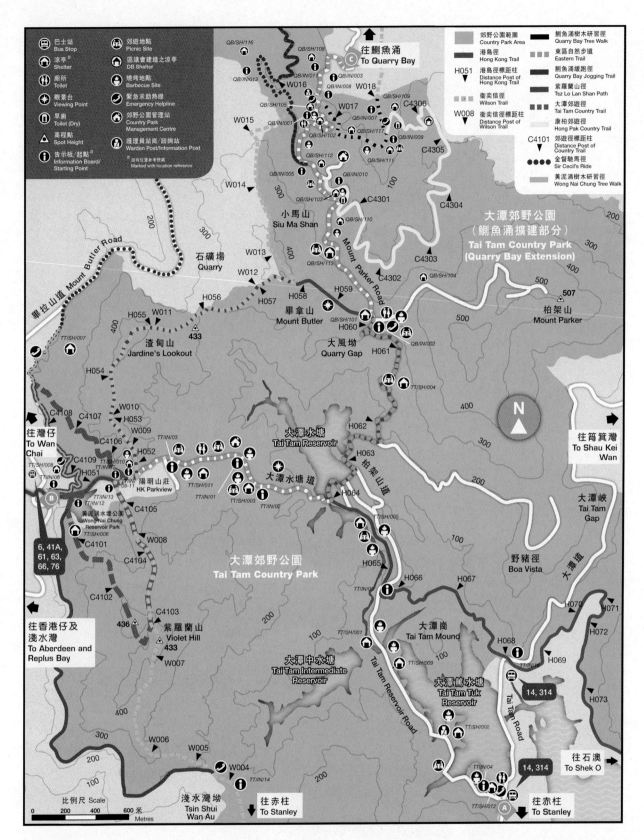

across Shek O, Big Wave Bay and Tung Lung Chau in the distance. At this point, the trail makes its way through dense forests, passing gurgling hill streams along the way. Vistas of grand landscape soon give way to serene valley scenery. Just past Pottinger Gap, on your approach to Big Wave Bay, you look across the dynamic south coast of Hong Kong Island. Big Wave Bay marks the end of the Hong Kong Trail.

Pottinger Peak Country Trail is an alternative path, from Pottinger Gap to Cape Collinson Road. It is a level catchment route. Shaded with trees, it gives delightful scenery. On your left and right are Pottinger Peak and Mount Collinson respectively. To the south of Mount Collinson, the rolling ridgelines of Wan Cham Shan and Shek O Peak strike a breathtaking presence – the Dragon's Back.

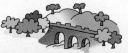

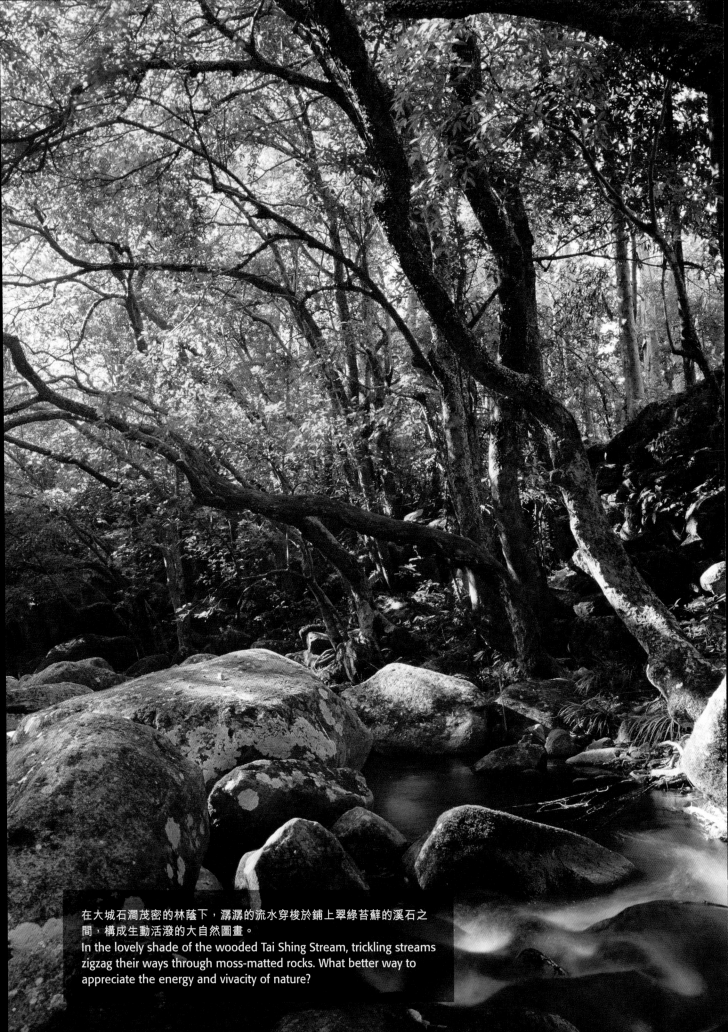

在大城石澗茂密的林蔭下，潺潺的流水穿梭於鋪上翠綠苔蘚的溪石之間，構成生動活潑的大自然圖畫。
In the lovely shade of the wooded Tai Shing Stream, trickling streams zigzag their ways through moss-matted rocks. What better way to appreciate the energy and vivacity of nature?

城門郊野公園

城門（シンムン）
Shing Mun Country Park

地圖
MAP *p.31*

城門郊野公園於1977年成立，是全港首批郊野公園之一，佔地達1,400公頃，北接鉛礦坳，南至城門道，西鄰大帽山，東至草山及針山。

広さ1,400ヘクタール、1977年にカントリーパークに指定されたシンムンカントリーパークは香港最初のカントリーパークの一つです。北の鉛鉱坳（リードマインパス　Lead Mine Pass）から南のシンムン貯水池道まで広がっています。西の境界は大帽山（Tai Mo Shan）中にあり、東は草山（Grassy Hill）から針山（Needle Hill）への稜綫です。周囲を山々に囲まれてのどかな景観に恵まれています。

Designated in 1977, Shing Mun Country Park was one of the first batch country parks in the territory, commanding a site of 1,400 hectares. From its northern edge in Lead Mine Pass, it extends to Shing Mun Road in the south. The western border lies in Tai Mo Shan, while Grassy Hill and Needle Hill mark the eastern margin.

郊野景點

城門郊野公園遊客中心位於菠蘿壩小巴總站旁，內設展覽，介紹地區歷史和林地生態環境等資料，公園內的標本林則可讓遊人在天然環境中認識種類繁多的植物。

城門水塘位於大帽山東南山麓，是大帽山下最大的儲水庫，被針山、草山、大帽山及金山環繞，風景秀麗。水塘於1936年建成，適逢英皇喬治五世登基25周年紀念，故又名為銀禧水塘。

大城石澗位處大帽山東南面和水塘西北面，水源始於大帽山，下注城門水塘，所以得「大」「城」之名，是本港遠足界的九大名澗之一。

城門標本林是全港唯一的標本林，位於鉛礦坳及城門水塘之間，其面積4公頃，原為荒廢梯田，自1970年代初開始，當局陸續在此種植具代表性的樹木。直至2000年，已植有270多種本地或華南地區原生植物，共7,000多株，其中包括不少稀有及瀕危物種，對植物的存護極為重要。

郊遊路綫

城門水塘一帶有不少值得探索的地方，其中最令人心曠神怡的是沿東岸漫步一趟。路徑始自主壩北端盡處，

小徑貼近水畔迂迴前進，風光旖旎。繼續上攀，經過一些大型河道，然後下行，可穿越由昔日大圍村風水林逐漸繁衍而成的林地，樹木參天，樹種多達七十多個，此處經已劃為受到特別保護的「特別地區」。

城門一帶最茂盛的樹林，位於水塘北側的城門谷，這裏堪稱全港數一數二的優秀林區。沿衞奕信徑第七段，由城門水塘主壩至元墩下輕鬆踏足山徑，途中便可欣賞此番好風光。除了走進山谷之外，登上山嶺又是另一種飽覽青山綠水的方法。麥理浩徑第七段自城門水壩北端起步，登上針山漫長的階梯，在532米的尖峰之上，可鳥瞰鄰近地區及城門水塘。下山之後，又再沿緩緩上坡的行車道攀登647米的草山。草山標誌著城門谷和沙田谷的分界，其所在處亦位於城門水塘集水區和大埔滘林區溪澗的源頭山坡之間，景觀壯麗。在沙田後方，是馬鞍山山脈的巨大山坡，再在其後則是西貢半島。

見所

1936年に完成したシンムン貯水池は大帽山下で最大の貯水池です。キング・ジョージ5世の戴冠25周年記念の年だったのでジュビリー（Jubilee）貯水池とも呼ばれています。貯水池の北西には大帽山から貯水池へ流れ下る大城（Tai Shing）渓谷があります。ハイカーがつけた名前で高山から低地へ流れることを意味しています。

シンムンカントリーパークは豊かな森で有名です。貯水池の前には古い村の跡があり、そばには70種類以上の素晴らしい古木からなる風水林があります。原産植物保護のためここは特別保護区に指定されました。

大戦の折に日本軍がシンムンを占領し一帯の樹木を切り払いほとんどの山が禿山になってしまいました。戦後直ちに植林が始められ今では香港で最も重要な造林地のひとつとなっています。

ビジターセンターから歩いて1時間ほどで香港唯一の標本林に着きます。かつて水田だった4ヘクタールの土地に1970年代以降多くの植物が植えられてきました。2000年の調査では香港と南中国原産の270種類、7,000本以上の樹木の生育が確認されています。その多くは稀少種や絶滅危惧種で、標本林は植物保護に大きな役割を果たしています。標本林に出かけるのは植物図鑑を眺めるより勉強になります。

主要ルート

この自然のままの地域には隠れた探索の場所が沢山あります。貯水池の東側の土手の道を行けば気楽に自然美を堪能できるでしょう。トレイルは貯水池の北端から始まり土手沿いに曲がりくねりながらシンムンの深く美しい森の中に入ってゆきます。

貯水池の北端でリードマインパスに相対するシンムン谷には香港で最も豊かな森が広がっています。

ウィルソントレイルのステイジ7はシンムンダムから元墩下（Yuen Tun Ha）にいたります。もしあまり辛くなく眺めの良いルートを歩きたければこのステイジがふさわしいかもしれません。山々は自然美という今ひとつの魅力であなたを魅了するでしょう。

他方、マクリホーストレイルのステイジ7はダムの北の端から始まります。532メートルの針山の頂上に立てば新界の北西部分が一望できます。見下ろせばすぐ下の貯水池と緑の森影が涼しげです。

階段を下るとトレイルは647メートルの草山に向かって登る自動車道路になります。この山はシンムンと沙田（Sha Tin）の分水嶺です。急な斜面はシンムン導水路と大埔カウ（タイポカウ Tai Po Kau）営林区の水源です。頂上からの眺めは見事に尽きます。沙田の向こうには巨大な馬鞍山が堂々と聳えています。その背後からは西貢半島が手招きしています。

Attractions

Situated next to the minibus terminus, Shing Mun Country Park Visitor Centre offers interesting exhibits that present Shing Mun's history and woodland habitats. Inside the country park, the Shing Mun Arboretum with its rich plant resources is a wonderful place to appreciate Hong Kong's flora.

Shing Mun Reservoir is nestled deep in the southeastern hills of Tai Mo Shan and surrounded by Needle Hill, Grassy Hill, Tai Mo Shan and Golden Hill. It is the largest water storage facility at the foot of Tai Mo Shan. It was completed in 1936. As the year was the the 25th anniversary of King George V's ascent to the throne, the reservoir is also known as the Jubilee Reservoir.

Tai Shing Stream is located at the southeast of Tai Mo Shan and the northwest of Shing Mun Reservoir. It is a waterway that runs from the uplands of Tai Mo Shan to the reservoir. The name Tai Shing Stream has been given by hikers, and reflects the stream's highland origin and lowland end.

Located between Lead Mine Pass and Tai Mo Shan, the 4-heactare Shing Mun Arboretum is Hong Kong's only live arboretum. It has been converted from abandoned rice terraces. Since the 1970s, many representative flora species have been planted here. At the last count in 2000, this green sanctuary boasted more 7,000 trees belonging to over 270 species native to Hong Kong or South China. Among them are many rare and endangered species. Indeed, the arboretum plays a vital role in flora conservation.

Major Routes

There are many hidden corners for the explorer in Shing Mun Country Park. The most relaxing way to experience its natural beauty is to stroll along the east bank of the lake. The trail starts at the northern end of the main dam. Meandering along the embankment, it takes you deep into the beautiful Shing Mun woodlands. Continuing up the hills, the trail passes some large streams before making a descent through dense forests developed from overgrowing fung shui woods of the old Tai Wai Village. This fung shui wood harbours magnificent old trees belonging to more than 70 species. To preserve the local flora, this site has been designated a Special Area protected by law.

Richest woodlands can be found in Shing Mun Valley at the northern end of the reservoir facing Lead Mine Pass. Stage 7 of the Wilson Trail leads from the Shing Mun main dam to Yuen Tun Ha. It is a good choice for an easy scenic route. The uplands lure you with an alternative brand of natural beauty. Stage 7 of the MacLehose Trail starts at the north end of the main dam. From the 532m summit of Needle Hill, the view of nearby countryside and Shing Mun Reservoir is really spectacular. After some steps, the trail soon joins a vehicular road to travel uphill for Grassy Hill, a formidable summit rearing up some 647m. Grassy hill is a watershed that divides Shing Mun Valley and Shatin Valley. Its steep slopes are the upland sources of the Shing Mun catchment and streams that run through the Tai Po Kau plantation. The vistas at the top are simply mesmerizing. Beyond Shatin, the colossal Ma On Shan range squats firmly on the lowlands. In the background, the grand Sai Kung Peninsula beckons.

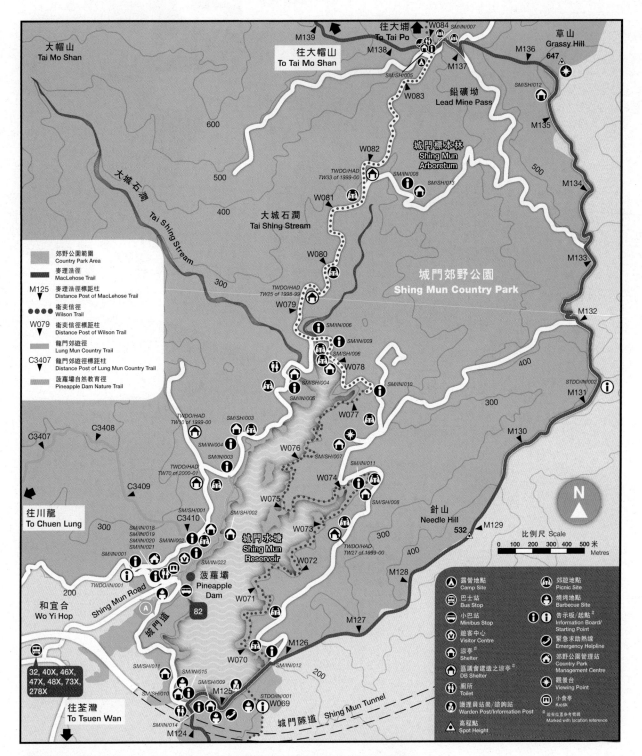

前往方法・行き方・**HOW TO GET THERE**

A 城門郊野公園 Shing Mun Country Park

　　在荃灣港鐵站B出口步行至兆和街，乘坐82號專綫小巴至菠蘿壩總站，在小巴總站旁邊的石階拾級而上，可達城門郊野公園遊客中心，亦可沿平路前往城門水塘主壩。

　　MTR荃灣(Tsuen Wan) B出口を出て歩道橋を兆和街(Shiu Wo Street)へ向かい緑のミニバス82で菠蘿霸(Pineapple Dam)へ。右手の道を城門水塘(Shing Mun Reservoir)へ。階段の途中にビジターセンターあり。

　　Leaving Tsuen Wan（荃灣）MTR station by Exit B, take the walkway to Shiu Wo Street（兆和街）to catch green minibus 82. Getting off at Pineapple Dam（菠蘿壩）terminus, you can reach Shing Mun Country Park Visitor Centre by walking up the staricases beside the terminus; or taking the opposite track to the Shing Mun Reservoir（城門水塘）.

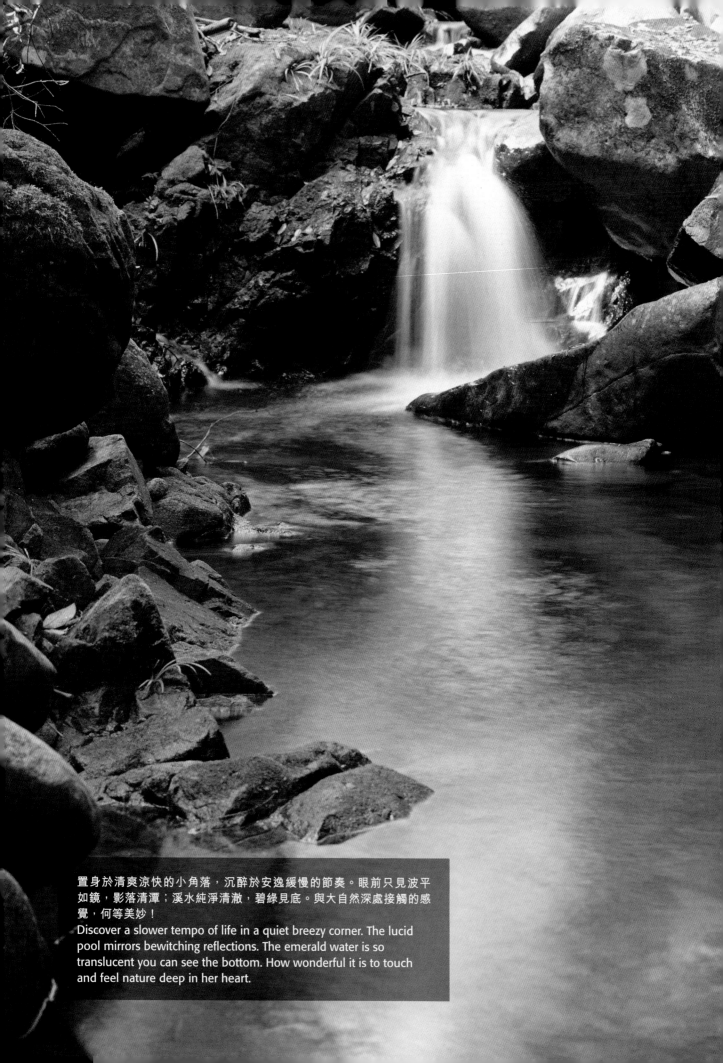

置身於清爽涼快的小角落，沉醉於安逸緩慢的節奏。眼前只見波平如鏡，影落清潭；溪水純淨清澈，碧綠見底。與大自然深處接觸的感覺，何等美妙！

Discover a slower tempo of life in a quiet breezy corner. The lucid pool mirrors bewitching reflections. The emerald water is so translucent you can see the bottom. How wonderful it is to touch and feel nature deep in her heart.

大埔滘自然護理區

大埔滘（タイポーカウ）
自然保護区
Tai Po Kau Nature Reserve

地圖
MAP *p.35*

大埔滘自然護理區是一片成熟的次生林，林內的動植物種類十分多樣化。

　　大埔滘林區位於新界中部，於1977年劃作特別地區，稱為大埔滘自然護理區，面積約460公頃，與城門、金山、大帽山及大欖郊野公園相連。樹林自海拔50米伸展至海拔647米的草山山頂，山澗終年潤澤山丘峭谷，動植物種類十分多元化，是科研的理想場地，其中以蜻蜓、蜉蝣、蝴蝶、飛蛾、鳥類、各種昆蟲及樹林生態等為最熱門的研究課題。

タイポーカウ 自然保護区は成熟した次生林で多様な動植物が生息しています。

　　1977年に新界中央にあるタイポーカウの森はカントリーパーク法により特別区として指定されタイポーカウ自然保護区となりました。森は高度50メートルから647メートルの草山まで広がっています。460ヘクタールあり城門、金山、大帽山、そして大欖（タイラム Tai Lam）カントリーパークと接しています。　山から常に流れ落ちる十分な水のおかげでこの谷は野生生物の天国となり目もくらむほどに多様な動植物が共生しています。タイポーカウの自然林はあらゆる種類、特別の生物学的、環境学的研究のために野性生物を観察し、データを収集するのに人気の場所です。トンボ、かげろう、蝶、苔、鳥、昆虫そして森の生態などが話題のテーマの例です。

Tai Po Kau Nature Reserve is a mature secondary forest that supports diverse flora and fauna.

In 1977, the Tai Po Kau woodlands in the Central New Territories were designated a Special Area under the Country Park Ordinance, and became Tai Po Kau Nature Reserve. The local forests spread from an elevation of about 50m to the summit of Grassy Hill (647m). The 460-hectare nature reserve is surrounded by the Shing Mun, Kam Shan, Tai Mo Shan and Tai Lam Country Parks. Nourished by hill streams that bring ample water all year round, the valley is a wildlife sanctuary where a dazzling mix of flora and fauna lead an interdependent coexistence. It is a popular site for observing wildlife and collecting data for specialized biological and ecological studies. Hot examples are dragonflies, mayflies, butterflies, moths, birds, insects and forest ecology.

郊野景點

　　1926年，政府開始在整個新界（包括大埔滘）植樹造林。當時大埔滘最常見的樹是馬尾松（亦稱山松），因此當地居民稱該區為松仔園。二次大戰後，當局在大埔滘區廣植樹木，經過半世紀，現已成為一個物種豐富的自然樹林，樹木達百多種，時至今日已相當成熟，構成十分多樣化的樹林生態環境。

　　由於大埔滘的林地獲得良好的管理及防火措施保護，倖免於山火，因此成為林鳥安居之所，吸引了逾160種鳥類，其種類及數量比香港任何地方都要多。區內特別設有林鳥介紹板，方便遊人辨認各種常見雀鳥。

郊遊路綫

　　這裏設有四條以顏色命名的小徑，長度在3公里至10公里之間，需時45分鐘至3.5小時不等。每條小徑各具特色：紅路起點設有郊遊地點，沿路平坦易走，穿梭於樹林中，可聽到鳥兒的歌聲及淙淙的流水聲，是適合一家老幼作短途漫步的好地方。藍路沿路古木參天，樹頂枝葉濃密，大部分已生長了數十年，步行其中，讓你有如置身於古老樹林一樣。啡路除了不同的喬木和灌木外，亦有數處竹林，你可在路上認識到不同的生態環境。最長的黃路既有樹林特色，更可在其中一段遠眺八仙嶺及吐露港的風光。

區內另有一條長1公里的自然教育徑，此徑橫過林地，展示一些較易觀察的林地生態，沿途設有傳意牌，解釋有關自然現象。

見所

　　新界の植林事業は1926年に始まりましたがその折の目標はタイポーカウを緑にしようと言うものでした。ここでは植林樹木は長尾松（Chinese Red Pine中国赤松）が一般的だったため谷は地元民から松仔園（Pine Garden）と呼ばれました。今日では亜熱帯種の自生林が東の斜面から草山そしてタイポ道へと広がり始めています。この緑豊かな谷は戦後の政府による植林事業の賜物です。

　　半世紀が経って今ではタイポーカウは100種以上の多様な種の混在する自然林に成長しています。定着した樹木は次第に楠木、China Fir、台湾相思、Paper-Bark Treeの様な新しい樹木と混成し、多様な生態を可能にする成熟した森を作って行ったのです。

　　しっかりした管理と防火体制のおかげでタイポーカウの森は山火事の被害を免れました。

　　タイポーカウは明るい色彩の160種類もの鳥を呼び込みました。これだけの多様性はほかの地域では見られません。鳥の解説板を見れば訪問客は鳥の種類を特定できます。

主要ルート

　　タイポーカウ自然保護区には4色に色分けされた周回トレイルがあります。3から10キロあり、45分から3.5時間で歩けます。それぞれ固有の特徴があります。

　　赤いトレイルは1時間で歩けます。スタート地点にはバーベキュー場がありやさしく平坦な道です。深い森の中を行き鳥の声と流れの音が聞こえます。家族連れにはぴったりの短いトレイルです。

　　それより少し長いのが青いトレイルです。背の高い成長した樹木沿いに道が続きます。もう20-30年たった木で、原始林の様に見えます。

　　樹木や薮から離れると竹薮の中を行く茶色のトレイルがあります。自然の多様性を経験するのにふさわしいトレイルです。

　　最長の黄色いトレイルは面白い森の生態を見せてくれます。八仙嶺や吐露湾の遠景が見える場所も所々あります。

　　タイポーカウ自然保護区には1キロほどの自然径があり観察しやすい森の動植物が展示されています。道沿いには様々な自然現象の解説板があります。

Attractions

The Government's afforestation programme for the New Territories (including Tai Po Kau) started in 1926. The Tai Po Kau Valley was named Pine Garden by the locals, as Chinese Red Pine was the most common afforestation species in these parts. Today, the subtropical plantations of the nature reserve stretch from the eastern slopes of Grassy Hill to Tai Po Road. This verdant valley is the fruition of the Government's postwar

前往方法・行き方・HOW TO GET THERE

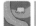 **大埔滘自然護理區** Tai Po Kau Nature Reserve

　　在大圍東鐵站乘搭72A巴士，或自大埔乘坐28K小巴或72號巴士，至松仔園巴士站下車，再朝大埔方向步行30米左右，便是大埔滘自然護理區的入口。

　　MTRの大圍(Tai Wai)からバス72A 、あるいは大埔墟(Tai Po Market)から28Kミニバスで松仔園(Tsung Tsai Yuen)へ。大埔(Tai Po)へ向けて30メートルほど歩くと大埔滘自然護理區(Tai Po Kau Nature Reserve)の入り口。

　　Take 72A bus from Tai Wai（大圍）MTR or minibus 28K or bus 72 from Tai Po（大埔）. Alight at Tsung Tsai Yuen（松仔園）bus stop and walk towards Tai Po（大埔）for about 30m to reach the entrance of Tai Po Kau Nature Reserve（大埔滘自然護理區）.

reforestation programme, during which a large number of trees were planted in the region. Now, half a century later, Tai Po Kau has developed into a natural forest of great diversity. The Tai Po Kau woodlands boast more than 100 species. Established trees, gradually merging with newer plantation varieties like Camphor Tree, China Fir, Taiwan Acacia and Paper-bark Tree, shape and form mature forests to provide manifold habitats.

Protected by sound management and fire prevention measures, the Tai Po Kau forests have been spared the devastation of fire. Tai Po Kau attracts some 160 bird species of vibrant colours. This impressive diversity is unique in the territory. Visitors can identify different species with the help of forest bird interpretation plates.

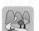

Major Routes

Tai Po Kau Nature Reserve features four colour-coded circular paths, with lengths ranging from 3km to 10km, requiring 45 minutes to 3.5 hours to finish. Each of them has a unique character. The Red Walk takes only an hour to complete. There is a picnic area at the starting point, and the going is easy and level all the way. This route cuts through lush woodlands and offers sweet sounds of bird songs and flowing water. It is a perfect short walk for the whole family. Slightly longer than the Red Walk, Blue Walk is lined with tall mature trees with dense canopies. Most of these trees have been here for a few decades. The setting resembles a primitive forest. Apart from trees and shrubs, there are bamboo thickets along Brown Walk, which provides a good chance to experience the diversity of nature. The longest route of all, the Yellow Walk, displays interesting woodland ecology, with one section featuring a distant view of Pat Sin Leng and Tolo Harbour.

Inside Tai Po Kau Nature Reserve, a 1km nature trail traversing the woods showcases many easily observable woodland flora and fauna. Along the way there are interpretation plates explaining the various natural phenomena found there.

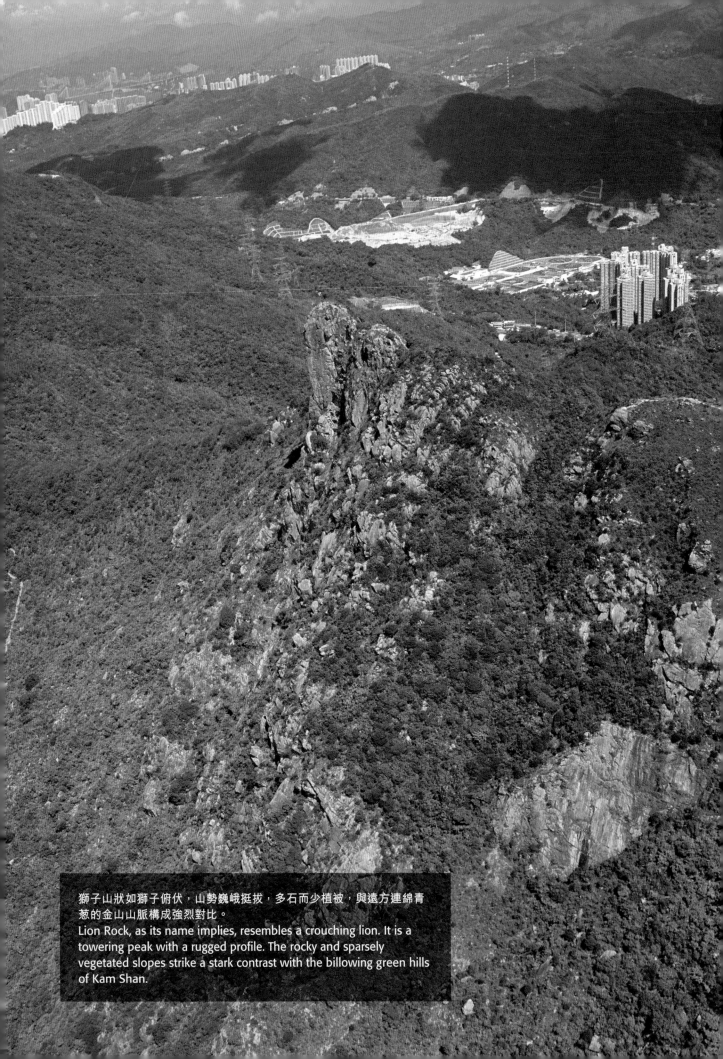

獅子山狀如獅子俯伏，山勢巍峨挺拔，多石而少植被，與遠方連綿青蔥的金山山脈構成強烈對比。

Lion Rock, as its name implies, resembles a crouching lion. It is a towering peak with a rugged profile. The rocky and sparsely vegetated slopes strike a stark contrast with the billowing green hills of Kam Shan.

獅子山郊野公園及金山郊野公園

ライオンロック, 金山 (Kam Shan) カントリーパーク
Lion Rock and Kam Shan Country Parks

地圖
MAP *p.38–p.39 & p.43*

p.38–p.39 & p.43

獅子山郊野公園是本港最早劃定的三個郊野公園之一，成立於1977年，範圍橫跨北九龍與沙田之間的山嶺，總面積為557公頃。金山郊野公園於同年設立，位於九龍以北，佔地337公頃，大部分屬九龍水塘集水區，北至走私坳，是最貼近九龍市區的郊野公園。

ライオンロックカントリーパークは香港最初の3つのカントリーパークの一つです。1977年6月24日に指定され、北九龍と沙田間の広い範囲の山々をカバーしています。西は金山 (Kam Shan) カントリーパークと大埔道を挟んで接し、全体で557ヘクタールあります。東西に続く幅の狭い山岳地帯です。ライオンロックは正にライオンのような形で九龍半島に君臨しています。頂上からはカオルーン市街と新界の大半が眺められます。

Lion Rock Country Park is one of the three earliest country parks of Hong Kong. Designated in 1977, it covers a wide upland region set between north Kowloon and Shatin. It commands a total area of 557 hectares.The 337-hecatre Kam Shan Country Park in north Kowloon is set mainly in reservoir catchment areas, extending to Smugglers' Pass in the north. Designated in 1977, it is the country park nearest to the Kowloon urban districts.

郊野景點

獅子山高495米，為一狹長的山嶺，西崖奇石嶙峋，形如獅子俯伏，獅子頭朝向西方，雄視香江。望夫石位處沙田紅梅谷對上的一個小山崗，海拔約250米，是獅子山連綿山嶺中的一座小山。筆架山高453米，位於獅子山西面，昔日設有烽火台，故又名煙燉山。據説清朝居民在發現海盜或外敵時用作示警；另有指其作用是傳播風向等天氣消息，現時天文台亦在此設立氣象站。

九龍水塘是九龍半島內一組共四個的水塘，包括1910年於新界最先建成的九龍水塘、石梨貝水塘（1925年建成）、九龍接收水塘（1926年建成）及九龍副水塘（1931年建成）。

孖指徑是一列向北延伸至城門谷的狹長山巒，其中位於北面的大片戰時軍事遺跡包括戰壕和碉堡，且有地道互通，是當年醉酒灣防線最重要的一部分。為確保安全，遊人不應進入這些軍事遺跡。

金山又被市民稱為「馬騮山」，原因是公園內的猴子數量眾多，牠們主要為恆河猴及長尾獼猴，都是昔日從外地引入，其後被放生而繁衍的。

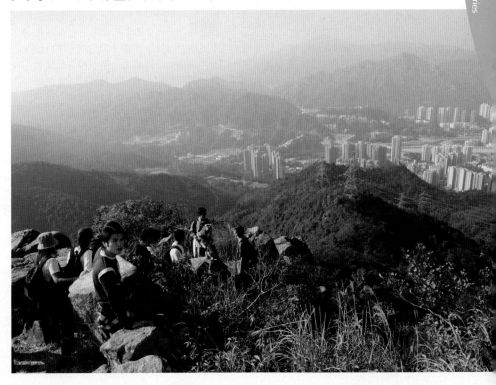

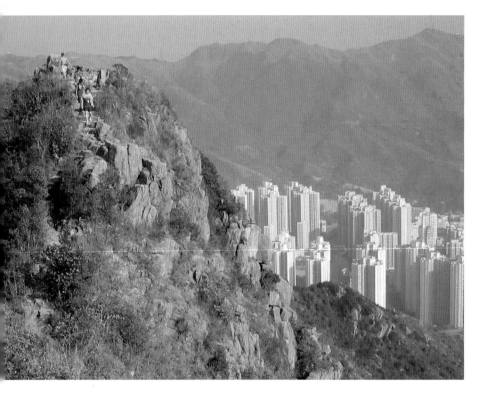

<table>
<tr><td>郊野公園範圍
Country Park Area</td><td>巴士站
Bus Stop</td><td>廁所
Toilet</td></tr>
<tr><td>麥理浩徑
MacLehose Trail</td><td>小巴站
Minibus Stop</td><td>告示板#
Information#</td></tr>
<tr><td>M100 麥理浩徑標距柱
Distance Post of MacLehose Trail</td><td>涼亭#
Shelter</td><td>燒烤地點
Barbecue Site</td></tr>
<tr><td>衛奕信徑第五段
Wilson Trail Section 5</td><td>觀景台
Viewing Point</td><td>區議會建
之涼亭#
DB Shelter</td></tr>
<tr><td>W047 衛奕信徑標距柱
Distance Post of Wilson Trail</td><td>郊遊地點
Picnic Site</td><td>緊急求助
Emergency Helpline</td></tr>
<tr><td>1 紅梅谷自然教育徑
Hung Mui Kuk Nature Trail</td><td>停車場
Car Park</td><td>#設有位置參考號碼
Marked with local reference</td></tr>
<tr><td>2 鷹巢山自然教育徑
Eagle's Nest Nature Trail</td><td></td><td></td></tr>
<tr><td>山徑
Footpath</td><td></td><td></td></tr>
</table>

郊遊路綫

　　麥理浩徑第五段全長10.6公里，起點設在馬鞍山郊野公園，至沙田坳則進入獅子山郊野公園。獅子山郊野公園的一段全程均是山路，另有多處較為陡斜費力的路段。

　　衛奕信徑第五段全長7.4公里，大部分是平路，其餘的是下斜坡路，最宜初習行山人士。在十二笏村後之山脊高處，可俯瞰大圍及沙田一帶景色；引水道路段會經過紅梅谷自然教育徑及登望夫石的路口，遊人可順道遊覽。

　　鷹巢山自然教育徑位於大埔道四咪半附近，起點在九龍山郊野公園管理站側，是環山一周的環迴路綫。沿路所見的九龍水塘，是九龍區最早興建的水塘。這裏有野生獼猴聚居，遊人只應遠觀，切勿餵飼及騷擾。

　　麥理浩徑第六段由大埔公路起步，經過九龍水塘，沿金山路，迂迴越過數個山丘，經過金山後向西北進發，隨着孖指徑的山谷而行，走過戰時遺下的防綫，至城門水塘為終站。沿途既可觀賞各具風格的山勢，亦可想像當年戰況。衛奕信徑第六段亦由大埔公路開始，繞過九龍水塘北岸，與金山家樂徑路綫重疊，繼而沿孖指徑山脈通向城門水塘主壩，途上同樣可以飽覽優美風光。

　　金山家樂徑位於九龍水塘以北，從金山路步行約20分鐘，便到達此徑的起點，最宜一家大小短途漫步，沿途可飽覽九龍水塘、孖指徑、獅子山和部分海港景色。公園內設置兩條緩跑徑，分別環繞九龍接收水塘及石梨貝水塘而建，供熱愛運動的人士使用，兩徑長度相若，全程約需時25分鐘。金山樹木研習徑位於九龍水塘西南面及九龍副水塘的北面，入口設在金山路的九龍水塘大壩旁，樹徑全長1,150米，介紹沿途20種樹木。

見所

　　パークの名前のもととなったライオンロックが第一の見所です。ライオンロックはこの一帯が小さな漁村から国際都市へと変貌を遂げてきた様子をずっと見守ってきました。495メートルのこの山の特徴は西側の崖です。遠くから見るとそれはライオンが頭を西に向けて座り、香港を警備しているかのように見えます。

　　望夫石（アマーロック Amah Rock）は沙田の紅梅谷（Hung Mui Kuk）の上の海抜250メートルの小山でライオンロックの一部です。この不思議な形の岩には感動的な昔話があります。

　　ライオンロックの西の筆架山（Beacon Hill）は煙燉山（Smoke Mound）とも呼ばれかつては烽火台でした。清の時代、村人はそこから海賊や侵入者を迎え撃つための信号を発したと言われています。天気を知らせる信号所だったと言う話もありますが。香港気象台は今ではここに自動気象観測装置を設置しているので、この話の方が現在と関係深そうです。

　　金山カントリーパークは狭いのですが4つの貯水池があります。九龍貯水池（1910年完成）は新界で初めて作られた貯水池です。それに石梨貝（Shek Lei Pui）貯水池（1925年完成）、九龍接水（Kowloon Reception）貯水池（1931年完成）、そして九龍副（Kowloon Byewash）貯水池（1931年完成）です。

　　北部にある大戦時の遺跡は大きな見所です。かつての軍事基地の跡で地下トンネルでつながった塹壕や掩蔽壕があります。スマグラーズリッジの防衛綫の掩蔽壕は1930年代中頃に作られたものでほぼ無傷のままです。ただし安全のため遺跡の中には入らないように。

　　地元の人がモンキーヒルと呼ぶ金山は猿の王国として有名です。パーク内では猿が最大の哺乳類です。主な種

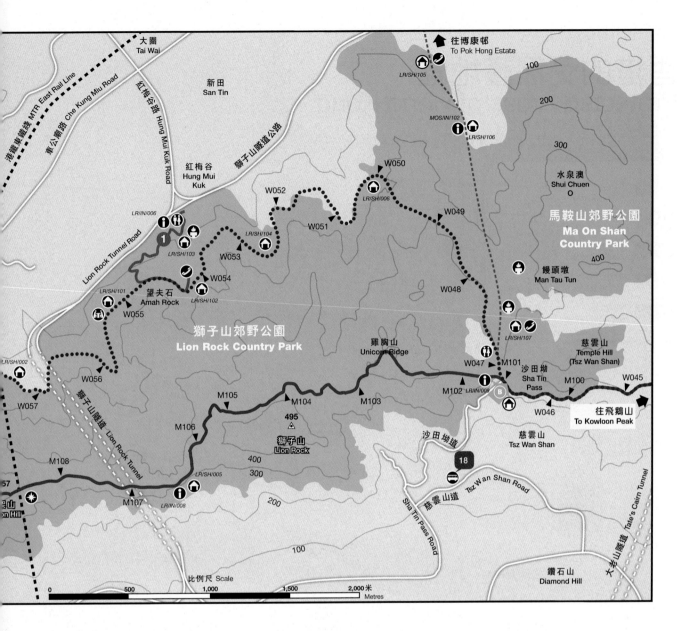

類は恆河猴（Rhesus Macaque）あるいは
長尾猿（尾長ざる longtailed Macaque）
で、もともとは捨てられたペットの末
裔です。

 ## 主要ルート

マクリホーストレイルのステ
イジ5　10.6キロは馬鞍山カントリー
パークから始まります。沙田パス経由
でライオンロックカントリーパークに
入るまでは大分距離があります。

ウィルソントレイルのステイジ5、
距離4キロはほぼ水平で素人にもやさし
いルートです。前半分は水平、後半分
は下りです。十二笏（Shap Yi Wat）村を
過ぎた稜線上からは大圍（Tai Wai）、沙
田、そしてトレイル沿いの導水路が見
えます。さらに下ると紅梅谷（Hung Mui
Kuk）自然径とアマーロックへ向かう道
があり、寄り道が出来ます。

大埔道4.5キロ付近にあるカオルー
ンヒル・カントリーパークのマネージ
メントセンターに鷹巣山自然教育径が
あります。丘をぐるぐる回るこのトレ
イルの始点と終点は同じ場所です。少
し行くと九龍最古の貯水池へ下る斜面
に目を奪われます。緑の楽園に野生の
猿の鳴き声が響いているのです。遠く
から見るだけにして餌を与えないでく
ださい。

この景色の良いルートでは様々な
形の山々が目を楽しませてくれます。
一帯の地形を眺めていると数十年前に
防衛軍がこの山中でどうやって防衛活
動をしたかが目に浮かぶようです。

ウィルソントレイルのステイジ6も
大埔道から始まります。九龍貯水池の
北側の土手を辿り、スマッグラーリッ
ジに合流してシンムン貯水池に向かい
ます。

九龍貯水池の北側にある家族径
は家族連れにぴったりの眺めの良い道で
す。石梨貝貯水池と九龍接水貯水池の
周りにはスポーツ愛好家のためのジョ
ギングコースがあります。自然愛好家
のためには金山樹木径もあります。

Attractions

Lion Rock, the 495m mountain,
is characterized by rugged escarpments on
the west side. Viewed from a distance, it
resembles a lion sitting regally with its head
facing west, as if to keep Hong Kong in
safe guard.

Amah Rock is a small knoll above
Hung Mui Kuk in Shatin. Rising about 250m
above the sea, it is one of the hillocks of
Lion Rock. This unusual rock is linked to a
moving tale.

香港的受保護地區
Protected Areas of Hong Kong

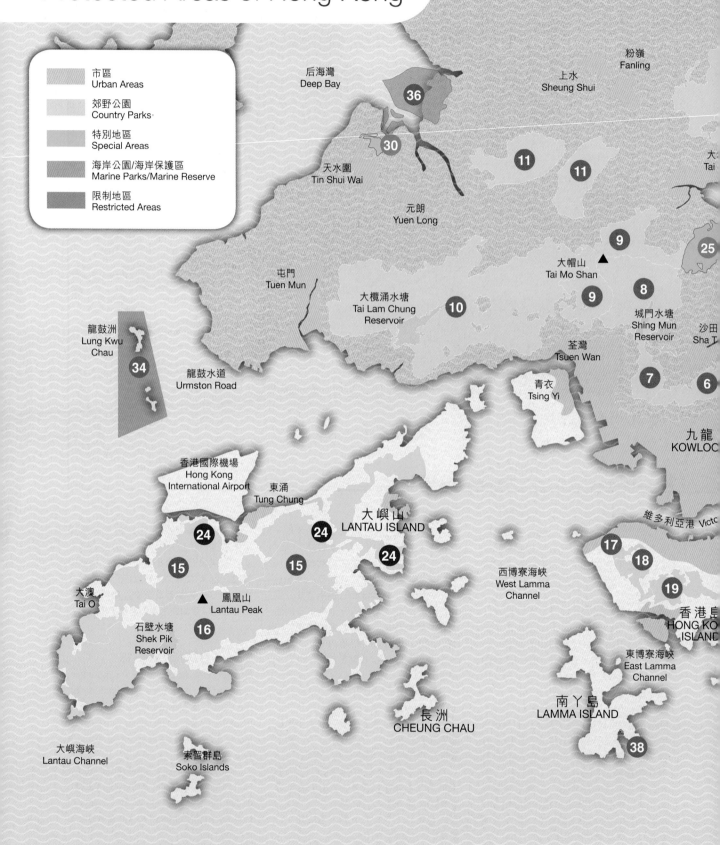

	市區 Urban Areas
	郊野公園 Country Parks
	特別地區 Special Areas
	海岸公園/海岸保護區 Marine Parks/Marine Reserve
	限制地區 Restricted Areas

后海灣
Deep Bay

粉嶺
Fanling

上水
Sheung Shui

36

30

天水圍
Tin Shui Wai

元朗
Yuen Long

11

11

9

25

大
Tai

大帽山
Tai Mo Shan

9

8

城門水塘
Shing Mun
Reservoir

沙田
Sha T

屯門
Tuen Mun

大欖涌水塘
Tai Lam Chung
Reservoir

10

荃灣
Tsuen Wan

7

6

龍鼓洲
Lung Kwu
Chau

34

龍鼓水道
Urmston Road

青衣
Tsing Yi

九龍
KOWLOC

香港國際機場
Hong Kong
International Airport

東涌
Tung Chung

大嶼山
LANTAU ISLAND

24

24

24

維多利亞港 Victo

17

18

15

15

19

大澳
Tai O

鳳凰山
Lantau Peak

西博寮海峽
West Lamma
Channel

香港島
HONG KO
ISLAND

石壁水塘
Shek Pik
Reservoir

16

東博寮海峽
East Lamma
Channel

長洲
CHEUNG CHAU

南丫島
LAMMA ISLAND

大嶼海峽
Lantau Channel

索罟群島
Soko Islands

38

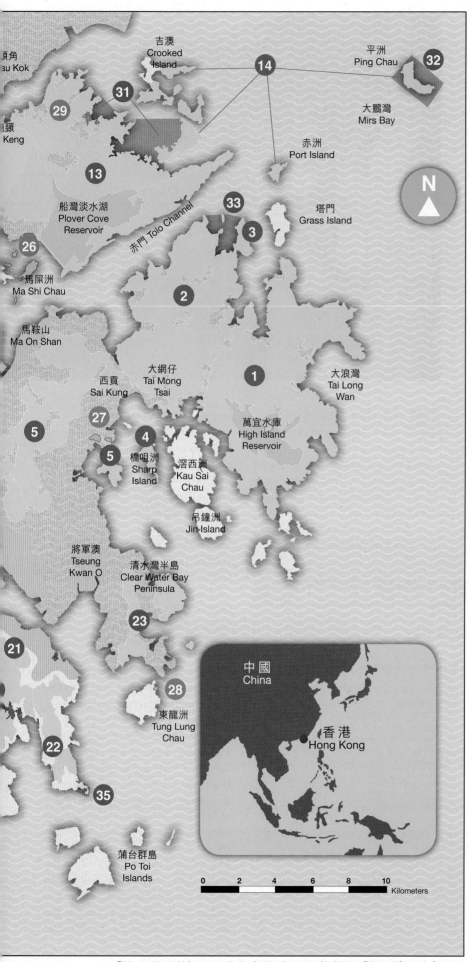

1	西貢東郊野公園 Sai Kung East Country Park
2	西貢西郊野公園 Sai Kung West Country Park
3	西貢西郊野公園（灣仔擴建部分） Sai Kung West Country Park (Wan Tsai Extension)
4	橋咀郊野公園 Kiu Tsui Country Park
5	馬鞍山郊野公園 Ma On Shan Country Park
6	獅子山郊野公園 Lion Rock Country Park
7	金山郊野公園 Kam Shan Country Park
8	城門郊野公園 Shing Mun Country Park
9	大帽山郊野公園 Tai Mo Shan Country Park
10	大欖郊野公園 Tai Lam Country Park
11	林村郊野公園 Lam Tsuen Country Park
12	八仙嶺郊野公園 Pat Sin Leng Country Park
13	船灣郊野公園 Plover Cove Country Park
14	船灣（擴建部分）郊野公園 Plover Cove (Extension) Country Park
15	北大嶼郊野公園 Lantau North Country Park
16	南大嶼郊野公園 Lantau South Country Park
17	龍虎山郊野公園 Lung Fu Shan Country Park
18	薄扶林郊野公園 Pok Fu Lam Country Park
19	香港仔郊野公園 Aberdeen Country Park
20	大潭郊野公園 Tai Tam Country Park
21	大潭郊野公園（鰂魚涌擴建部分） Tai Tam Country Park (Quarry Bay Extension)
22	石澳郊野公園 Shek O Country Park
23	清水灣郊野公園 Clear Water Bay Country Park
24	建議中之北大嶼郊野公園（擴建部分） Proposed Lantau North (Extension) Country Park
25	大埔滘自然護理區 Tai Po Kau Nature Reserve
26	馬屎洲特別地區 Ma Shi Chau Special Area
27	蕉坑特別地區 Tsiu Hang Special Area
28	東龍洲炮台特別地區 Tung Lung Fort Special Area
29	荔枝窩特別地區 Lai Chi Wo Special Area
30	香港濕地公園特別地區 Hong Kong Wetland Park Special Area
31	印洲塘海岸公園 Yan Chau Tong Marine Park
32	東平洲海岸公園 Tung Ping Chau Marine Park
33	海下灣海岸公園 Hoi Ha Wan Marine Park
34	沙洲及龍鼓洲海岸公園 Sha Chau and Lung Kwu Chau Marine Park
35	鶴咀海岸保護區 Cape D'Aguilar Marine Reserve
36	米埔 Mai Po
37	鹽灶下 Yim Tso Ha
38	深灣 Sham Wan

Beacon Hill (453m), also known as Smoke Mound, is at the west of Lion Rock. It was once a smoke signal station. According to legend, in the Qing Dynasty, villagers sent out warning signals from the hill to alert defending troops against pirates or invading enemies. Another version of Beacon Hill's origin is that it was a hilltop weather signal station. This may be closer to the present day situation as the Hong Kong Observatory has set up a meteorological station here as well.

The Kowloon Group of Reservoirs in Kowloon Peninsula is formed by 4 reservoirs: Kowloon Reservoir (completed in 1910), the first reservoir built in the New Territories; Shek Lei Pui Reservoir (completed in 1925); Kowloon Reception Reservoir (completed in 1926) and Kowloon Byewash Reservoir (completed in 1931).

Smugglers' Ridge is a long and narrow stretch of low ridge that extends all the way to Shing Mun Valley. There is a large area of wartime ruins in the northern part of the park. This key military position has a network of trenches and bunkers interconnected by underground tunnels. For their safety, visitors should not enter these sites.

Kam Shan, or Monkey Hill to most locals, is a famous macaques kingdom. Major species found here are Rhesus Macaque (*Macaca mulatta*) and Longtailed Macaque (*Macaca fascicularis*). These monkeys are probably descendants of individuals released by pet owners.

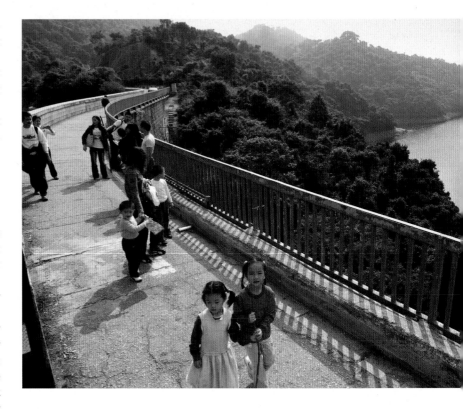

Major Routes

The 10.6km MacLehose Trail Stage 5 starting inside Ma On Shan Country Park enters Lion Rock Country Park via Sha Tin Pass. The path in this section is treacherous with some steep slopes uphill. The route is physically demanding.

7.4km Wilson Trail Stage 5 is largely level walk that is amateur friendly. The beginning section is all level, while the rest is made up of downhill sections. At a ridgetop high point after Shap Yi Wat Village, there is a broad view of Tai Wai, Shatin and the catchment section of the trail. Further up, there are turnings for the Hung Mui Kuk Nature Trail and Amah Rock, which you can make a detour to visit.

At 4½ miles Tai Po Road near the Kowloon Hills Country Park Management Centre, you find the Eagle's Nest Nature Trail. Orbiting the hills for one full circle, this trail begins and ends at the same point. A little further ahead, your gaze follows the slopes down to Kowloon Reservoir in the valley below. It is the oldest water storage facility in Kowloon. Here in this verdant haven wild macaques roam. These animals should be observed from a distance and should never be fed or disturbed.

Stage 6 of the MacLehose Trail makes a start at Tai Po Road and meanders up Golden Hill Road past Kowloon Reservoir. Negotiating its way across a series of knolls, it heads northwest after scaling the heights of Kam Shan. There, the trail cuts into the valley below Smugglers' Ridge, giving sights of wartime defense line ruins, and eventually ends at Shing Mun Reservoir. Along this scenic route, you feast your eyes with peaks and crests of different characteristics. Looking at the interesting topography, you can almost visualize how the defending

 前往方法・行き方・**HOW TO GET THERE**

金山郊野公園 Kam Shan Country Park

A 大埔道 *Tai Po Road*

乘坐港鐵至深水埗站，由D2出口經桂林街前往大埔道，經過嘉頓餅乾公司後，乘坐72、81或86B巴士，於石梨貝水塘巴士站下車，便可到達公園入口。

MTR の深水埗 (Sham Shui Po) D2出口を出て桂林街 (Kweilin Street) を通って大埔道 (Tai Po Road) へ。嘉頓餅乾 (Garden Biscuit Factory) を過ぎたら今は閉鎖されている北九龍裁判法院 (North Kowloon Magistracy) の反対側のバス停からバス72, 81 あるいは86で大埔道 (Tai Po Road) の公園入り口へ。公園を左手に見ながら進むと道は九龍浩塘 (Kowloon Reservoir) にぶつかる。

Take the MTR to Sham Shui Po (深水埗) station. Head for Exit D2 and walk up Kweilin Street (桂林街) to Tai Po Road (大埔道). After passing the Garden Biscuit Factory (嘉頓餅乾). Take buses 72, 81 or 86B up to the park entrance at Tai Po Road. Alight at Shek Lei Pui Reservoir bus stop to reach the park entrance.

獅子山郊野公園 Lion Rock Country Park

B 沙田坳 *Sha Tin Pass (p.39)*

乘坐港鐵至黃大仙站，在A出口的大廟旁邊轉乘18號專綫小巴，直達沙田坳總站。朝黃頂廟宇方向沿小路前行，約30分鐘後即抵沙田坳的麥理浩徑路口。

MTR黃大仙 (Wong Tai Sin) A出口を出た寺の横から緑のミニバス18で沙田坳道 (Sha Tin Pass Road) へ。黄色い瓦の寺をめがけて小道を登る。

Take MTR and get off at Wong Tai Sin (黃大仙). Use Exit A and get on green minibus 18 next to a large temple. This minibus takes you to the terminus at Sha Tin Pass Road (沙田坳道). Head for the yellow-roofed temple, follow the minor road and walk for 30 minutes to the Sha Tin Pass MacLeHose Trail junction (沙田坳).

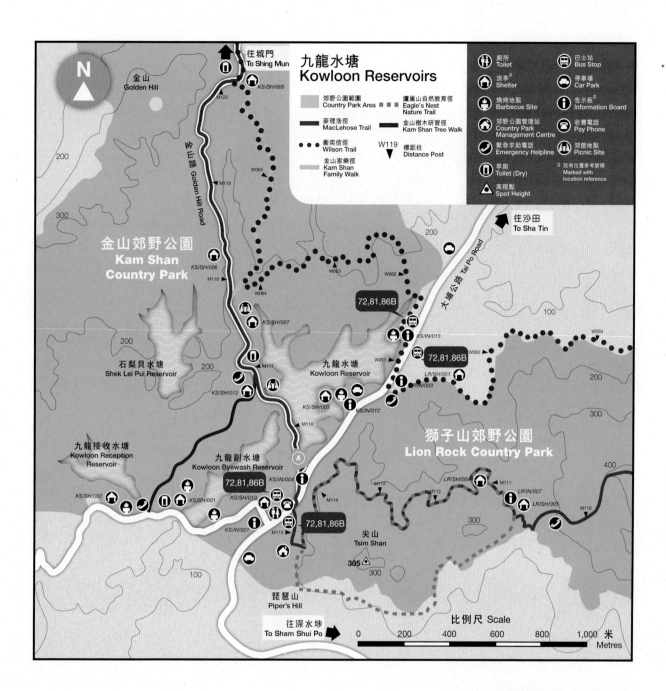

九龍水塘
Kowloon Reservoirs

郊野公園範圍 Country Park Area	鷹巢山自然教育徑 Eagle's Nest Nature Trail
麥理浩徑 MacLehose Trail	金山樹木研習徑 Kam Shan Tree Walk
衛奕信徑 Wilson Trail	W119 ▽ 標距柱 Distance Post
金山家樂徑 Kam Shan Family Walk	

Toilet — 廁所 / Toilet
涼亭 Shelter
燒烤地點 Barbecue Site
郊野公園管理站 Country Park Management Centre
緊急求助電話 Emergency Helpline
旱廁 Toilet (Dry)
巴士站 Bus Stop
停車場 Car Park
告示板 Information Board
收費電話 Pay Phone
郊遊地點 Picnic Site
設有位置參考號碼 Marked with location reference
高程點 Spot Height

往城門 To Shing Mun
金山 Golden Hill
金山路 Golden Hill Road
金山郊野公園 Kam Shan Country Park
石梨貝水塘 Shek Lei Pui Reservoir
九龍水塘 Kowloon Reservoir
往沙田 To Sha Tin
大埔公路 Tai Po Road
獅子山郊野公園 Lion Rock Country Park
九龍接收水塘 Kowloon Reception Reservoir
九龍副水塘 Kowloon Byewash Reservoir
尖山 Tsim Shan
琵琶山 Piper's Hill
往深水埗 To Sham Shui Po
72,81,86B

比例尺 Scale
0 200 400 600 800 1,000 米 Metres

troops manoeuvred in these hills many decades ago.

Stage 6 of the Wilson Trail also starts at Tai Po Road. Skirting around the north bank of Kowloon Reservoir, it overlaps with the Kam Shan Family Walk, before following the Smugglers' Ridge uplands to the main dam of Shing Mun Reservoir. Again, vistas along the way are truly captivating.

Kam Shan Family Walk lies north of Kowloon Reservoir. You arrive at the starting point after walking along Golden Hill Road for about 20 minutes. It is a short scenic route for the whole family. Here you can enjoy a view of Kowloon Reservoir, Smugglers' Ridge, Lion Rock and part of the harbour.

Orbiting the Kowloon Reception Reservoir and Shek Lei Pui Reservoir are two jogging trails. They are designed for sports enthusiasts and are of the same length. They take about 25 minutes to complete.

Kam Shan Tree Walk is located in southwestern side of Kowloon Reservoir and northern side of Kowloon Byewash Reservoir. Its entrance is at the main dam of Kowloon Reservoir in Golden Hill Road. 20 feature trees and plants feature in this 1,150m Tree Walk.

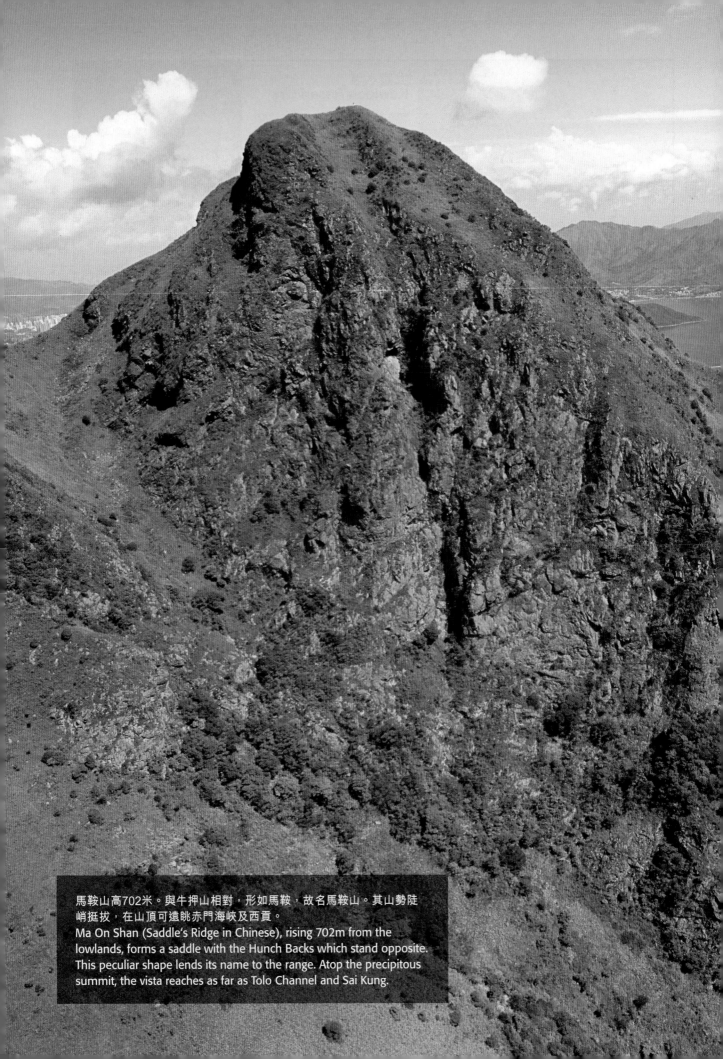

馬鞍山高702米。與牛押山相對，形如馬鞍，故名馬鞍山。其山勢陡峭挺拔，在山頂可遠眺赤門海峽及西貢。

Ma On Shan (Saddle's Ridge in Chinese), rising 702m from the lowlands, forms a saddle with the Hunch Backs which stand opposite. This peculiar shape lends its name to the range. Atop the precipitous summit, the vista reaches as far as Tolo Channel and Sai Kung.

馬鞍山郊野公園

馬鞍山
Ma On Shan Country Park

地圖
MAP — *p.47*

馬鞍山郊野公園位於西貢半島中部，佔地2,880公頃，由於包括馬鞍山的主要部分，因而得名。從公園的高處可遠眺海岸及離島的景色，其中的高山包括馬鞍山、牛押山、大金鐘、大老山及飛鵝山等。

西貢半島の中央部2,880ヘクタールを占める馬鞍山カントリーパークは広大な高原と山々からなる魅力的な地形です。パークの名前は奥深くに堂々と聳える馬鞍山の名前からつけられました。

Ma On Shan Country Park takes in 2,880 hectares of central Sai Kung Peninsula. It is named after Ma On Shan, the mountain range that sits largely inside the park. At many high points, sweeping views of coasts and islands feast your eyes. More prominent landmarks of the region are Ma On Shan, the Hunch Backs, Pyramid Hill, Tate's Cairn and Kowloon Peak.

郊野景點

馬鞍山高702米，是位列於大帽山之後的新界第二高峰，與牛押山相對，呈馬鞍形狀，故名馬鞍山。旅行人士將它分為馬鞍頭（即馬鞍山主峰）及馬鞍尾（牛押山），在新界多處都可以看見這個形狀突出的「馬鞍」。在馬鞍山的崎嶇斜坡上，間中可發現零星的稀有植物，如野生杜鵑、蘭花及一些鮮見的蕨類。

昂平是本港少有的高山平原。此處曾是繁盛的山村，相接廣闊的田野。在此遠眺西貢海一帶景色，令人心曠神怡；作為「看不到市區」的罕有高原，正是昂平最迷人之處。

馬鞍山廢礦場昔日盛產鐵礦，在1950年代的全盛時期，有多達二千多名採礦工人在此工作，直至1976年礦洞關閉，礦場才荒廢。馬鞍山村的村民，有很多就是當日的礦工及其家人。

郊遊路綫

馬鞍山地形峭拔，山路崎嶇難行，只適合有豐富遠足經驗者前往。由於東北面的登山路較難行，所以應由南面出發，經昂平高地登山較佳。在大金鐘西面山脈有幾條通往馬鞍山的小徑。走過高原草地後，再沿一條由砂礫堆砌而成的小徑，可登上馬鞍山之巔，這裏可飽覽由北面的赤門海峽至東面的西貢半島全景。

由衛奕信徑第四段的井欄樹出發，經樹木參天的古道西至沙田坳，途經馬鞍山郊野公園部分範圍，包括東洋山、飛鵝山、大老山等，全程需時約3小時。

麥理浩徑第四段則由水浪窩開始，經過大金鐘、昂平、水牛山、大老山等地，至著名的基維爾營地，沿途風光明媚，全程約需5小時。

馬鞍山郊遊徑從馬鞍山村開始，通往大水井，途經美麗的昂平，可俯覽西貢半島景色。路途上，山如其名的大金鐘、高達702米的馬鞍山及險峻的吊手岩就在北面前方巍然聳立；遠眺東面的西貢半島、蚺蛇尖、萬宜水庫、滘西洲和西貢海對出的橋咀洲——可辨。走至西貢大水井，便是郊遊徑的終點，全程需3.5小時。

企嶺下樹木研習徑位於西沙路旁的水浪窩，全長650米，介紹沿途20種樹木及植物。

 ## 見所

702メートルの馬鞍山は新界では大帽山に次ぐ2番目の高さです。　牛押山の反対側に聳える馬鞍山の名前は馬の鞍の形をした稜綫から名付けられました。ハイカーは鞍頭（馬鞍山主峰）、鞍尻（牛押山）と呼んでいます。馬鞍山の印象的な姿は新界の多くの地点から望見できます。このパークは西貢半島と沙田を区切る境界と言う特別な位置にもあります。北東面の姿が最も有名で危険に満ちています。

昂平（Ngong Ping）は香港では数少ない高原の一つです。かつては大きな村があり端の方には米の畑がありました。西貢海（Inner port Shelter）の海岸や島々の広々とした眺めが広がります。また、昂平は高地でありながら市街の姿が全く見えない、香港と言う小さな世界の中では実に珍しい場所です。

馬鞍山カントリートレイルは馬鞍山村と古い鉱山を通ります。かつてここでは鉄鉱石が採れました。1950年代のブームの折にはここで2,000人以上の鉱夫が働いていました。1976年に閉山され廃鉱となりました。今では鉱夫と家族は馬鞍山村に住んでいます。

主要ルート

馬鞍山は大変急峻な山として有名で登山道は厳しく健康で経験のある人しか登れません。

トレイルは多種多様でウィルソントレイルのステイジ4は井欄樹（Tseng Lan Shu）から始まります。樹木におお

われた道は古い道を通って沙田パスまで続きます。3時間ほどかかります。

マクリホーストレイルのステイジ4は水浪窩（Shui Long Wo）から始まります。道は上下を繰り返し大金鐘、昂平、水牛山（Buffalo Hill）、大老山（Tate Cairn）を通って基維爾営地（Gilwel）にいたります。5時間ほどかかります。

馬鞍山カントリートレイルは馬鞍山村から大水井（Tai Sui Tseng）にいたる眺めの良い道です。途中昂平高原を通り西貢半島の素晴らしい眺めを楽しめます。大金鐘、馬鞍山、吊手岩（Tiu Shau Ngam）等の三角形の山々が次々と姿を見せます。東には西貢半島、シャープピーク、ハイアイランド貯水池、カイサウチャウ島、シャープ島等々がはっきりと見えます。3.5時間半ほどかかります。

650メートルの企嶺下樹木径は水浪窩から始まり20種類の樹木の解説板があります。

 ## 前往方法・行き方・HOW TO GET THERE

A 馬鞍山郊野公園 Ma On Shan Country Park

在馬鞍山新港城乘坐鄉村小巴 NR84，可直達馬鞍山。亦可在鑽石山港鐵站乘搭 92 號巴士，或於彩虹乘 1A 小巴往西貢墟，再轉乘 3 號小巴往菠蘿輋，郊野公園入口距小巴總站約 10 分鐘步程。

村のミニバスで新港城（Sunshine City）から馬鞍山（Ma On Shan）へあるいは MTR の彩虹（Choi Hung）の C 出口からミニバス 1A、MTR 鑽石山（Diamond Hill）C2 出口からバス 92 で西貢（Sai Kung）方面へ西貢墟（ウェルカム＋マックの前 Sai Kung Town）でミニバス 3 に乗り換え菠蘿輋（Po Lo Che）へ。パーク入り口はミニバス駅から徒歩 10 分ほど

Take a village minibus NR84 from Sunshine City to Ma On Shan（馬鞍山）. Alternatively, take bus 92 from Diamond Hill（鑽石山）MTR station or minibus 1A from Choi Hung（彩虹）to Sai Kung（西貢）. Then take minibus 3 to Po Lo Che（菠蘿輋）. The entrance is about 10 minutes from the minibus terminus.

Attractions

Ma On Shan, rising 702m above sea level, is the second highest peak in the New Territories, ranking just after Tai Mo Shan. Standing opposite to the Hunch Backs, Ma On Shan gets its Chinese name from the saddle-shaped passes, known to hikers as the "head saddle" (the Ma On Shan main peak) and "end saddle" (the Hunch Backs). Ma On Shan's striking profile is visible from many parts of the New Territories. Rare flora species, such as wild rhododendrons, orchids and uncommon ferns, grow on the precipitous slopes of Ma On Shan.

Ngong Ping is one of Hong Kong's few plateaus. Once the site of a large village, it has paddy fields on the fringes. There are wide open views of the coves and islands of Inner Port Shelter. Another unique feature of Ngong Ping is that it is one of the very few high points where the urban districts are

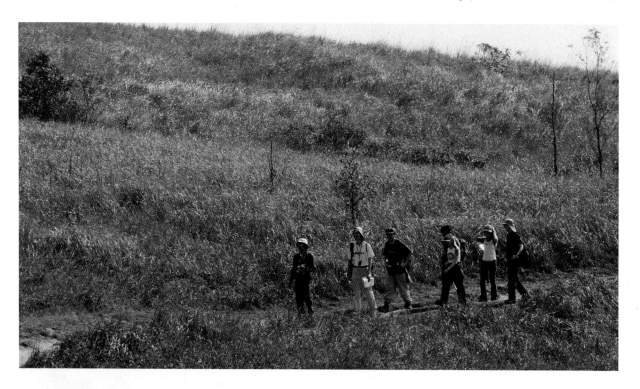

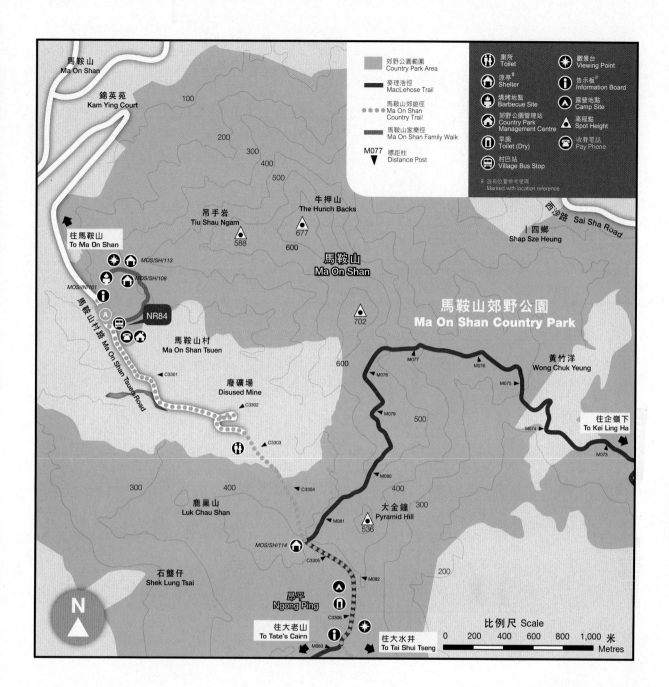

totally out of sight. A rare quality indeed in a city as compact as Hong Kong.

Iron ore was a major product of old Ma On Shan mine in the past. During the 1950s boom, more than 2,000 miners worked here. After closure of the pits in 1976, the mine was abandoned. Today, many of these former miners and their families live in Ma On Shan Village.

Major Routes

Ma On Shan is famous for its treacherous terrain, with rugged hill trails conquerable by the fit and experienced only. The uphill route from the northeastern side is difficult. The trail in the south via Ngong Ping plateau provides an easier route to the summit. There are many paths to Ma On Shan on the west of Pyramid Hill. After passing through the grassland on the plateau, follow the sand-paved footpath towards the top of Ma On Shan. At the summit, there are broad views from Tolo Channel in the south to Sai Kung Penisula in the east.

Stage 4 of the Wilson Trail is a hiking trail that starts at Tseng Lan Shue. This hike takes about 3 hours to complete.

Stage 4 of the MacLehose Trail begins at Shui Long Wo in Kei Ling Ha. The trail winds up and down the uplands of Pyramid Hill, Ngong Ping, the Hunch Backs, Tate's Cairn and the nearby region, and ends in Gilwell Campsite of Tate's Cairn. It is a 5-hour hike.

The Ma On Shan Country Trail is a scenic route that leads from Ma On Shan Village to Tai Shui Tseng. The trail passes through the grassy Ngong Ping Plateau where you enjoy a sweeping view of Sai Kung Peninsula. Along the trail, the conical profile of Pyramid Hill, the 702m Ma On Shan and the treacherous Tiu Shau Ngam emerge one by one in the north. To the east, Sai Kung Peninsula, Sharp Peak, High Island Reservoir, Kau Sai Chau and Sharp Island (Kiu Tsui) in Inner Port Shelter come clearly into view. Up ahead, the trail ends at Tai Shui Tseng in Sai Kung. This hike takes about 3.5 hours to complete.

The 650m Kei Ling Ha Tree Walk starts at Shui Long Wo and provides information on 20 feature trees and plants.

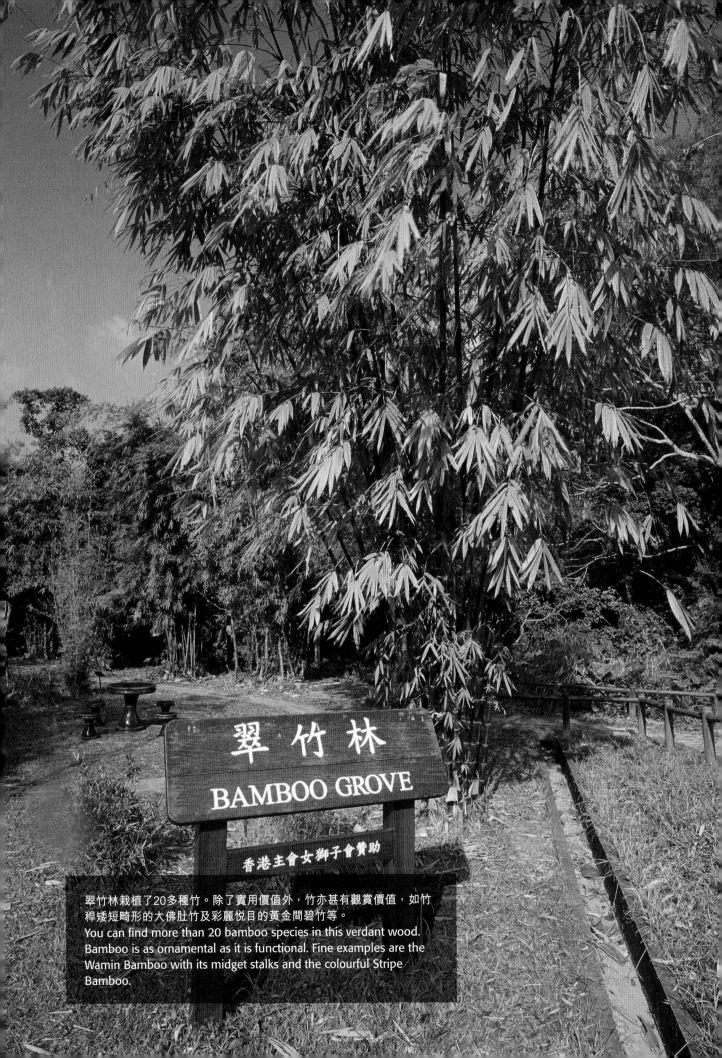

翠竹林
BAMBOO GROVE

香港主會女獅子會贊助

翠竹林栽植了20多種竹。除了實用價值外，竹亦甚有觀賞價值，如竹稈矮短畸形的大佛肚竹及彩麗悅目的黃金間碧竹等。
You can find more than 20 bamboo species in this verdant wood. Bamboo is as ornamental as it is functional. Fine examples are the Wamin Bamboo with its midget stalks and the colourful Stripe Bamboo.

獅子會自然教育中心

ライオンズクラブ自然教育センター
Lions Nature Education Centre

地圖
MAP *p.51*

郊野景點
中心的低谷有小型耕地和農圃，展出各類農作物和植物標本，另有園林展區、展覽館和其他趣味盎然的景點。特別適合一家大小參觀，中心的中草藥園展出本港500多種野生的藥用草本植物。蜻蜓池長滿水生植物，設有傳意牌介紹生態資料。

中心有不少值得參觀的展覽館，當中包括專題介紹本港生態的兩大展館。在昆蟲館可了解昆蟲習性，貝殼館則展出琳瑯滿目的美麗貝殼。此外的三個展覽館分別以本港漁業、農業及保護自然環境為主題。

郊遊路綫
看過展品和展覽後，不妨沿自然教育徑攀上谷頂，沿途別忘記閱讀傳意牌，以加深對本地動植物的認識。在嶺上回望，可見西貢和巍峨聳立的馬鞍山，盡顯香港郊野的動人魅力。

獅子會自然教育中心四周綠樹成蔭，其中的園林區展出各類植物標本，另有展覽館和其他趣味景點。

中心所在地位於西貢墟以南，佔地約16公頃，昔日曾是政府農場，鑒於自然保育價值甚大，於1987年正式劃為蕉坑特別地區，其後於1991年獲得獅子會贊助，成立自然教育中心。

ライオンズクラブ自然教育センターは深い森に囲まれた緑の殿堂です。造林園には各種の植物標本があり、それ例外にも興味深い展示があります。

ライオンズクラブ自然教育センターは西貢マーケットの南にありかつては政府所有の16ヘクタールの農園でした。1987年、蕉坑（Tsiu Hang）地区が自然保護の価値ありとして特別区に指定され、その後1991年にライオンズクラブの寄付を得て今日のセンターになりました。

見所
平地の小さな耕地と農園が農作物と植物標本を作り出しています。果樹園と植物園もあって家族連れにふさわしい展示がされています。薬草園もあって香港で見つかった500種類以上の野性の薬草が植えられています。トンボ池には水草が豊富でトンボが生き生きと過ごしています。生態情報を伝

Lions Nature Education Centre is a green sanctuary fringed with sylvan woodlands. The specimen orchard and arboretum exhibit an extensive flora collection. There are many other exhibition galleries and interesting attractions.

Lions Nature Education Centre is located south of Sai Kung Town. The 16-hectare site was formerly a government farm. In 1987, Tsiu Hang was declared a Special Area for its significant nature conservation value. Later in 1991, with donation from Lions Club, it became today's Nature Education Centre.

える解説板もあります。

展示館は教育用で香港の野生生物を紹介する2つの施設があります。昆虫館ではセンターが実施している昆虫の習性観察について学べます。貝殻館では美しい海の貝のコレクションが見られます。その他三つの展覧館があって、香港の漁業、農業、そして自然環境保護の実態について解説しています。

主要ルート
展覧施設を見たあと自然教育道を通って谷を登ります。途中香港の動植物について書かれた解説板を読みましょう。丘に登ると西貢の海と雄大な馬鞍山の眺めが広がります。その雄大さと壮麗さで香港の郊野は人を魅了し続けることでしょう。

Attractions
Small agricultural fields and terraces in the lowlands feature an assortment of farm crops and plant specimens. There are also a specimen orchard and aboretum, different exhibition galleries and other interesting sights well suited for family visitors. Also

前往方法・行き方・HOW TO GET THERE

A 獅子會自然教育中心 Lions Nature Education Centre

在鑽石山港鐵站C2出口乘搭92號巴士，或於彩虹港鐵站C2出口乘坐1A專綫小巴前往西貢，於北港巴士站下車，對面便是獅子會自然教育中心。

MTRの彩虹（Choi Hung）のC2出口からミニバス1A、あるいはMTR鑽石山（Diamond Hill）C2出口からバス92で西貢（Sai Kung）方面へ途中、北港（Pak Kong）で下車。道の反対側が獅子會自然教育中心（Lions Nature Education Centre）

Take bus 92 from Diamond Hill（鑽石山）MTR station Exit C2 or geen minibus 1A from Choi Hung（彩虹）MTR station Exit C2 to Sai Kung（西貢）. Alight near Pak Kong（北港）. The Lions Nature Education Centre（獅子會自然教育中心）is right opposite.

worth exploring is the Chinese herbal garden with more than 500 wild Chinese herbs found in Hong Kong. The dragonfly pond is a vibrant dragonfly habitat rich in aquatic plants. There are interpretation plates providing ecological information.

The exhibition galleries in the centre are highly educational. These include two major halls that feature Hong Kong wildlife, an insectarium where you can learn about the habitual behaviour of insects, and a shell house with an impressive collection of beautiful sea shells. Three other exhibition galleries showcase thematic

exhibits of Hong Kong's fishing industry, farming industry and natural environment conversation respectively.

Major Routes
After seeing the exhibits and live specimens, follow the nature trail to the top of the valley. Don't forget to read the interpretation plates along the way to gain more knowledge of local flora and fauna. The hilltop gives splendid vistas of Sai Kung and the magnificent massif of Ma On Shan. With all its grandeur and splendour, Hong Kong's countryside never fails to captivate.

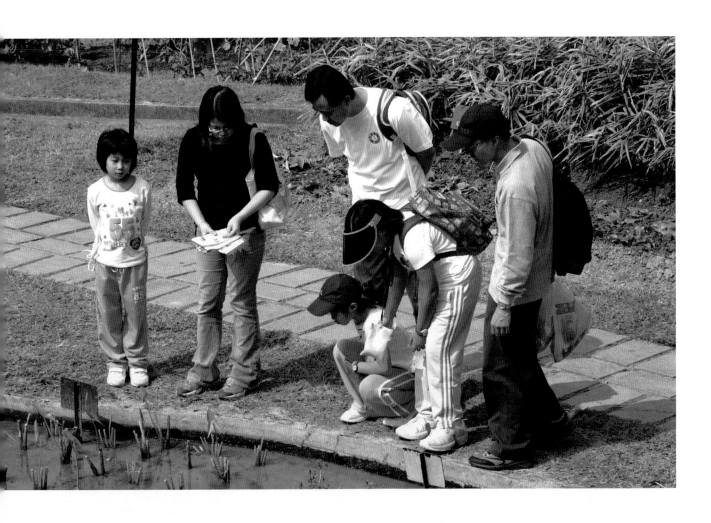

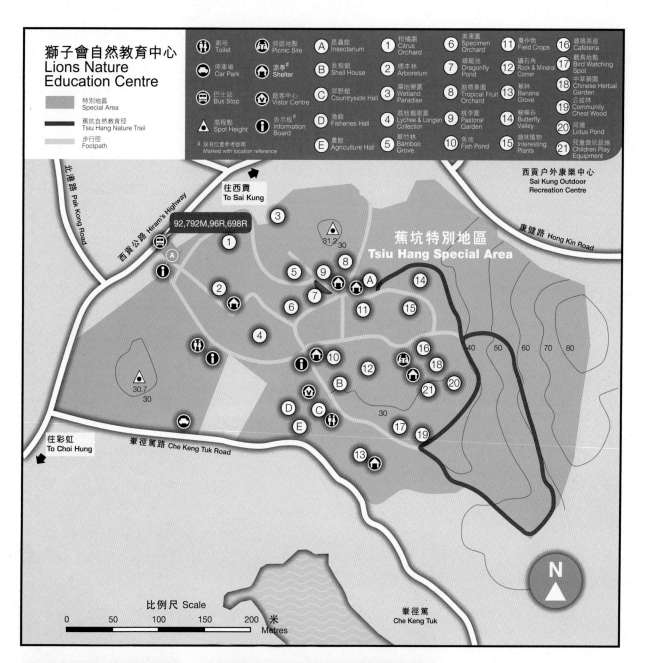

獅子會自然教育中心
Lions Nature Education Centre

特別地區
Special Area

蕉坑自然教育徑
Tsiu Hang Nature Trail

步行徑
Footpath

廁所 Toilet	郊遊地點 Picnic Site	A 昆蟲館 Insectarium	1 柑橘園 Citrus Orchard	6 美果園 Specimen Orchard
停車場 Car Park	涼亭# Shelter	B 貝殼館 Shell House	2 標本林 Arboretum	7 蜻蜓池 Dragonfly Pond
巴士站 Bus Stop	遊客中心 Vistor Centre	C 郊野館 Countryside Hall	3 濕地樂園 Wetland Paradise	8 熱帶果園 Tropical Fruit Orchard
高程點 Spot Height	告示板# Information Board	D 漁館 Fisheries Hall	4 荔枝龍眼園 Lychee & Longan Collection	9 桃李園 Pastoral Garden
		E 農館 Agriculture Hall	5 翠竹林 Bamboo Grove	10 魚池 Fish Pond

設有位置參考號碼
Marked with location reference

11 農作物 Field Crops
12 礦石角 Rock & Mineral Corner
13 蕉林 Banana Grove
14 蝴蝶谷 Butterfly Valley
15 趣味植物 Interesting Plants
16 聽鳴茶座 Cafeteria
17 觀鳥地點 Bird Watching Spot
18 中華桑園 Chinese Herbal Garden
19 公益林 Community Chest Wood
20 荷塘 Lotus Pond
21 兒童遊玩設施 Children Play Equipment

北港路 Pak Kong Road
西貢公路 Hiram's Highway
往西貢 To Sai Kung
西貢戶外康樂中心 Sai Kung Outdoor Recreation Centre
康健路 Hong Kin Road
92,792M,96R,698R
31.2 30
蕉坑特別地區
Tsiu Hang Special Area
往彩虹 To Choi Hung
30.7 30
窩徑篤路 Che Keng Tuk Road
40 50 60 70 80
30
窩徑篤 Che Keng Tuk

比例尺 Scale
0 50 100 150 200 米 Metres

N

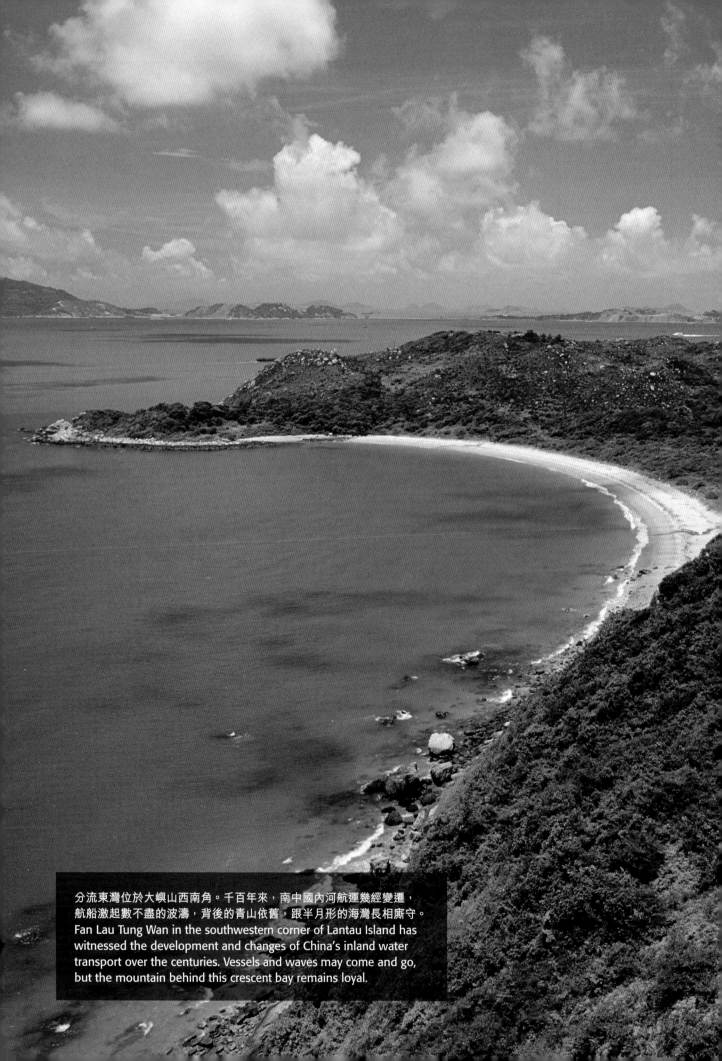

分流東灣位於大嶼山西南角。千百年來，南中國內河航運幾經變遷，
航船激起數不盡的波濤，背後的青山依舊，跟半月形的海灣長相廝守。
Fan Lau Tung Wan in the southwestern corner of Lantau Island has
witnessed the development and changes of China's inland water
transport over the centuries. Vessels and waves may come and go,
but the mountain behind this crescent bay remains loyal.

北大嶼郊野公園及
南大嶼郊野公園

北大嶼 ランタオ北部 &
ランタオ南部
Lantau North and
South Country Parks

地圖
MAP *p.55 & p.57*

北大嶼郊野公園於1978年成立,面積2,200公頃,範圍包括大東山、二東山、蓮花山、鳳凰山北坡,以及彌勒山、昂坪以北等地。

　　南大嶼郊野公園於同年成立,為全香港最大的郊野公園,總面積達5,640公頃。著名景點包括分流炮台、鳳凰山、石壁水塘、芝麻灣石林等。

ランタオ北カントリーパークは2,200ヘクタール、1978年に指定されました。大東山(Sunset Peak)、二東山(Yi Tung Shan)、蓮花山(Lin Fa Shan)、鳳凰山(Lantau Peak)北斜面、弥勒山(Nei Lak Shan)、昂坪(Ngong Ping)北部をカバーしています。

　　ランタオ南部カントリーパークは1978年に指定され、5,640ヘクタールのランタオ最大のパークです。名勝地としては分流砲台、芝麻湾岩場、ランタオピークの日の出があります。

Lantau North Country Park was designated in 1978. Occupying a total area of 2,200 hectares, it encompasses Sunset Peak, Yi Tung Shan, Lin Fa Shan, northern slopes of Lantau Peak, Nei Lak Shan and the region north of Ngong Ping.

　　Lantau South Country Park was designated in the same year as the largest country park in the territory, occupying 5,640 hectares. Famous sights include Fan Lau Fort, Lantau Peak, Shek Pik Reservoir, Chi Ma Wan rock formation.

郊野景點

　　位處北大嶼郊野公園的山谷環境清幽,由昂坪高原可循遠足徑進入東涌谷,沿途盡見天然林木及流水淙淙的溪澗,更有不少蜻蜓、淡水魚及兩棲動物棲息其中。

　　大嶼山自古以來扼守南中國河流的出口交通要衝,在島上所發現的古跡,均顯示新石器時代已有人類在南部居住。位於芝麻灣半島二浪灣的古代石灰窰可供遊人參觀。第一座在十八世紀初建於大嶼山西南尖端的分流炮台,至今已廢棄多年,其遺址雖然野草叢生,但仍然清晰可見。

　　石壁水塘儲水量達2,446萬立方米。只要站在昂坪高原上,便可以俯瞰整個水塘。

郊遊路綫

　　北大嶼郊野公園東面的黃龍坑郊遊徑,全長2.3公里,走畢全程需時約1小時45分,被稱為全港最崎嶇的郊遊徑。起點由二東山開始,終點則在東涌黃龍坑道,路程雖短,可是前半段山路陡峭,加上苔蘚濕滑,故此難度極高。

大嶼山 | Lantau

地塘仔郊遊徑則平緩易走，起步點不遠處便是「鳳東飛流」，前行一段再回望，東面是大東山，東北是石獅山和禾寮墩，北面為東涌沖積平原。平原上支流密布，十多條村落盡收眼底。

法門古道以東山法門為起點，沿途經寶林寺、羅漢寺、石門甲、石榴埔、黃家圍，最後到達馬灣涌碼頭，全程約6.5公里。遊人在欣賞山水之餘，切記不可喧嘩，以免礙人清修。

鳳凰徑貫穿整個郊野公園，遊人可以由梅窩出發，經二東山、大東山、伯公坳、鳳凰山、昂坪、羌山、萬丈布、大澳、二澳、分流、石壁、水口半島、貝澳、十塱回到梅窩，全長70公里，共分為12段。

鳳凰山是南大嶼郊野公園內的最高山峰，高934米，是本港登山人士的旅遊勝地。昂坪奇趣徑全長2.5公里，當中另闢一條350米長的「樹徑」，種有20種本地野生植物，最適合一家大小和熱愛植物的遊人前來觀賞。環繞芝麻灣半島一周的芝麻灣郊遊徑為全港最長的郊遊徑。

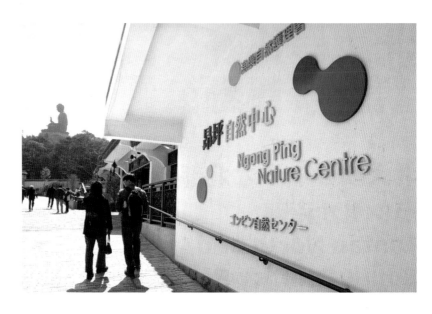

見所

東涌谷(トンチョンTung Chung Valley)はハイキングに格好の目的地です。超近代的なチェックラップ空港とトンチョンニュータウンとは対照的な静かな谷は魅惑的な天国です。この緑の神殿を訪れるにはゴンピンからカントリートレイルを歩くのがよいでしょう。途中森を通り、流れを横切りますがそこには、ランタオの主役、トンボ、淡水魚、両生類等々が成育しています。

ランタオ島はその地理上の位置のせいで昔から香港南方水域の船の出入りの警護の要衝とされてきました。古代の遺跡から南ランタオには新石器時代から人が住み着いていたことが知られています。政府はつい最近二浪湾と芝麻湾半島の古代石灰窯の復元作業を終え、公開しました。

18世紀初頭には広東総督の命令で一連の砦が建設され沿岸警備のために軍隊が駐屯しました。最初の砦は島の南西端の分流(Fan Lau)に設置されまし

た。何年も前に放棄され今では草におおわれています。

石壁(Shek Pik)貯水池は2,446万㎡ありハイアイランド、プルバコーブに次ぎ香港で第3位の大きさの貯水池です。全体を眺めるにはゴンピンに登るのが良いでしょう。

主要ルート

ランタオ北カントリーパーク東部の黄龍坑(Wong Lung Hang)カントリートレイルは悪名高い難路です。長さ2.3キロ、1時間45分で歩けるのですがハイカーの間では香港で最も困難なルートと言われています。二東山(Yi Tung Shan)の中腹から東涌の黄龍坑(Wong Lung Hang)道までの下りです。下りで距離が短いからと馬鹿にしてはいけません。最初の半分はほとんど日が射さないうっそうたる森の中の急な階段です。大変急で苔の生えた道にしっかり足を踏ん張るのが大変です。

地塘仔(Tei Tong Tsai)カントリートレイルは平坦で歩き易い道です。ト

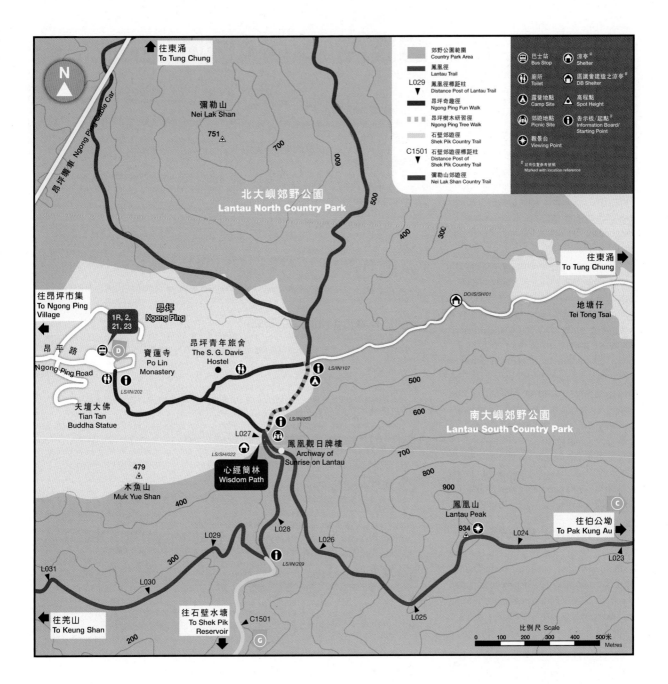

ンチュン道の伯公坳 (Pak Kung Au) の峠から北へ800メートルほどの出発点から200メートルで東ランタオ川の鳳東飛龍 (Fung Tung Waterfall) にぶつかります。ランタオピークの北東面をほとばしり落ちる急流です。飛び散るしぶきは空気を清浄にし、急な流れは見る者に生気を与え、世俗の悩みを洗い流してくれます。さらに300メートルほど行くと特徴的な突出した稜綫を越えます。ここからは北ランタオの荒々しい地形が見えます。東を見れば荘厳な大東山 (Sunset Peak)、北東には石獅山 (Shek Sze Shan)、禾寮墩 (Wo Liu Tun) が聳えています。北ではトンチュンの沖積平原が海沿いにおだやかな様子でたたずんでいます。まとまりなく広がった川

の支流と点在する村落がこの平地の特徴です。

6.5キロの法門 (Hun Men) 古道はゴンピンの東山法門 (Dong Shan Fa Mun) から始まります。寶林寺 (Po Lam Monastery)、石門甲 (Shek Mun Kap)、石榴埔 (Shek Lau Po)、黄家圍 (Wong Ka Wai) と下って馬湾涌 (Ma Wan Chung) フェリー埠頭で終わります。道は森におおわれすがすがしい雰囲気です。香港国際空港が見え、古い寺院も訪問できます。詩的な風景を楽しむ折には騒音をたてないようにしましょう。

ランタオトレイルはカントリーパークをくまなく辿るハイキングルートです。ムイオから始まり周回する形で、二東山、大東山、伯公坳、鳳凰山、昂

坪、羌山 (Kau Shan)、萬丈布、大澳 (Tai O)、二澳、分流、石壁、水口半島、貝澳 (Pui O)、十ロンを経てムイオに戻ります。総延長70キロ、12のステイジに分けられています。

ランタオピークはこのカントリーパークの最高峰で934メートルあります。頂上はハイカーの憧れで日の出を見るために暗い中を登って行きます。最も良い方法はゴンピンのホステルで夜を過ごし、まだ暗い内に出発して夜明けまでに頂上にたつことでしょう。

ゴンピン奇趣径は初心者に適した2.5キロの平坦で広い道です。45分で歩けます。この道沿いに350メートルの樹木道があり20種類の原産の稀少種や珍奇種の樹木が植えられています。家族

連れや植物愛好者には最適の道です。

ランタオ島の南東のはずれにある芝麻湾半島を一周するカントリートレイルは一帯で最も長いトレイルです。

Attractions

Tung Chung Valley is a choice destination. To visit this green sanctuary, get on the country trail that begins in Ngong Ping. This enjoyable walk passes through woodlands and streams where a host of dragonflies, freshwater fish and amphibians breed and feed.

From ancient remains, we know South Lantau was first inhabited in the Neolithic Age. The Government has recently finished restoring a group of ancient lime kilns in Yi Long Wan in Chi Ma Wan Peninsula. These relics are now open to the public. In the early 18th Century, by order of the Governor of Canton, a series of forts were built. The first fort was placed in Fan Lau at the southwestern tip of the island. Abandoned many years ago, the remains are now overgrown with grass.

Shek Pik Reservoir in Lantau South Country Park has a capacity of 24.46 million m$^3$. For a panoramic view of Shek Pik Reservoir, climb up to Ngong Ping Plateau.

Major Routes

Wong Lung Hang Country Park Trail in the eastern part of Lantau North Country Park is a famously challenging hike. Rated the most difficult country trail in Hong Kong by hikers, this 2.3km route takes about 1 hour 45 minutes to complete. Beginning

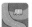
南大嶼及北大嶼郊野公園 Lantau Country Parks

梅窩 Mui Wo

可由中環六號碼頭乘搭渡輪前往，約45分鐘一班。航程時間視乎風向而定，約需1小時，快船則只需半小時左右。

セントラルの離島第6埠頭から連絡船で梅窩(Mui Wo)へ。大型船は45分、ホバージェットは30分ほどで到着。

From Pier 6 in Central take the ferry to Mui Wo（梅窩）. Departures approximately every 45 minutes. The journey takes around an hour depending on the prevailing wind speed. The fast hover-jets will take slightly more than half hour.

南山 Nam Shan

由梅窩巴士站乘坐任何路綫的巴士，在南山站下車。這裏設有郊遊地點、避雨亭、地圖板及公廁。

梅窩(Mui Wo)からどのバスでも可。3つ目の停留所で下車。南山ピクニックエリアにあり雨避け小屋、地図、トイレもある。

Take any bus from the Mui Wo（梅窩）bus station. Get off at the Nam Shan bus stop. This entrance is right at the Nam Shan（南山）picnic area with a rain shelter, mapboard and toilet block.

C 伯公坳 Pak Kung Au (p.55)

在東涌乘搭前往大嶼山南部的巴士，於東涌道的最高點伯公坳站下車。亦可由梅窩乘搭往東涌方向的巴士，在同一地點下車。由於東涌道為雙向單程路，故此偶有延誤及須予等候，情況在週末尤甚。

東涌(Tung Chung)から南へ向かうバスはどれでも可。東涌路(Tung Chung Road)の最高点、伯公凹(Pak Kung Au)で下車。これとは逆に梅窩(Mui Wo)から東涌(Tung Chung)にいたるバスでも可。東涌路(The Tung Chung Road)はこの2つの町を結ぶ唯一の道路で週末には渋滞がひどい。現在道路の新設、拡幅工事が行われており工事関係の車両の通行も多い

Take any bus from Tung Chung（東涌）bound for southern Lantau and get off at Pak Kung Au（伯公坳）, the highest point of Tung Chung Road（東涌道）. Alternatively, get on any bus from Mui Wo（梅窩）heading for Tung Chung（東涌）and get off at Tung Chung. The Tung Chung Road（東涌道）is a single track road serving traffic of both directions. Please at allow for delays and waiting especially on weekends.

D 昂坪 Ngong Ping (p.55)

可在東涌港鐵站旁乘坐纜車，或在東涌或梅窩乘搭前往昂坪(寶蓮寺)的巴士。

最も便利な方法は東涌駅の隣から出るケーブルカー。代わりの経済的方法は東涌(Tung Chung)あるいは梅窩(Mui Wo)から寶蓮寺(Po Lin Monastery)へ行くバス

Take the cable car which departs from beside Tung Chung（東涌）MTR Station. Alternatively, take any bus from Tung Chung（東涌）or Mui Wo（梅窩）to Ngong Ping Po Lin Monastery（寶蓮寺）.

E 深屈 Sham Wat

乘坐任何前往大澳或昂坪的巴士，經過大澳道交界處，在深屈道站下車，回頭走片刻即到達公園入口。

大澳(Tai O)あるいは昂平(Ngong Ping)向けのバスに乗り、大澳道(Tai O Raod)との交差点を過ぎ、ランタオトレイルの案内板があるところで下車。入り口まで少し戻る。

Take any bus bound for Tai O（大澳）or Ngong Ping（昂坪）. Get off at the Sham Wat bus stop after passing the junction with Tai O Road. You need to walk back a short distance to get to the entrance.

F 大澳 Tai O

東涌或梅窩均有巴士前往大澳，每逢星期日及公眾假期，更可自屯門慧豐園渡輪碼頭乘船至此。

大澳(Tai O)行きバスは東涌(Tung Chung)、梅窩(Mui Wo)どちらからもあり。日曜祝日には屯門(Tuen Mun)の海上公園からフェリーサービスもあり

Take a bus from either Tung Chung（東涌）or Mui Wo（梅窩）. On Sundays and public holidays, you may also take a ferry from the Marina Garden Ferry Pier of Tuen Mun（屯門）.

G 石壁 Shek Pik

自梅窩和東涌駛往大澳或昂坪的巴士均會途經石壁水塘，在經過水壩之後，在石壁站下車。巴士站設在公廁旁邊。

大澳(Tai O)あるいは昂坪(Ngong Ping)向けのバスはいずれも石壁水塘(Shek Pik Reservoir)に停車。ダムを過ぎてから下車。すぐそばにトイレあり。

Buses heading towards Tai O（大澳）or Ngong Ping（昂坪）from Mui Wo（梅窩）and Tung Chung（東涌）all have to pass the Shek Pik Reservoir（石壁水塘）. Get off the bus after passing through the dam. The bus stop is next to a public toilet.

H 水口 Shui Hau

乘搭任何前往大澳或昂坪的巴士，在水口村下車，前行5分鐘，路徑起點設有地圖板。

大澳(Tai O)あるいは昂平(Ngong Ping)向けのバスに乗り水口村(Shui Hau Village)で下車。5分ほど前方に歩くと案内地図板のところからトレイルが始まる。

Board any bus bound for Tai O（大澳）or Ngong Ping（昂坪）, and alight at Shui Hau Village（水口村）. Walk ahead for about 5 minutes. The trail starts at a mapboard on the inland side of the road.

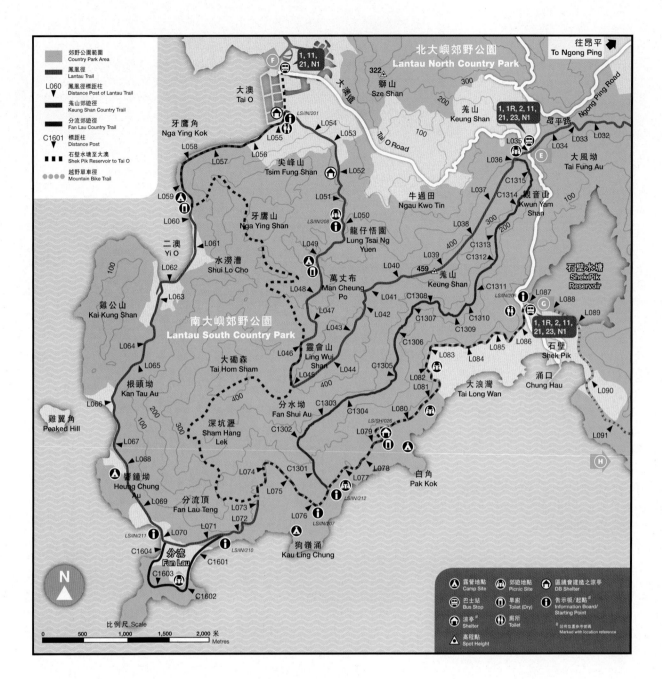

at Yi Tung Shan, it descends to Wong Lung Hang Road in Tung Chung. Don't let its short distance fool you, for the first half of the trail is all treacherous steps and the dense forest canopy almost completely blocks out sunlight. The going is tough and securing a steady footing on the moss-covered ground is a major challenge.

The Tei Tong Tsai Country Trail is a level easy walk. Not far from the starting point, you find East Lantau Stream, a rushing cascade plunging down from the northeastern face of Lantau Peak. Looking east, you see the majestic Sunset Peak. Looking northeast, Shek Sze Shan and Wo Liu Tun surge above the lowlands. Looking north, the Tung Chung alluvial plain lies peacefully on the coast. The plain is marked by a sprawling network of tributaries and rural hamlets.

The 6.5km Fa Mun Traditional Path starts at Dong Shan Fa Mun. It trails through Po Lam Monastery, Lo Han Monastery, Shek Mun Kap, Shek Lau Po and Wong Ka Wai to end at the Ma Wan Chung Ferry Pier. The nearby woodlands and ravines harbour many monasteries and religious recluses. Visitors should remember to keep quiet while enjoying the poetic scenery.

The Lantau Trail is a hiking route that traverses the entire breadth of the country park. You can start your hike in Mui Wo, and embark on a circular route that visits Yi Tung Shan, Sunset Peak, Pak Kung Au, Lantau Peak, Ngong Ping, Keung Shan, Man Cheung Po, Tai O, Yi O, Fan Lau, Shek Pik, Shui Hau Peninsula, Pui O and Shap Long, before heading back to Mui Wo. The 70km Lantau Trail is divided into 12 sections.

Lantau Peak is the highest peak in Lantau South Country Park. The 934m summit is a mecca for local hikers. The Ngong Ping Fun Walk is a 2.5km scenic path suitable for hiking beginners. The Agriculture, Fisheries and Conservation Department has built a 350m Tree Walk along the Fun Walk. Planted along the walk are 20 native wild plants. This walk is a choice destination for families and plant lovers. Chi Ma Wan Country Trail that orbits the peninsula is the longest trail of its kind in the territory.

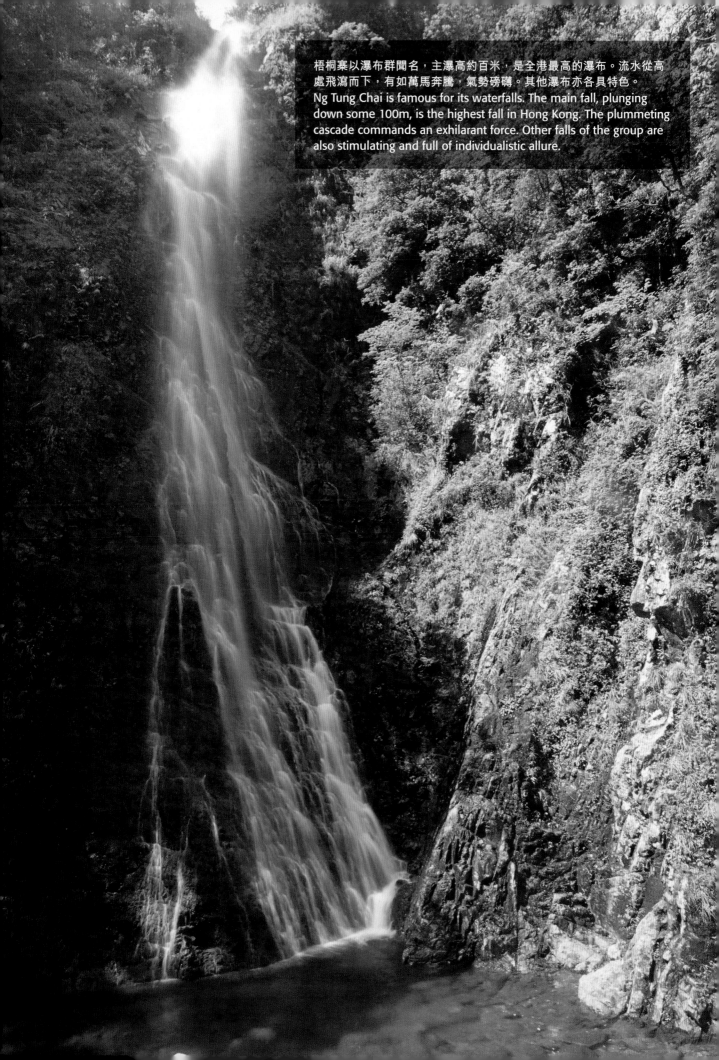

梧桐寨以瀑布群聞名，主瀑高約百米，是全港最高的瀑布。流水從高處飛瀉而下，有如萬馬奔騰，氣勢磅礡。其他瀑布亦各具特色。
Ng Tung Chai is famous for its waterfalls. The main fall, plunging down some 100m, is the highest fall in Hong Kong. The plummeting cascade commands an exhilarant force. Other falls of the group are also stimulating and full of individualistic allure.

大帽山郊野公園、大欖郊野公園及林村郊野公園

大帽山（タイモー）、大欖（タイラム）＆林村（ラムツェン）
Tai Mo Shan, Tai Lam and Lam Tsuen Country Parks

 地圖 **MAP**—*p.62-p.63*

大帽山高達957米，是香港最高的山峰。佔地1,440公頃的大帽山郊野公園物種豐富，單是雀鳥已有超過100種的記錄。

　　大欖郊野公園位於新界西部，於1979年成立，佔地5,370公頃，是全港面積第二大的郊野公園，範圍廣及荃灣至屯門地區。該郊野公園所在之處昔日幾乎寸草不生，經歷多年的自然演替及植林工作，現今所見，各種樹木蔚然成林，一片青翠。

　　林村郊野公園位於新界北部，佔地1,520公頃，成立於1979年，橫跨大埔、粉嶺及元朗三區，被粉錦公路分隔為大刀岃及雞公嶺兩部分。

957メートルのこの山は香港最高峰です。1979年にこの山を含む1,440ヘクタールがタイモー山カントリーパークに指定されました。

　　新界の西部5,370ヘクタールを占めるタイラムカントリーパークは香港で第2の大きさのカントリーパークです。1979年に指定され荃灣（ツェン湾 Tsuen Wan）から屯門（ツェンムン Tuen Mun）までの広大な地域にわたっています。数十年前まではタイラムカントリーパーク一帯はわずかな植物しかない禿山で雨水でひどく浸食されていました。植林専門家の長年にわたる熱心な作業のおかげで今日見られるような緑が次第に成育し、多くの種類の木々が公園のあらゆる部分で見られるようになりました。

　　新界北方に位置する林村（Lam Tsuen）カントリーパークは1979年に指定され大埔（タイポ Tai Po）、粉嶺（ファンリン Fanling）、元朗（ユンロン Yuen Long）の3区、1,520ヘクタールを占めています。パークは粉嶺（Fan Kam）道により大刀岃（Tai To Yan）と鶏公嶺（Kai Kung Leng）の二つの山域に分かれています。

Standing 957m, Tai Mo Shan is Hong Kong's highest peak. Enveloping this massif is 1,440 hectares of natural territory, designated in 1979 as the Tai Mo Shan Country Park. Tai Mo Shan is a haven for a great variety of wildlife, with more than 100 bird species recorded.

Occupying 5,370 hectares of sylvan grounds in the western New Territories, Tai Lam Country Park is the second largest country park in Hong Kong. Designated in 1979, it encompasses a vast area extending from Tsuen Wan to Tuen Mun. A few decades ago, Tai Lam Country Park was a barren domain with scanty vegetation. Thanks to years of dedicated work of afforestation experts, the lush vegetation we see today slowly emerged and many tree species have colonized most parts of the park today.

Lam Tsuen Country Park is situated in the northern New Territories. Designated in 1979, it commands a total area of 1,520 hectares that spans over Tai Po, Fanling and Yuen Long. The park is divided into two parts by Fan Kam Road: Tai To Yan and Kai Kung Leng.

郊野景點

大帽山的雨量是香港之冠，雨水流進溪澗，飛瀉而下，匯聚成梧桐寨群瀑。其中的主瀑高約100米，是全港最高的瀑布；另外尚有散髮瀑、中瀑及井底瀑等。公園的郊遊設施主要集中在扶輪公園一帶，從觀景台可飽覽荃灣、青衣、港島區及大帽山附近一帶的景色。位於大帽山道的郊野公園遊客中心在星期六、日及公眾假期開放。

大欖郊野公園內大大小小的水塘及聚水塘共七個，景致各具特色。該公園毗鄰屯門及深井，是新界西居民的熱門郊遊地點。甲龍至河背水塘引水道、大棠山及麥理浩徑第十段一帶均設有燒烤場地，其中大棠山及石崗燒烤場為區內學校的旅行熱點。田夫仔、河背及荃錦坳則設有露營地點。

遊人到林村郊野公園，大多是慕大刀屻之名而來。顧名思義，大刀屻是險峰，山脊猶如刀刃，山路窄且險，兩邊山勢陡峭，中央只有一條窄路，若在「刀刃」上遇上強風，便難免會有一絲搖搖欲墜的心理壓力。

郊遊路綫

欲一遊大帽山頂峰，可沿大帽山道車路步行而至。天朗氣清時，在觀景台可俯瞰幾乎所有新界西部及北部地方，以及元朗和八鄉平原全景，甚至遠及內地的蛇口和深圳。大帽山家樂徑大部分由碎石鋪成，寬闊平坦，適合一家大小漫步遊覽。川龍家樂徑途經蒼翠的紅膠木林及竹林，在山丘頂上可遠望大欖及大帽山郊野公園植林區的景色。遠足研習徑是一條循環路徑，全程約1公里，需時30分鐘，是學習遠足技巧的理想地方。

在登上大刀屻的山徑上，可遠眺元朗平原及林村谷等壯麗景色，但相當費力難行，只適合有遠足經驗者前往。

若論郊遊路綫的數量，大欖郊野公園為全港眾郊野公園之冠，共達12條之多，其中最為人熟悉的是麥理浩徑第九及第十段。此外，公園內修建了甲龍林徑及甲龍古道，途中可觀賞多種樹木。荃錦自然教育徑、大欖自然教育徑、大棠自然教育徑、大棠樹徑及河背水塘家樂徑都是適合一家大小前往的路綫；元荃古道郊遊徑、大欖涌郊遊徑及圓墩郊遊徑則為精力充沛者而設。在郊野公園西面的屯門徑提供14個健身站，供遊人及晨運人士鍛練身體。

見所

またタイモー山の雨量は香港最大で雨は急流となり急峻な峡谷が斜面に深く食い込み梧桐寨(Ng Tung Chai)の連続滝となって落下します。この有名な滝の中心部は100メートルもあり香港最長です。これ以外に散髪滝(Scatter Falls)、中滝(Middle Falls)、井底滝(Bottom Falls)と呼ばれる部分もあります。一帯の歴史、地質、生態についての知識を得たいのであれば休日にオープンするタイモウ山道にあるビジターセンターに行って見ましょう。展示ケースには地元の動植物が展示されています。

7つの貯水池と集水池がタイラムカントリーパークののどかな水辺の風景を生み出しています。

屯門(ツェンムンTuen Mun)や深井(Sham Tseng)にほど近いタイラムカントリーパークはハイカーやピクニック

の人気の的です。甲龍(Kap Lung)、河背(Ho Pui)の導水路沿い、大欖(タイラム Shan)、ツェンムンにはバーベキュー場があります。ツェンムンではマクリホーストレイルステイジ10が横切ります。中で大棠山(Tai Tong Shan)、石崗(Shek Kong)バーベキュー場は地元の生徒のお気に入りの場所です。キャンプが好きなら田夫仔(Tin Fu Tsai)、河背(Ho Pui)、荃錦坳(Tsuen Kam Au)等にキャンプ場があります。

　中国語の名前の通り大刀屻は刀の刃のように鋭い稜線を持った危険な山です。登山路の両側は眼もくらむほどに切れ落ち、狭くて危険です。稜線通しの不安定な唯一の道には隠れる場所も無く風の強い日には大変神経を使います。神経の細い人にはとてもお勧めできないルートです。

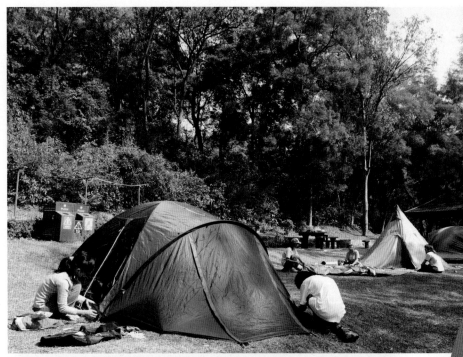

主要ルート

　タイモー山へはタイモー山道を通って車で登れます。晴れた日には新界の北部や西部、元朗(ユンロン Yun Long)、八郷(Pat Heung)平原までもが見渡せます。蛇口(Shekou)や深圳(シンセン Shenzen)まで見える日も有ります。タイモウ山家族径は家族連れのハイキングに適した平坦な砂利道です。タイモー山ロータリーパークから始まり香港郊外になじみの深い樹木におおわれています。川龍(Chuen Lung)家族径は紅膠木(Brisbane Box)や竹やぶに囲まれた森の道です。この道の最高点からは大欖(タイラム Tai Lam)とタイモー山の植林地帯が遠くに見えます。タイモー山ハイキング練習徑はわずか1キロの周回ルートで30分で終わります。バーベキュー場や森の中を通ります。フィットネステスト板やハイキングの基本知識を書いた解説板などがあります。こうしてハイキングの基礎を学べばハイキングはより楽しくなります。

　タイラムはランタオ南カントリーパークに次ぐ大きなカントリーパークです。ハイキングルートとなるとその数は他を寄せ付けません。有名なマクリホーストレイルのステイジ9 10を含む12のトレイルがあります。

　体力と元気のある人には元荃(Yuen Tuen)古代径、タイラムカントリートレイル、元荃(Yuen Tuen)カントリートレイルがふさわしいでしょう。タイラムカントリーパークの西端にはツェンムン区議会が設置したツェンムントレイルがあります。ハイカーや朝の散歩者のために14の体操場があります。

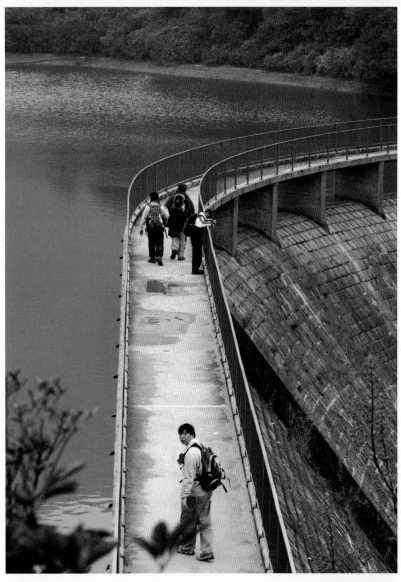

A 大帽山郊野公園 Tai Mo Shan Country Park

乘坐港鐵至荃灣站，在A出口左轉上大河道天橋，轉乘51號巴士至荃錦坳，在郊野公園巴士站下車後，再往荃灣方向步行數十米左轉入大帽山道，便到達大帽山郊野公園入口。

MTR荃灣A出口を出てすぐ左に曲がり大河道（Tai Ho Road）へ出、バス51で荃錦坳（Tsuen Kam Au）方面へ。峠の上、「元朗（Yuen Long）へようこそ」と書かれた看板のところで下車。タクシーだとここまで$50ほどM156脇の郊野公園管理站（Country Parks Management Centre）の横のゲートを通り、通行制限されている森の道にはいる

Leave Tsuen Wan (荃灣) MTR station by Exit A, then turn left and walk up to Tai Ho Road (大河道) bridge. Catch bus 51 to Tsuen Kam Au (荃錦坳). After getting off at the Country Park bus stop, walk along Tai Mo Shan Road to the park entrance.

大欖郊野公園 Tai Lam Country Park

B 大棠 Tai Tong

由朗屏乘輕鐵接駁巴士K66，或在元朗紅棉圍乘坐小巴前往大棠山道巴士站下車，然後沿大棠山道上行30分鐘，即到達公園入口。

LRTのバスK66で朗屏（Long Ping）から大棠（Tai Tong）へ。あるいは元朗シティー・モールからミニバスで大棠（Tai Tong）へ。大棠山道を30分ほど登ってゆくと公園入口。

Take LRT feeder bus K66 from Long Ping (朗屏) or minibus from Yuen Long Hung Min Court to Tai Tong. Get off at Tai Tong Shan Road bus stop and walk along Tai Tong Shan Road uphill for about 30 minutes to the park entrance.

C 馬鞍崗 Ma On Kong

由市區乘搭往元朗或相反方向的68M、68X、69M、69X、269B或269D巴士，在大欖隧道轉車站下車。

元朗からバス68M、68X、69M、69X、269Bまたは269Dで大欖（Tai Lam）トンネルを越え最初の停留所へ。

Take buses 68M, 68X, 69M, 69X, 269B or 269D from urban areas to Yuen Long (元朗) or vice versa, get off at Tai Lam (大欖) Tunnel bus interchange.

林村郊野公園 Lam Tsuen Country Park

於大埔墟或太和東鐵站乘64K巴士至嘉道理農場暨植物園，沿對面馬路的小徑步行至大刀岃。回程可沿箕勒仔經蓬瀛仙館出粉嶺東鐵站，或經營盤村往粉錦公路乘車至上水或元朗。

タイポマーケットあるいはタイオMTR駅からカドーリー農場行き64Kバスに乗車。道路反対側の小道が大刀岃へと登ってゆく。帰りには箕勒仔ケ蓬瀛僊館経由で粉嶺駅まで歩ける。あるいは営盤村を経て粉錦道に出れば上水或いは元朗へのバスやタクシーが有る。

Get on bus 64K for Kadoorie Farm and Botanic Garden at the Tai Po Market or Tai Wo MTR Station. The small path opposite the road will take you up Tai To Yan. For your return journey, you can walk from Kei Lak Tsai to Fanling MTR Station via Fung Ying Seen Koon, or opt for the shorter route to Fan Kam Road via Ying Pun Village. Public transport to Sheung Shui and Yuen Long is available on Fan Kam Road.

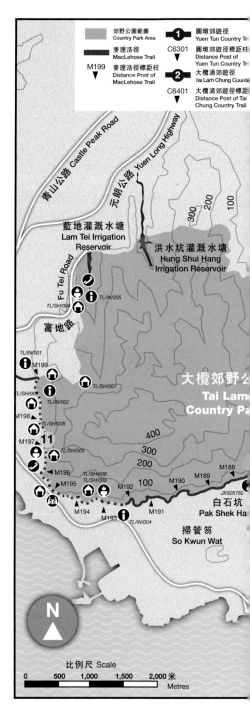

ラムツェンカントリーパーク内のトレイルはどれも急で厳しく元気で経験のある人にしか適しません。稜綫の上からはユンロン平原の広大な眺めとラムツェン谷の眺めが楽しめます。

 Attractions

At Tai Mo Shan, rainwater rushing streams and sheer gullies cut forcefully down the slopes and merge into the Ng Tung Chai Waterfalls. The 100m Main Fall, a famous section of the Ng Tung Chai Waterfalls, has the highest drop of all. Other sections are the Scatter Fall, Middle Fall and Bottom Fall. For a general perspective of the region's history, geology and ecology, call at the Tai Mo Shan Country Park Visitor Centre on Tai Mo Shan Road open on public holidays, Sundays & Saturdays.

The idyllic waterscapes of Tai Lam Country Park are made up of 7 reservoirs and settlement basins. Only a stone's throw away from Tuen Mun and Sham Tseng, Tai Lam Country Park is a hot destination for hikers and picnickers. There are barbecue areas in the Kap Lung and Ho Pui catchments, Tai Tong Shan and Tuen Mun which Stage 10 of MacLehose Trail traverses. Among these, the most sizeable Tai Tong Shan and Shek Kong Barbecue Area is a favourite field trip destination for local schools. You will find camp sites in Tin Fu Tsai, Ho Pui and Tsuen Kam Au.

Most hikers visit Lam Tsuen Country Park for the famous summit of Tai To Yan.

As its Chinese name implies, Tai To Yan is a treacherous peak with razor sharp ridges and crags. The ascent is narrow and hazardous, with dizzying escarpments on both sides. The only pathway along the ridge is precarious and highly exposed. It could be quite nerve-wrecking to take it on windy days. Definitely not a route for the faint-hearted.

Major Routes

The summit of Tai Mo Shan is accessible by the vehicular Tai Mo Shan Road. On clear days, the lookout gives a spectacular panoramic view of the northern and western New Territories, as well as the Yuen Long and Pat Heung plains. You can even see Shekou and Shenzhen on the Mainland on good days. Tai Mo Shan Family Walk is a level gravel path suitable for family hikes. Chuen Lung Family Walk is a wooded path dressed by pockets of Brisbane Box (*Lophostemon confertus*) and lush bamboo

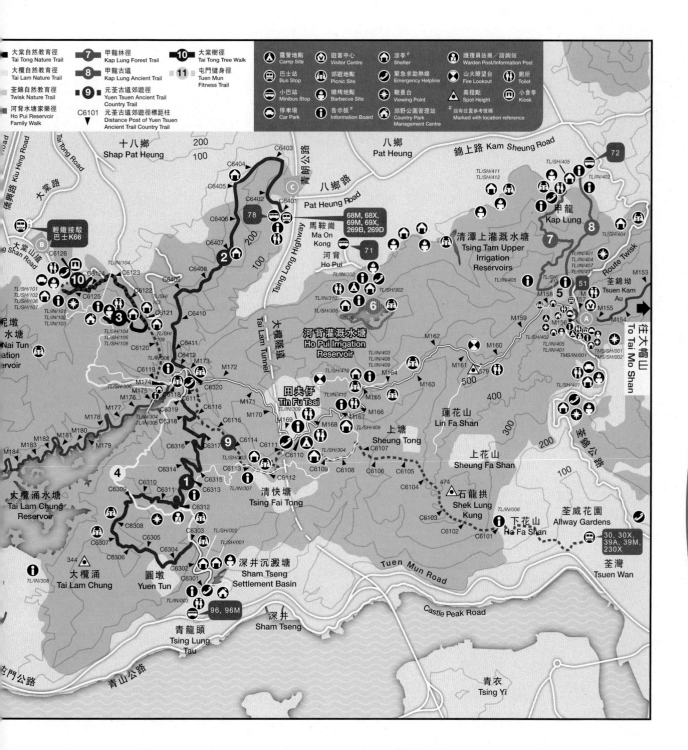

groves. The Tai Mo Shan Hiking Practice Trail is a 1km circular route that takes only 30 minutes to complete. With such a lovely setting to train for essential skills, hiking is more pleasurable than ever.

Tai Lam is the second largest country park in Hong Kong, ranking just after the most expansive Lantau South Country Park. When it comes to the number of hiking routes, however, no other park comes close. There are twelve trails within the boundaries of Tai Lam Country Park, including the well trodden Stage 9 and Stage 10 of MacLehose

Trail. Two other popular hiking routes are Kap Lung Forest Trail and Kap Lung Ancient Trail. Passing through diverse woodlands, these trails introduce you to the wonderful world of forest ecology. Also worth exploring are easy family routes like the Twisk Nature Trail, Tai Lam Nature Trail, Tai Tong Nature Trail, Tai Tong Tree Walk and Ho Pui Reservoir Family Walk. For the fit and energetic, check out the Yuen Tsuen Ancient Trail Country Trail, Tai Lam Chung Country Trail and Yuen Tun Country Trail. On the western edge of Tai Lam Country Park, you find the Tuen Mun

Trail. This route features 14 fitness stations for hikers and morning walkers.

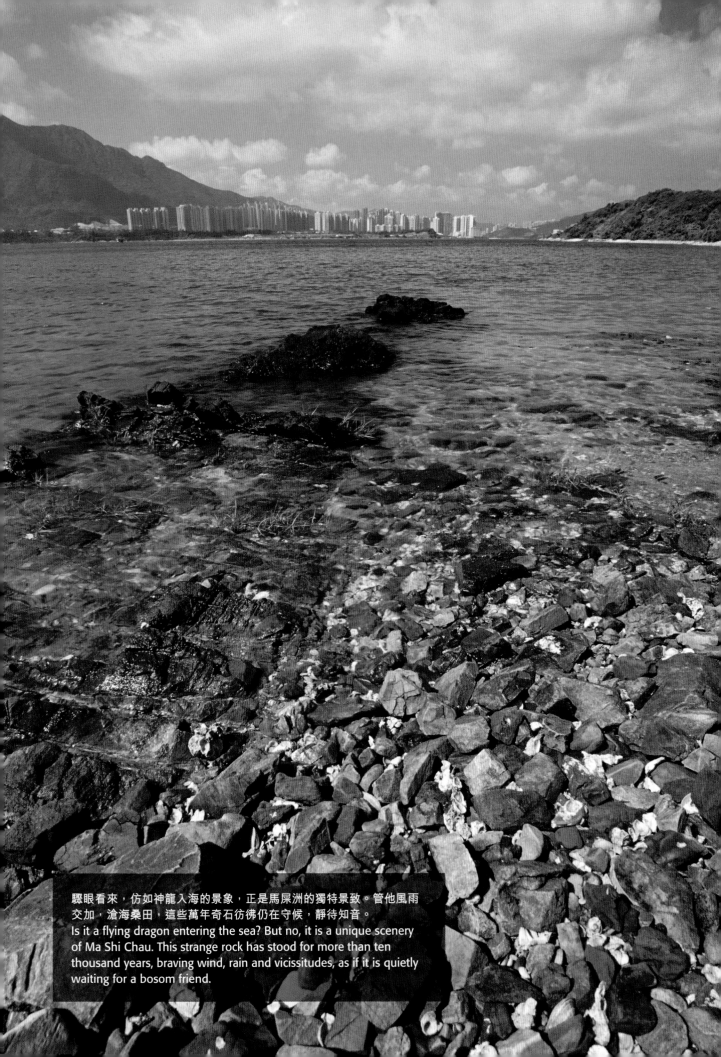

驟眼看來，仿如神龍入海的景象，正是馬屎洲的獨特景致。管他風雨交加，滄海桑田，這些萬年奇石彷彿仍在守候，靜待知音。
Is it a flying dragon entering the sea? But no, it is a unique scenery of Ma Shi Chau. This strange rock has stood for more than ten thousand years, braving wind, rain and vicissitudes, as if it is quietly waiting for a bosom friend.

船灣郊野公園、荔枝窩特別地區及馬屎洲特別地區

船湾（プロバーコーブ）荔枝窩特別区及馬屎洲岩石特別区
Plover Cove Country Park, Lai Chi Wo Special Area and Ma Shi Chau Special Area

 地圖
MAP — *p.68–p.69*

位於香港東北面的船灣郊野公園建於1978年，面積達4,594公頃，三面臨海，中央山巒重疊，西接山勢雄奇的八仙嶺郊野公園；北面的擴建部分則於1979年劃定，範圍包括印洲塘一帶的小島，是香港最美麗的海岸地區之一。

位於吐露港內的馬屎洲特別地區擁有多姿多采的地質及地貌特徵，是愛好奇岩怪石人士的好去處。

荔枝窩位處新界東北，毗鄰船灣郊野公園及印洲塘海岸公園，區內的一片風水林已於2004年12月劃定為特別地區。這裏有典型的客家村落，亦有茂密的闊葉樹林、紅樹林、泥灘及溪流，更有形態奇特的古樹，例如「通心樹」和「五指樟」，交織成多樣化的生態環境。

香港の北東に位置するプロバーコーブカントリパークは1978年に指定されました。4,594ヘクタールあり3方で海に面し、中央部にはゆるやかな山なみが続く対照的な地形を包含しています。西側には眼もくらむような峨々たる山なみで有名な八仙嶺カントリーパークが有ります。1979年には北側のエクステンションが指定され、そこには香港で最も美しい海岸が続く印洲塘（Yan Chau Tong）があります。

吐露湾の馬屎洲（Ma Shi Chau）岩石特別区には多様な地質構造と地形があります。の三つの宝はその独特の魅力で人を魅了します。

新界の北東はるかに奥に位置する荔枝窩特別区はプルバーコーブカントリーパークと印洲塘（Yan Chau Tong）海洋公園に隣接するいかにも田園的な天国です。2004年12月にそこの風水林が特別区に指定されました。荔枝窩は古くからの客家の故郷です。加えて有名なのは豊かな広葉樹の森、マングローブ床、沼地、そしてあたりを流れる小川です。通心樹あるいは五指樹の様な古い個性豊かな木々も相まって荔枝窩はきわめて多様な生態系を提供しています。

Set in northeastern Hong Kong, Plover Cove Country Park was designated in 1978. A large park of 4 594 hectares, it encompasses contrasting landforms. Meeting the sea on three sides, the park features a range of undulating peaks in the central part. To its west lies Pat Sin Leng Country Park, famous for its dizzying, rugged uplands. The northern extension of Plover Cove Country Park was designated in 1979. This part of the park includes the Yan Chau Tong which harbours some of Hong Kong's most beautiful coasts. Ma Shi Chau Special Area in Tolo Harbour has a great variety of geological features and landforms. If you like extraordinary rock formations, head for Ma Shi Chau.

Nestled in the remote northeastern New Territories, Lai Chi Wo is a bucolic haven neighbouring Plover Cove Country Park and Yan Chau Tong Marine Park. In December 2004, the local fung shui wood was declared a Special Area. Lai Chi Wo is the home of a classic Hakka village. Also famous are its profuse broadleaved forests, mangroves beds, mudflats and stream. Coupled with unique old trees like the "Hollow Tree" and "Five-finger Camphor", Lai Chi Wo presents an ecological system of great biodiversity.

郊野景點

談到山水美景，船灣郊野公園中最為人熟悉的景點之一，自然是新娘潭。新娘潭位處樹叢之中，上有瀑布流水不斷，予人世外桃源的感覺。照鏡潭、龍珠潭、橫涌山澗和人工修建的船灣淡水湖，均為郊遊熱點。此外，印洲塘於1996年列為海岸公園，享有「印塘三寶」美譽的印洲、筆架洲和白沙頭咀景色尤為獨特，散布附近的大小島嶼亦各具美態。

荔枝窩四周被高山和茂密的樹林包圍，在這裏記錄到的蝴蝶多達115種，蜻蜓30多種，也可找到不少林鳥和水鳥。其中荔枝窩村後的一片風水林，面積達5.7公頃，植物非常豐富，已錄得多於100種。在荔枝窩村前，可找到一個稀有及古老的銀葉樹林，林內的銀葉樹粗壯奇特，其板根的高度更幾可及胸，白花魚藤如巨蟒般穿梭林中。

位於馬屎洲的沉積岩於地質年代中的二疊紀形成，距今約二億八千萬至二億二千五百萬年，是香港最古老的岩石之一。可在這裏找到的化石有瓣鰓類動物、腕足動物、雙殼動物和菊石；這些生物只生存至二疊紀，是香港岩石中十分古老的地質時段。在此亦可看見香港其中一個大型的褶曲。褶曲是岩層受到橫壓力而出現的情況，在有層理的沉積岩上會更為明顯。

郊遊路綫

船灣郊野公園內的新娘潭自然教育徑、大美督家樂徑、涌背樹木研習徑和烏蛟騰郊遊徑都是熱門的郊遊路綫。其中，接近新娘潭溪出口的新娘潭自然教育徑首段兩旁為樹木，在此可靜聽不同雀鳥和昆蟲的鳴聲或觀察地理特徵；沿溪澗上走更可見到岩石上的壺穴、新娘潭瀑布和跌水潭，最宜一家同遊或作短途考察。

荔枝窩設有自然步道，全長1.2公里，沿路的傳意牌介紹荔枝窩的大自然生趣和鄉村歷史。此外，多條小徑連接荔枝窩與其他村落，四通八達。以荔枝窩為起點，北行可通鎖羅盆、谷埔及鹿頸，南行可達三椏村、九擔租，西行則可經分水凹返烏蛟騰，因此，荔枝窩一直是旅遊熱點。

馬屎洲是研習地理的好去處，在細小的範圍內，可觀賞到本港古老的沉積岩、褶曲現象、入侵岩脈、連島沙洲及不同類型的灘岸。島上的自然教育徑全長1.5公里，沿海岸而建，設有彩色傳意牌，介紹島上的地質特徵、地貌及灘岸植物。

見所

新娘潭（Bride's Pool）はプルバーコーブカントリーパークの中でのどかな田園地帯として最も有名な一帯です。素晴らしい滝があり、原始的でまるで天国のようです。

そのほか人気のあるところとしては鏡潭（Mirror Pool）、龍珠潭（Lung Chu Pool）、橫涌山澗（Wang Chung Stream）そして人工のプロバーコーブ貯水池等々があります。この貯水池は24ヘクタールあり香港最大です。長さ2キロもあるダムでも有名です。今では自然の魚の池となり多様な種類が生息しています。印洲塘（Yan Chau Tong）一帯は1996年にマリンパークとして指定されました。印洲、筆架洲（Pak Ka Chau）、白沙頭咀（Pak Sha Tau Tsui）の三つの宝はその独特の魅力で人を魅了します。

高い山や森に囲まれた荔枝窩は自然の野生生物の聖域です。115種類以上の蝶、30種以上のトンボ、鳥や水鳥が

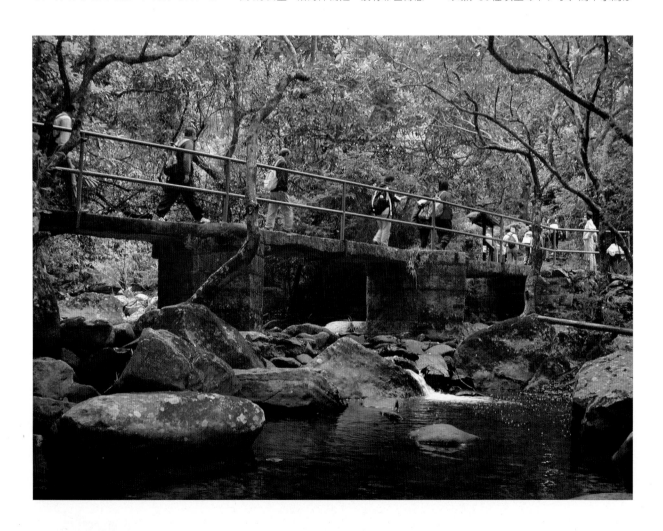

いJA。村のうしろの5.7ヘクタールの風水林には今日までに100種類以上の樹木の種類が確認されています。林のうしろからは一本の道が村の広場へ通じています。村のすぐ前には胸まで高さのある板根を見せびらかすかのような銀葉樹(Coastal Heriteria)の薮があります。そこに珍しい古い白花魚藤(Derris alborubra)がぐるぐる巻きになってからまっています。

香港で最古のこの島の堆積岩盤の起源は今から2億8千万年から2億 2千5百万年前の二畳紀に遡ります。ここで見つかった化石には瓣鰓類動物(lamellibranchs)、腕足動物、二枚貝、アンモナイトなどが含まれます。これらの生物は二畳紀には絶滅したため一帯の岩は大変昔の地質時代のものだったことが分かったのです。馬屎洲では香港周辺で最大の岩の褶曲が見られます。褶曲は岩盤が横からの圧力を受ける時に発生します。頁岩の岩盤の場合褶曲は一層顕著になります。

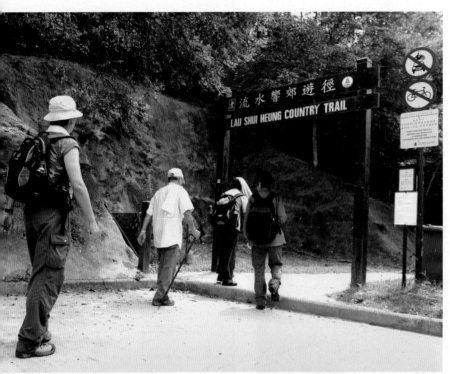

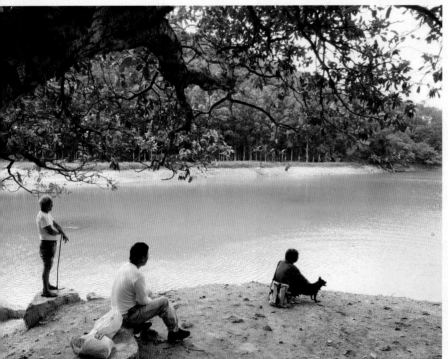

主要ルート

ハイカーのために様々な体力と興味に応じたいくつかのトレイルがあります。

新娘潭(Bride's Pool)自然径、大美督(Tai Mei Tuk)家族径、涌背(Chung Pui)樹木径、烏蛟騰(Wu Kau Tang)カントリートレイル、カントリートレイル等です。

新娘潭(Bride's Pool)のそばの自然径では大変楽しい自然体験ができます。スタート地転では両側に木々が茂り途中では鳥や昆虫の鳴き声が聞こえ、また独特の地形を鑑賞することもできます。

さらに上流に行くと岩の上に穴が開いているのが見えます。大変ユニークな新娘潭(Bride's Pool)の滝と滝壺です。

荔枝窩自然径は長さ1.2キロで道の脇に一帯の生態の見所と歴史の解説板がいくつか立っています。

荔枝窩からほかの村へと通じる道もあり、これが格好のハイキングルートになります。このため荔枝窩は常に人気の高い場所です。

荔枝窩から北へ向かえば鎖羅盆(So Lo Pun)、谷埔(Kuk Po)そして鹿頸(Luk Keng)へ、南へ向かえば三椏(Sam A)そして九擔租(Kau Tam Tso)へ行けます。烏蛟騰へ帰るには分水凹(Fan Shui Au)を通って西へ向かいます。

馬屎洲は比較的狭い場所で様々な地質構造を見られるため地質学の素晴らしい野外教室と言えます。大昔の頁岩、褶曲、入侵岩脈、砂洲そして様々な種類の海岸などがあります。島の自然径は1.5キロ、海岸沿いにあります。興味深い地形、構造、水辺の植物についての解説板もあります。

Attractions

Bride's Pool is one of the most famous idyllic spots in Plover Cove Country Park. Here, a magnificent waterfall sets the scene. The atmosphere is so pristine it seems almost celestial. Other popular scenic spots include Mirror Pool, Lung Chu Pool, Wang Chung Stream and the man-made Plover Cove Reservoir. The area around Yan Chau Tong was designated as a marine park in 1996. The three gems of Yan Chau Tong — Yan Chau, Pat Ka Chau and Pak Sha Tau Tsui — lure you with their unique brand of charm. Also full of individual magic are the islands around.

船灣郊野公園 Plover Cove Country Park

A 荔枝窩 *Lai Chi Wo*

在大埔乘搭小巴20C至烏蛟騰田心村總站，或乘搭假日行駛的275R巴士至新娘潭，再步行至烏蛟騰起步。由烏蛟騰步入荔枝窩約需2小時。

MTR大埔墟(Tai Po)のからミニバス20C、あるいは日祝日には275Rで新娘潭(Bride's Pool)へ。歩いて烏蛟騰(Wu Kau Tang)へ。そこからさらに荔枝窩(Lai Chi Wo)まで2時間ほど。

Take minibus 20C from Tai Po to Wu Kau Tang or alight at Bride's Pool Bus Station by 275R on Sundays and public holidays, then walk to Wu Kau Tang. It takes two hours to walk from Wu Kau Tang to Lai Chi Wo.

B 馬屎洲特別地區 *Ma Shi Chau Special Area*

乘東鐵至大埔墟站，轉乘74K巴士或20K專綫小巴往三門仔總站，沿路標前行15分鐘，即可找到馬屎洲特別地區的入口。

MTRで大埔墟(Tai Po Market)まで行き、バス74K，あるいは綠のミニバス20Kに乗り換え三門仔(Sam Mun Tsai)下車。道標に從って進むと15分ほどで馬屎洲特別地區(Ma Shi Chau Special Area)入口着。

Take the MTR to Tai Po Market (大埔墟) and get on the bus 74K or green minibus 20K from the bus and minibus terminus. Get off at Sam Mun Tsai (三門仔) terminus. Follow the waymark and walk for 15 minutes to reach the entrance of the Ma Shi Chau Special Area (馬屎洲特別地區).

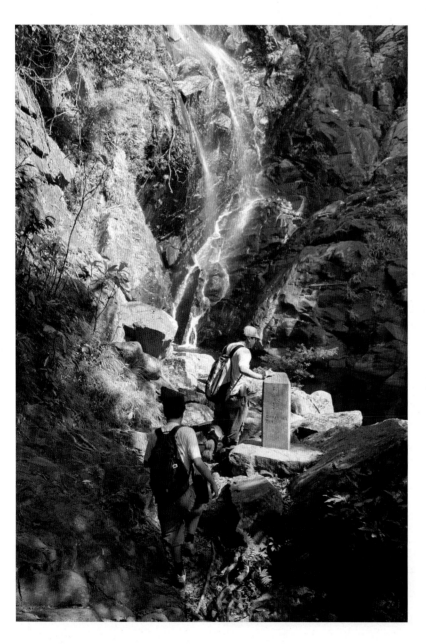

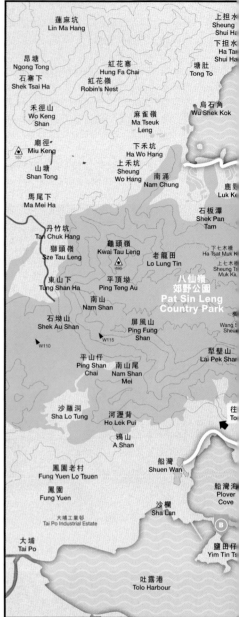

Shielded by high peaks and forests, Lai Chi Wo is a natural wildlife sanctuary. Here you find more than 115 butterfly species, over 30 dragonflies and a host of forest birds and waterfowls. The 5.7-heactre fung shui wood behind the village is extremely rich in flora, with more than 100 plant species recorded to date. Just before the village, there are thickets of Coastal Heritiera (*Heritiera littoralis*) flaunting chest-high buttress roots. Entwined among them is a rare old White-flowered Derris (*Derris alborubra*) that whirls and twirls like a giant python.

Among the oldest in Hong Kong, sedimentary rock beds on Ma Shi Chau date back to the Permian Period, i.e. some 280-225 million years ago. Fossils unearthed

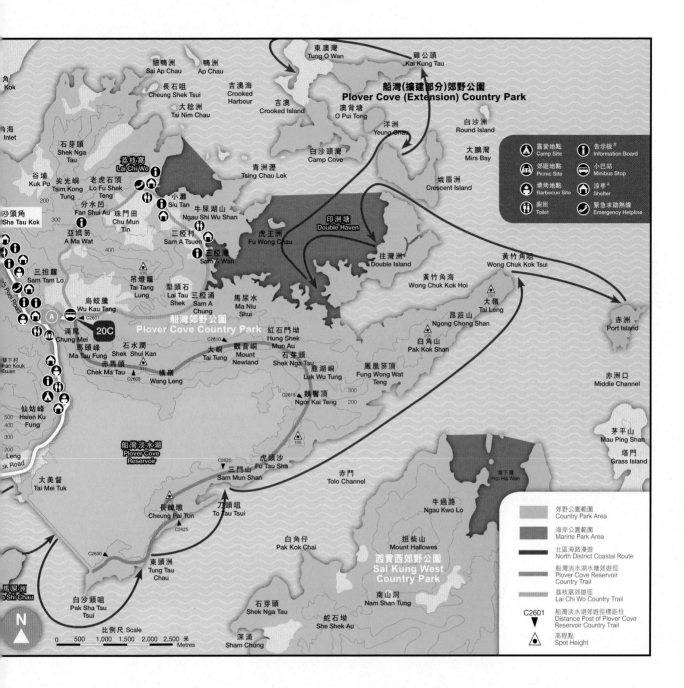

here include lamellibranchs, brachiopoda, bivalvia and ammonoids. As these animals were extinct by the Permian Period, these rock beds belong to a very ancient geological age. Ma Shi Chau is home to one of the largest rock foldings in the territory. Foldings are formed when a rock bed is subjected to lateral pressure. They are particularly conspicuous in sedimentary rock beddings.

Major Routes

The park has several routes for hikers of different interests and fitness levels: the Bride's Pool Nature Trail, Tai Mei Tuk Family Walk, Chung Pui Tree Walk and Wu Kau Tang Country Trail. Bride's Pool Nature Trail near the outlet of Bride's Pool offers a

delectable nature experience. The starting section is lined by trees on both sides. Along the way, there are sweet songs of birds and insects, as well as unique landforms to observe. Further upstream, you find unusual potholes, the Bride's Pool cascade and plunge pool.

Lai Chi Wo Nature Trail is a 1.2 km walk with interpretation plates along the way to explain local ecological attractions and rural history. There are also other paths that lead from Lai Chi Wo to other villages. These routes make up an easy and extensive hiking network. For this reason Lai Chi Wo has always been a popular destination. From Lai Chi Wo, you can reach So Lo Pun and Kuk Po and Luk Keng in the north, or Sam A Tsuen

and Kau Tam Tso in the south. To return to Wu Kau Tang, walk west via Fan Shui Au.

Ma Shi Chau is an excellent outdoor classroom for geological studies because you get to observe a wide range of geological features in a relatively small area: ancient sedimentary rock, foldings, vein encroachments, tombolo and many different types of shores. The nature trail on the island is 1.5 km long. Skirting the coastline, it offers interpretation plates on the interesting landforms, terrain features and riparian plants of Ma Shi Chau.

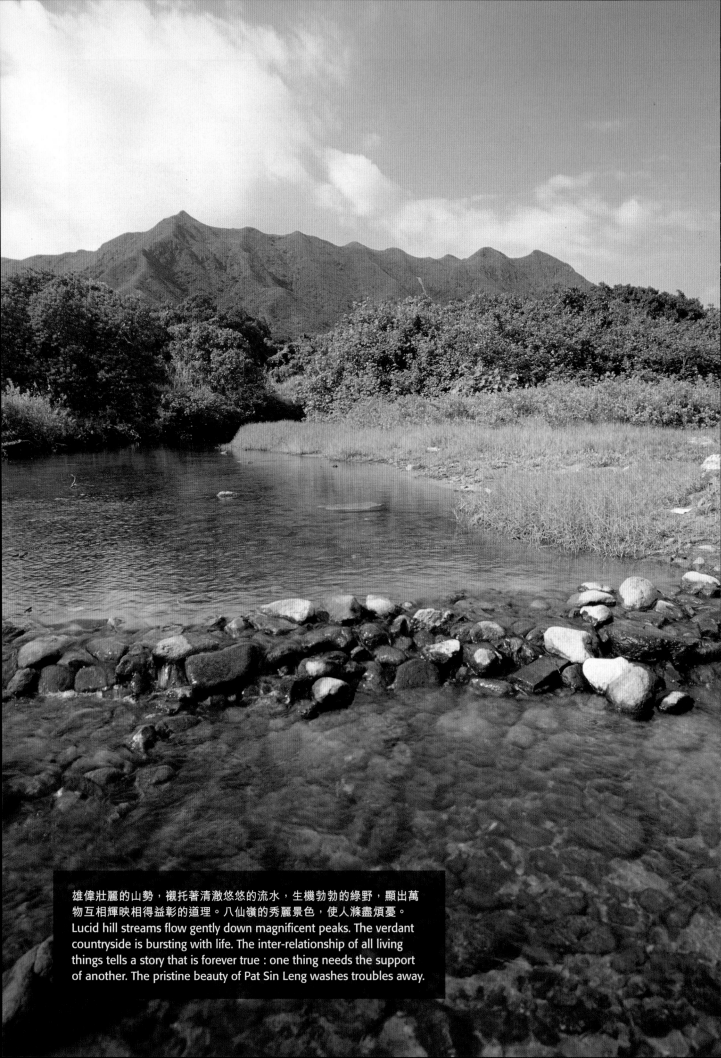

雄偉壯麗的山勢，襯托著清澈悠悠的流水，生機勃勃的綠野，顯出萬
物互相輝映相得益彰的道理。八仙嶺的秀麗景色，使人滌盡煩憂。
Lucid hill streams flow gently down magnificent peaks. The verdant
countryside is bursting with life. The inter-relationship of all living
things tells a story that is forever true : one thing needs the support
of another. The pristine beauty of Pat Sin Leng washes troubles away.

八仙嶺郊野公園

八仙嶺
センター
Pat Sin Leng Country Park

地圖
MAP——*p.72-p.73*

位於香港東北部的八仙嶺，狀如屏風，八峰並列，有如傳説中的八位神仙。

八仙嶺郊野公園於1978年成立，面積達3,125平方公頃，名稱源於狀如八仙的連綿山嶺，其他著名山峰尚有黃嶺、屏風山、九龍坑山及龜頭嶺等。在怡人恬靜的鶴藪水塘及流水響水塘旁，以及每於假日旅遊車穿梭頻繁的新娘潭路一帶，均設有燒烤及郊遊場地；另有多個露營地點，供遊人進行野外探索活動。

新界の北東にある八仙嶺は伝説の八人の仙人のように横に並んだ八つの嶺の連峰です。1978年に指定された八仙嶺カントリーパークは新界北東部の3,125ヘクタールの野生に満ちた地帯をカバーしています。

八つの堂々たる峰々はそれぞれ中国の神話に出てくる八人の仙人のように圧倒的な存在感を見せて聳えています。そのほかには黄嶺(Wong Leng)、屏風山(Ping Fung Shan)、九龍坑山(Cloudy Hill)、亀頭嶺(Kwai Tau Leng)等の山があります。この山の中にはエメラルド色の小さな湖が点在しています。鶴藪(Hok Tau)水塘、流水響(Lau Shui Heung)水塘にはバーベキュー場やピクニック場があります。

Pat Sin Leng in the northeastern New Territories is a range of eight peaks standing parallel like the legendary Eight Fairies.

Designated in 1978, Pat Sin Leng Country Park covers 3,125 hectares of natural terrain in the northeastern New Territories. Pat Sin Leng — the Eight Fairies — is a range of eight stately peaks, each commanding an imposing presence like the fairy in Chinese mythology. Other famous spurs within the park are Wong Leng, Ping Fung Shan, Cloudy Hill (Kau Lung Hang Shan) and Kwai Tau Leng. These majestic uplands are set amidst emerald lakes. The picturesque barbecue and picnic areas can be found on the idyllic banks of Hok Tau and Lau Shui Heung Reservoirs, and also in Chung Pui and Chung Mei by Bride's Pool Road which are frequented by many tourist coaches on public holidays.

郊野景點
若以連續上下坡次數密集程度計算，八仙嶺必列於本港最具挑戰性的山峰之一。這裏的八個山峰氣勢宏大，以中國傳説中的八仙為命，由東面起為何仙姑(仙姑峰)、韓湘子(湘子峰)、藍采和(采和峰)、曹國舅(曹舅峰)、鐵拐李(拐李峰)、張果老(果老峰)、漢鍾離(鍾離峰)和呂洞賓(純陽峰)。主峰為純陽峰，高590米，由此可遠眺新界東北壯麗的景觀。

郊遊路綫
正所謂「欲窮千里目，更上一層樓」，若想一睹壯麗的山川氣勢，便要登上八仙嶺。登山之路沿著連綿的山脊修建，山勢巍峨陡峭，置身其中，儼如飛鷹於天際翱翔；兩旁景色有若天地合一，蔚為奇觀。多條山徑均可以通上八仙嶺，較為安全且路標清晰的是衞奕信徑第九及第十段。路線由九龍坑山開始，下行至鶴藪水塘，再攀上屏風山；沿山脊東行，先經黃嶺及犁壁山，再挑戰八仙嶺的八座山峰；繼而向北下行，直達橫山腳及下七木橋，最後途經尤德爵士紀念亭達南涌，全長17.4公里，走畢全程需7小時。站在嶺上高處眺望，遼闊的郊野、起伏的山巒、壯麗的船灣淡水湖景色，盡收眼底；在天朗氣清的日子，更可以遠眺內地的深圳經濟特區。此外，亦可從大美督郊野公園管理站附近起步，以鶴藪水塘為終點站，全程12公里，需時5.5小時。

若只打算輕鬆親近大自然，則宜選擇鶴藪郊遊徑及流水響郊遊徑，前者經過鶴藪的優美鄉郊；後者則沿山坳而走，沿途飽覽流水響水塘的湖光山色。公園內另設多條不同難度的郊遊路綫，包括南涌郊遊徑、鶴藪水塘家樂徑、鳳坑家樂徑、八仙嶺自然教育徑和涌背樹木研習徑等。

見所
香港の山に難易度をつけるとすれば八仙嶺は頻繁な上下のせいで「難しい」になるでしょう。八つの嶺には中国の神話の仙人の名前が付けられています。東から仙姑嶺(Hsien Ku Fung)、 湘子峰(Sheung Tsz Fung)、采和峰(Choi Wo Fung)、曹舅峰(Tsao Kau Fung)、拐李峰(Kuai Li Fung)、果

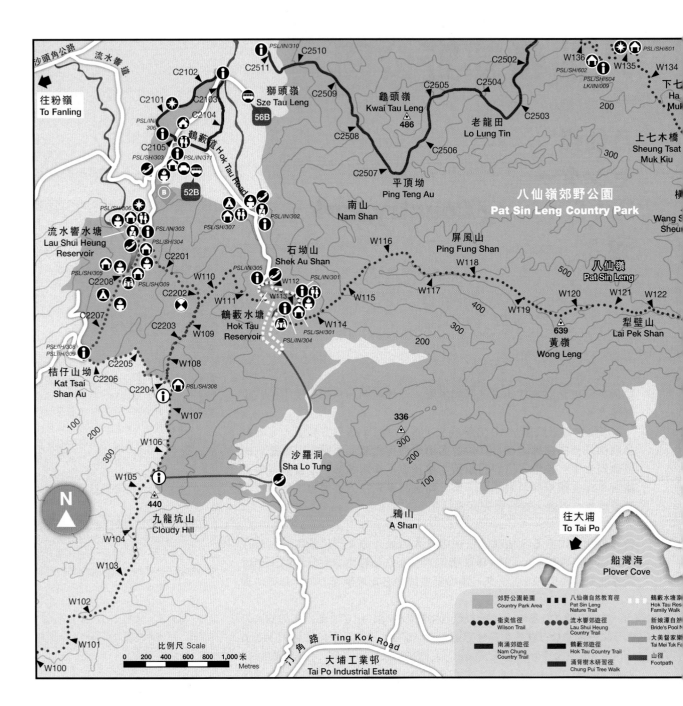

往粉嶺
To Fanling

沙頭角公路
流水響道

C2102
C2101
C2103
C2104
PSL/IN/306
C2105
PSL/SH/303 PSL/IN/311
鶴藪道 Hok Tau Road
B 52B
PSL/SH/306
流水響水塘
Lau Shui Heung Reservoir
PSL/IN/303
PSL/SH/304
PSL/SH/307
C2201
PSL/SH/309
C2208 PSL/SH/309
C2207
C2202
C2203
C2205
C2206 W108
桔仔山坳
Kat Tsai Shan Au
PSL/IH/308
PSL/IH/309
C2204 PSL/SH/308
W107
W106
W105
440
九龍坑山
Cloudy Hill
W104
W103
W102
W101
W100

PSL/IN/310
C2511 C2510
獅頭嶺
Sze Tau Leng
56B
C2509
C2508
C2507
C2502 C2505 C2504
C2503
C2506
龜頭嶺
Kwai Tau Leng
486
老龍田
Lo Lung Tin
平頂坳
Ping Teng Au
南山
Nam Shan
石坳山
Shek Au Shan
PSL/IN/305
W110
W111
W109
鶴藪水塘
Hok Tau Reservoir
W112
W113
PSL/IN/301
W114
PSL/SH/301
PSL/IN/304
沙羅洞
Sha Lo Tung
336
300
200
鴉山
A Shan

W136 W135 W134
PSL/SH/601
PSL/SH/602
PSL/SH/604
LK/IN/009
200
下七木橋
Ha Mu
上七木橋
Sheung Tsat Muk Kiu
300
八仙嶺郊野公園
Pat Sin Leng Country Park
Wang S
Sheu
屏風山
Ping Fung Shan
W116
W118
八仙嶺
Pat Sin Leng
500
W117
W120 W121 W122
W119
400
犁壁山
Lai Pek Shan
639
黃嶺
Wong Leng
300
200
100

往大埔
To Tai Po

船灣海
Plover Cove

N

比例尺 Scale
0 200 400 600 800 1,000 米
Metres

門角路 Ting Kok Road
大埔工業邨
Tai Po Industrial Estate

郊野公園範圍
Country Park Area
衛奕信徑
Wilson Trail
南涌郊遊徑
Nam Chung Country Trail
八仙嶺自然教育徑
Pat Sin Leng Nature Trail
流水響郊遊徑
Lau Shui Heung Country Trail
鶴藪郊遊徑
Hok Tau Country Trail
涌背樹木研習徑
Chung Pui Tree Walk
鶴藪水塘家樂徑
Hok Tau Res Family Walk
新娘潭自然
Bride's Pool N
大美督家樂徑
Tai Mei Tuk Fa
山徑
Footpath

老峰 (Kao Lao Fung)、鐘離峰 (Chung Li Fmg)、純陽峰 (Shun Yeung Fung) と続き、主峰は西端の純陽峰590メートルです。頂上からは北東方面の比類なき海山の景色が眺められます。

 主要ルート

古くから言われている様に高く登れば登るほど眺めは良くなります。香港の山々の雄大さを味わうにはぜひ八仙嶺に登りましょう。山道は稜綾通しにくねくねと続きさえぎるものの無い眺望が欲しいままです。高みからは山々の険しい姿がはっきりと見えます。空中にいるかの様な感覚は酩酊を誘いまるで鷹となって飛んでいるか

のようです。香港でもこれだけ天国に近い思いを味わわせてくれる場所は稀です。天と地の完璧なハーモニーの好例でしょう。

多くのルートがありますが安全に配慮し、道標も完備したウィルソントレイルステイジ9，10を辿るのが最適でしょう。ステイジ9は九龍坑山 (Cloudy Hill) から始まり鶴藪 (Hok Tau) 水塘に下りそこから屏風山に登ります。山の上では稜綾通しに東に向かい、黃嶺 (Wong Leng)、犁壁山 (Lai Pek Shan) を越えて八仙嶺に向かいます。東端の仙姑嶺 (Hsien Ku Fung) を越えると道は北へ下ります。横山 (Wang Shan Keuk)、下七木橋 (Ha Tsat Muk Kiu) と辿り、Sir

Edward Youde (エドワード・ヨウデ卿) 記念碑にいたり、南涌 (Nam Chung) に着きます。合計17.4キロ、7時間かかります。

礫岩で出来た八仙嶺の頂上は地質構造上良く知られた帽岩と呼ばれています。東側の大美督 (Tai Mei Tuk) カントリーパーク管理所から逆に歩き始め鶴藪 (Hok Tau) 水塘まで行くことも可能です。全長12キロ、5時間半のコースです。

もしもう少し楽な方法で自然と付き合いたいなら鶴藪カントリートレイルあるいは流水響 (Lau Shui Heung) カントリートレイルを歩くのが良いでしょう。前者は鶴藪の田園地帯を周回す

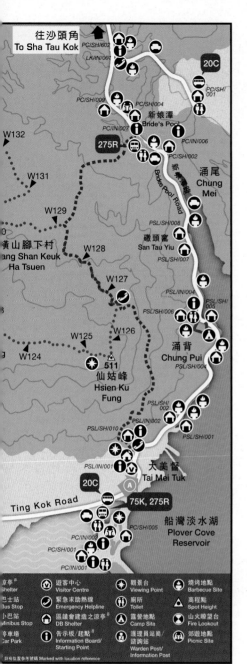

八仙嶺郊野公園 Pat Sin Leng Country Park

Ⓐ 八仙嶺 Pat Sin Leng

乘東鐵至大埔墟站，轉乘75K巴士至大美督巴士總站，下車後沿汀角路到達船灣郊野公園遊客中心，靠左前行，即到達繞山坡修建的八仙嶺自然教育徑。

MTR 大埔墟 (Tai Po Market) からバス75K で大美督 (Tai Mei Tuk) へ。Ting Kok Road (汀角路) を大美督 (Tai Mei Tuk) カントリーパークビジターセンターまで行く。春風亭 (Spring Breeze Pavilion) から八仙嶺自然教育徑 (Pat Sin Leng Nature Trail) を辿って丘を行く。

Take the MTR to Tai Po Market (大埔墟) and get on the 75K bus. Alight at Tai Mei Tuk (大美督) terminus and follow the Ting Kok Road (汀角路) to the Plover Cove Country Park Visitor Centre. Keep left and enter the Pat Sin Leng Nature Trail (八仙嶺自然教育徑) around the hillside.

Ⓑ 鶴藪 Hok Tau

乘坐東鐵至粉嶺站，轉乘52B專線小巴。在流水響迴旋處下車，步行至流水響郊遊徑。假如想到鶴藪圍的話，則在小巴總站下車。

MTR粉嶺 (Fanling) から緑のミニバス52B (駅の反対側) で流水響 (Lau Shui Heung) へ。そこから流水響 (Lau Shui Heung) カントリートレイルを歩く。鶴藪圍 (Hok Tau Wai) に行きたい場合はそこまでバスに乗る。

Take the MTR to Fanling (粉嶺) and get on the green minibus 52B opposite the station. Get off at the round-about of Lau Shui Heung (流水響) to Lau Shui Heung Country Trail. For Hok Tau Wai (鶴藪圍), get off at the terminus.

Ho Hsien Ku (Hsien Ku Fung), Han Sheung Tsz (Sheung Tsz Fung), Lam Choi Wo (Choi Wo Fung), Tsao Kuok Kau (Tsao Kau Fung), Teh Kuai Li (Kuai Li Fung), Cheung Kao Lao (Kao Lao Fung), Han Chung Li (Chung Li Fung) and Lu Tung Bin (Shun Yeung Fung). The 590m Shun Yeung Fung is the main peak of the range. Its summit gives an incomparable panorama of landscape and seascape of the northeastern New Territories.

Major Routes

Like the old saying goes, "climb higher for farther views". To experience the true grandeur of Hong Kong's uplands, labour your way up Pat Sin Leng. The hill path snakes along the continuous ridgeline and offers unobstructed views of the region's magnificent peaks. Here at this elevated point, severe profiles of jagged crests are sharply defined. The airiness is intoxicating, almost as if you are an eagle in flight. Indeed, very few places in Hong Kong give such a celestial feeling. It is a fine example of heaven and earth in perfect harmony. There are many different paths in the range, but it is best to take Stages 9 and 10 of the Wilson Trail which are safe purpose-built routes with clear direction signs. Beginning at Cloudy Hill, the trail leads downhill to Hok Tau Reservoir and then up to Ping Fung Shan. In the uplands, it travels eastwards along the ridgeline, passing Wong Leng and Lai Pek Shan on the way, before challenging the eight crests of the Pat Sin Leng range. Beyond the summits,

the trail continues north, cutting through the abandoned villages of Wang Shan Keuk and Ha Tsat Muk Kiu via the Sir Edward Youde Memorial Pavilion, and eventually ends at Nam Chung. It is 17.4km in total length and takes 7 hours to complete. On fine days, the view at the top is simply arresting. For miles across, peaks roll and billow, their intense greens set against the glinting water of Plover Cove Reservoir. When the sky is clear, you can see the urban maze of Shenzhen of the Mainland in the distance. Alternatively, you can approach Pat Sin Leng from Tai Mei Tuk Country Park Management Centre to Hok Tau Reservoir. The entire 12km route takes 5.5 hours to complete.

If you are looking for a less strenuous encounter with nature, Hok Tau Country Trail or Lau Shui Heung Country Trail is the answer. The former is an easy walk through bucolic country of Hok Tau. The latter winds along a hill pass and offers delightful vistas of hills and lake. For hikers, there are country trails of varying difficulty levels: Nam Chung Country Trail, Hok Tau Reservoir Family Walk, Fung Hang Family Walk, Pat Sin Leng Nature Trail, Chung Pui Tree Walk and the greatly challenging Stage 9 and Stage 10 (ending stage) of Wilson Trail.

る容易な道で、後者は山や湖を見晴らかす丘の道を行きます。

南涌カントリートレイル、鶴薮貯水池家族径、鳳坑 (Fung Hang) 家族径、八仙嶺自然径、涌背 (Chung Pui) 樹木径、そしてウイルソントレイルステイジ 9，10と様々なトレイルがあります。

Attractions

If we were to rate Hong Kong's mountains by level of difficulty, Pat Sin Leng must be one of them with its numerous ascents and descents. The eight monumental peaks are named after the Eight Fairies in Chinese mythology. From the east, they are

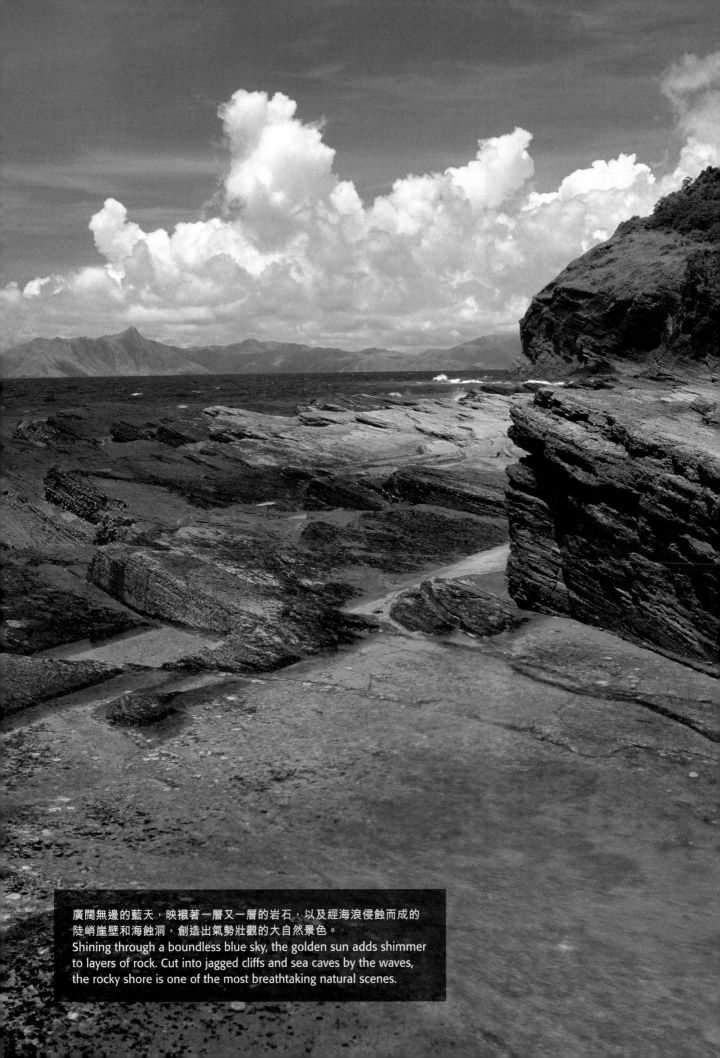

廣闊無邊的藍天，映襯著一層又一層的岩石，以及經海浪侵蝕而成的
陡峭崖壁和海蝕洞，創造出氣勢壯觀的大自然景色。
Shining through a boundless blue sky, the golden sun adds shimmer
to layers of rock. Cut into jagged cliffs and sea caves by the waves,
the rocky shore is one of the most breathtaking natural scenes.

東平洲

東平洲エクステンション
Tung Ping Chau

 地圖
MAP *p.77*

 ### 郊野景點

東平洲全島面積1.1平方公里，最高點是位於南部的鶴岩頂(48米)，北面較高的則有歐公山(37米)。島的中央部分是高15米至25米的平頂台地，賦予這個小島最為人熟悉的「扁平」地形。島的西及南面沿岸是岩石崖壁，由於長期受夏季西南季候風的影響，物理及化學風化與侵蝕尤其嚴重，形成典型的海岸侵蝕地貌。島的東部和北部是向平洲海緩緩傾斜的矮坡，東部沿海地帶主要由王爺角碼頭以北的沙灘及碼頭以南的岩石平台組成，由於風浪較弱，是沙石沉積的區域，亦是適合珊瑚生長的好地方。

東平洲是愛好奇岩怪石人士的好去處。經過千百年侵蝕、沉積及地殼變動等過程而形成的沉積岩看似千層糕，層理清楚，顏色變化豐富，是欣賞和研究地理特徵的好去處。

 ### 郊遊路綫

東平洲雖然面積細小，但擁有多樣化的生態環境，景色又特別，更遠離香港本土。踏足島上，遊人有遠離塵囂、回歸自然的感覺。

島上大部分土地均屬船灣郊野公園擴建部分，為配合成立郊野公園的目的，漁農自然護理署設置了環島郊遊徑及相連小徑、野餐地點、露營地點、多個告示板、路標、涼亭及廁所等基本郊遊設施，供遊人享用，並按自然環境種植適合的樹木，美化康樂場地。

東平洲位於香港境內東北水域之大鵬灣內，與內地的大、小梅沙沙灘遙遙相對，島形如新月，是本港最東面的一個海島。該島以奇岩怪石聞名，公認為香港野外四大景觀之首。全島由沉積岩組成，岩石一層一層的平疊著，地勢平坦，故得「平洲」之名。

東平洲は香港東北部海域の大鵬湾に位置し.中国内地の大梅沙.小梅沙ピーテと 跨離を置いて對峙しています。新月形のこの島 は香港では最も東にある島です。この島はその奇妙な形の岩と石で名を知られ，香港の 自然四景のなかでも筆頭に挙げられます。島全体が水成岩（堆積岩の一種）で形成され，平らな岩層が一層ずつ積み重なる平坦な地勢から，「平洲」の名で呼ばれています。

Tung Ping Chau sits in Mirs Bay on the northeastern side of Hong Kong. Looking across the Dameisha and Xiaomeisha beaches on the Mainland, this crescent-shaped outlying island at the easternmost end of Hong Kong's waters is renowned for its spectacular rock formations and geological features. It is named the best of Hong Kong's four famous natural sights. Tung Ping Chau is an island of sedimentary rocks. The name Ping Chau (Flat Island) comes from the unique formations of such flat sedimentary rock landscape.

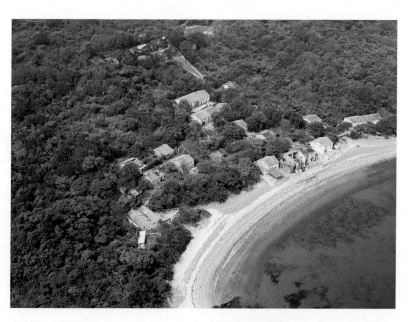

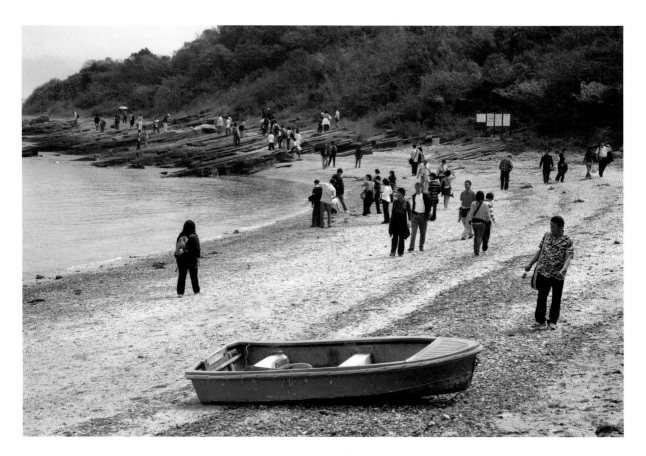

欲在島上度宿的遊人，除了可在指定地點露營外，亦可選擇租住由村屋改裝而成的「士多度假屋」。島上共有六所「士多度假屋」，透過預約，可獲提供簡單的床舖及膳食，收費一般都頗便宜。部分更提供觀察珊瑚的浮潛及潛水設備，可於預約住宿時查詢。

全長6公里的平洲環島郊遊徑帶領遊人盡賞島上獨特的岩石奇景，如在東南端海蝕平台上稱為「更樓石」的海蝕柱；西南面邊緣呈三角形、稱為「龍落水」的厚石帶；另外，斬頸洲、難過水等奇石勝景亦會在環島旅程中一一展現眼前。

 ## 見所

東平洲の総面積は1.1平方キロ。最も高い場所は南部の鶴岩頂（48メートル）で，北部で高い場所は欧公山（37メートル）です。中央部の海抜15~25メートルの平らなテーブル状の台地が。この島の有名な扁平地形を形成しています。島の東西の沿岸は岩壁ですが，長期に及ぶ夏の西南季節風の影響により，物理的、化学的浸食が顕著な典型的海食地形とねています。島の東部、北部は平洲海に向かて緩く短い傾倒地におっています。また東部沿岸地帯は主に玉爺角埠頭以北の砂浜と埠頭以南の岩のテラスからなります。この地域は風や波が比較的弱く，砂や石

が堆積しているので珊湖の生長に適しています。

平洲は名前の通りスポンジケーキのように平らぐ、香港唯一の頁岩の島です。長い年月の間の地殻変動、堆積、浸食の結果生まれたものです。岩が風化するにつれ自然の特性と色彩の多様性が相まって様々な色を生み出しました。ところによっては眼もさめるような色の岩の帯が出来ています。

 ## 主要ルート

 6キロの平洲カントリートレイルを歩けば大変不思議な形の岩に出会えます。島の南東端では波に削られた岩棚の上に7－8メートルの岩塔＝更楼石が乗っています。

南西端には龍落水と言う名前で知られる不思議な岩の列があります。三角形の岩がいくつも長くつながって、まるで海に入ってゆく龍の背のようです。そのほかにも斬頸洲（Cham Keng Chau）、難過水（Lan Kwo Shui）などの地形が見られます。

 ## Attractions

Tung Ping Chau is 1.1 square km in size. Hok Ngam Teng (48m) at the southern tip of the island is the highest peak, while Au Kung Shan (37m) in the north marks another high point. The central region is a 15–25m tall flat terrace, which gives the island's most recognizable "sheet" shape. There are striking rock cliffs on Tung Ping Chau's western and southern coasts. Taking constant beating from the southwesterly summer monsoon, the rocks here are subject to severe physical

 ### 前往方法・行き方・HOW TO GET THERE

A 東平洲 Tung Ping Chau

乘坐東鐵至大學站，步行15分鐘至馬料水碼頭，即可乘搭平洲渡輪到平洲王爺角碼頭。（只在星期六上午9時、下午3時30分及星期日上午9時開出）

MTRの中文大学駅から歩いて15分ほどで馬料水碼頭（Ma Liu Shui Pier）。そこから平洲渡輪（Ping Chau Ferry）で平洲王爺角碼頭（Ping Chau Wong Ye Kok Pier）へ。（土曜日出発9:00と15:30。日曜日9：00のみ）

Take the MTR to University station and walk for about 15 minutes to Ma Liu Shui Pier（馬料水碼頭），then take the Ping Chau Ferry（平洲渡輪）to get to Ping Chau Wong Ye Kok Pier（平洲王爺角碼頭）. (Depart at 9:00 and 15:30 on Saturday and 9:00 on Sunday only).

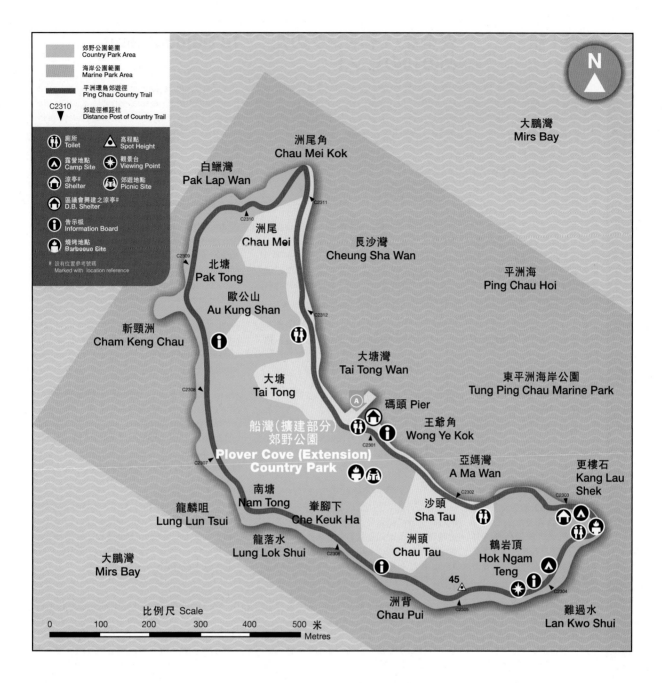

and chemical weathering and erosion, thus forming typical coastal erosion landscapes. On the eastern and northern parts of the island, gentle slopes roll down to Ping Chau Hoi. The eastern coast stretches from the beach north of Wong Ye Kok Pier to the rock stacks south of the pier. In this sheltered area where the wind and waves are less ravaging, sedimentation takes place. It is also a good habitat for corals.

Major Routes

For a small island, Tung Ping Chau's ecological systems and natural vistas are surprisingly diverse. As the island is a long way off the mainland of Hong Kong, it is just the place to forget the hubbub of city life. Tung Ping Chau has basic facilities like a circular Country Trail and linking paths, picnic areas, camp sites, information boards, waymarkers, shelters and washrooms. To create a more pleasant recreational environment, the Agriculture, Fisheries and Conservation Department has planted a wide variety of trees suited to the local terrain.

If you wish to stay overnight, you can either camp at designated camping sites or check into a "grocery shop lodge". The latter are six lodges which were formerly village houses with very basic fittings. Advance booking is required, and rates are usually quite competitive. The owners will prepare beds and simple meals for you. A number of these grocery shop lodges have scuba diving and snorkeling equipment for hire. Visitors who wish to take a dive to see Tung Ping Chau's famous coral formations may make inquiries when they book their accommodation.

The 6km Ping Chau Country Trail, takes you to extraordinary rock formations. One example is Kang Lau Shek, two 7-80m sea stacks on a wave-cut platform at the southeastern tip of Ping Chau. In the southwest, there is a strange looking band of rock, known as Lung Lok Shui, with long and triangular rock formation resembles the spine of a dragon entering the sea. Other features like Cham Keng Chau and Lan Kwo Shui may also been seen along the route.

郊遊十記　安全なハイキングのための10のヒント　10 Outdoor Hints

#	中文	日本語	English
1	明白郊野環境與市區有所不同，出發前先作行程計劃，量力而為，並須掌握遇到意外的應變措施。	郊野の環境は街とは全く違います。自分の体力の限界をわきまえ、出かける前に十分な準備をし、万一トラブルが起きたらどうするかを考えておいてください。	The countryside is very different to the city, so it is important to have safe, sensible activities. Be aware of your physical limitations. Always plan your day out, and know what to do if you get into any difficulty.
2	尊重他人，盡量降低聲浪及減少對自然生態的影響。保持清潔，將攜來的垃圾帶走。	ほかのハイカーに配慮し、動物を驚かせたりしないように静かに行動しましょう。カントリーパークを汚さず、ゴミは持ち帰りましょう。	Respect other countryside users. Keep your noise down to minimize disturbance to animals. Keep the Country Parks clean; take your litter home.
3	愛護自然環境，遵守郊野公園規例。拋棄垃圾、未經許可而於郊野公園內駕駛車輛、在非指定地點生火或露營、攜帶氣槍或捕獵器具均屬違法，可被檢控。	カントリーパークの規則を守り自然環境を保護しましょう。ゴミを捨ててはいけません。指定地域以外で、炊事をしたり、テントを張ったりしてはいけません。無許可で自動車で侵入したり、空気銃やその他の狩猟用具を持ち込むことは厳しく禁止されています。	Protect the nature environment and follow Country Parks Regulations. Do not litter. Lighting cooking fires, and erecting tents or shelters, is only allowed at designated sites. The unauthorized entry of vehicles, or bringing in of airguns or hunting implements, are strictly prohibited.
4	穿戴合適的衣服、鞋及帽子。穿長袖襯衫及長褲可避免被草木刮傷。	活動しやすい衣服を着て、滑りにくい靴を履き、つばの広い帽子をかぶりましょう。長ズボン、長袖シャツを着ていると密生した薮の中で切り傷を避けるのに役立ちます。	Wear comfortable clothes, good traction shoes and wide hats. Wearing long sleeved shirts and trousers helps prevent scratching from dense vegetation.
5	帶備「郊區地圖」、指南針、充足的食水、食物、電筒、手提電話及個人急救箱。切勿攜帶大量財物。若多人同行，可將其中一部手提電話關掉，放在背囊內備用。	郊野地図、コンパス、十分な水と食料、ライト、携帯電話、救急薬品を持ってゆきましょう。貴重品は持ってゆかないようにしましょう。複数の人と歩く場合には緊急事態に備えて携帯電話の内1台はスイッチを切っておきましょう。	Always take a Countryside Series map, a compass, ample water and food, a torch, and a mobile phone. Carry a personal first aid kit. Avoid bringing personal valuables. If you are hiking with several people, switch one of the group's mobile phones off – to preserve its battery for use in an emergency.
6	出發前應小心計劃行程，並告知親友該路綫及大約回程時間，以防逾時未返而無人知曉。須留意流動電話網絡覆蓋並不全面，部分地區可能會出現接收困難。	コースは慎重に決めましょう。万一予定通り戻らない場合に備えてコースの詳細と帰宅予定時間を知人に知らせておきましょう。携帯電話の電波のカバー範囲は地域によって違うので、誰かがあなたの行く先を知っていることは大変重要です。	Plan your route carefully. Leave details of your route and return time with someone, to raise the alarm if you fail to return. Mobile phone coverage varies among districts, so it is essential that someone knows where you have gone.
7	不要離開遠足徑到附近的樹林或山溪尋幽探秘。遇上可疑人物，應立即報案。若不幸遇劫，應保持鎮定，切勿反抗，留意匪徒的外貌及特徵，以便日後協助警方辨認疑犯。	ハイキングルートを離れて森に入ったり、川沿いを進んだりしないようにしましょう。不振な行動をしている人を見かけたら直ちに警察に連絡しましょう。強盗が出た場合には静かにして争わないようにしましょう。後刻、警察の捜査に役立つように強盗の顔や特徴をできる限り覚えておきましょう。	Do not venture off marked trails, such as into woodlands or along streams. If you see anyone behaving suspiciously, ring the police immediately. If anyone tries to rob you, stay calm and avoid confronting them. To help the police identify the suspects later, try to remember as much as you can about the robbers' appearance and character.
8	如遇上事故，應先鎮定下來。若需要撥電或到路徑以外地方求助，請記錄最近的標距柱號碼。這些標距柱遍布郊野公園，間距約為500米，柱上標明如H056之號碼，有助救援人員盡快找到遇事地點。	トラブルが起きた場合は先ず立ち止まりましょう。助けを求めるために電話をしなければならなかったり、ハイキングをやめなければならなかったりする場合は一番近い場所にある標距柱の番号を記録しましょう。この柱にはたとえば「H056」といった番号が書かれていて500メートルごとに立てられています。一番近くの番号を警察に伝えれば救援隊はあなたのいる場所に迅速に到達できます。	If in trouble, always stop. If you must telephone, or hike out, for help always record the nearest Distance Post. These are spaced about 500m apart, with numbers like "H 056". Give the nearest Distance Post to the police, so your rescuers can reach your exact position effectively and quickly.
9	帶備野外考察指南、動植物名錄及筆記簿，作辨認生物及記錄之用。	郊野についてより多くのことを見つけ、より興味を持つためには動植物が分かるフィールドスタディーガイドを携帯することをお勧めします。	To discover more about the countryside and find more of interest, bring along some field study guides, checklists and notebooks – for identifying and recording plants and animals.
10	旅程前閱讀有關的書籍，加深對郊野及自然環境的了解，可增加郊遊樂趣。	出発前にコースの概要を読んでおきましょう。そうすればより多くの発見があります。	Read about your route before heading out, to discover more about the countryside.

地圖目錄　Map Index

HONG KONG NATURE 香港自然美 Let's Go!

作者 Author	： 漁農自然護理署 Agriculture, Fisheries and Conservation Department
導向委員會 Steering Committee	： 詹志勇、許招賢、李家松、范佐浩、潘萱蔚、林煒瀚（郊野公園之友會社區及教育委員會） C. Y. Jim, John Hui, William Lee, Paul Fan, H. W. Poon, Patrick Lam (Friends of the Country Parks Community and Education Committee)
編輯 Editor	： 陳慧聰、胡卿旋 W. C. Chan, H. S. Wu
資料、地圖及標題 Research, Maps and Captions	： 李錦昌、李進歡、鍾港增、歐麗梅、陳淑瓊、洪烈招、梁耀森、李國衡（漁農自然護理署） K. C. Lee, C. F. Lee, K. C. Ah Kong Chung, L. M. Au, S. K. Chan, L. C. Hung, Y. S. Leung, K. H. Lee (Agriculture, Fisheries and Conservation Department)
攝影 Photography	： 楊家明（漁農自然護理署）、譚志榮* K. M. Yeung (Agriculture, Fisheries and Conservation Department), C. W. Tam*
英文翻譯 English Translation	： 達意翻譯服務中心 Word Power Language Service Ltd.
日文翻譯 Japanese Translation	： 金子晴彥 Haruhiko Kaneko
出版 Publisher	： 郊野公園之友會 Friends of the Country Parks http://www.focp.org.hk 三聯書店（香港）有限公司 Joint Publishing (H. K.) Co., Ltd.
國際書號 ISBN	： 978 962 04 2740 4
地圖及設計 Maps and Design	： 設計堂有限公司 The Design Associates Ltd.
承印 Printing	： 第一美術出版有限公司 Daiichi Publishers Co Ltd.
版次 Edition	： 2008年2月第1版第2次印刷 2nd impression Feburary 2008